PETER MAY
HEBRIDES

PHOTOGRAPHS BY DAVID WILSON

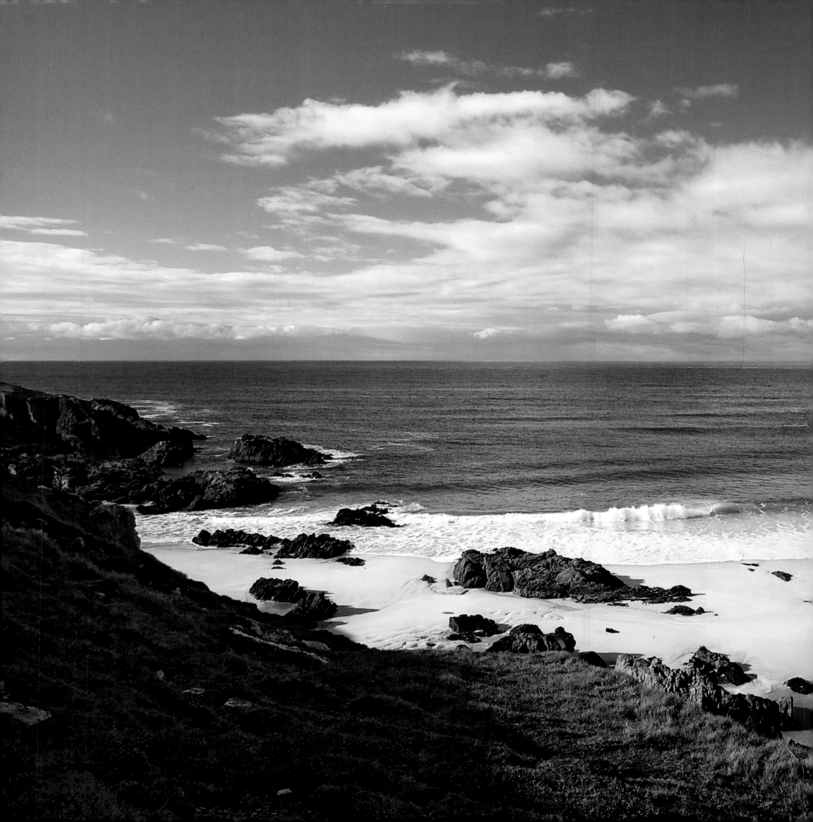

PETER MAY
HEBRIDES

PHOTOGRAPHS BY DAVID WILSON

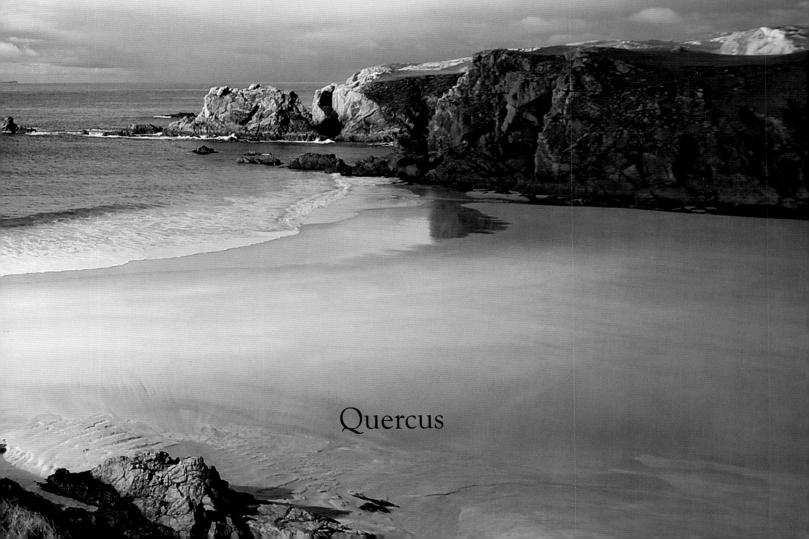

Quercus

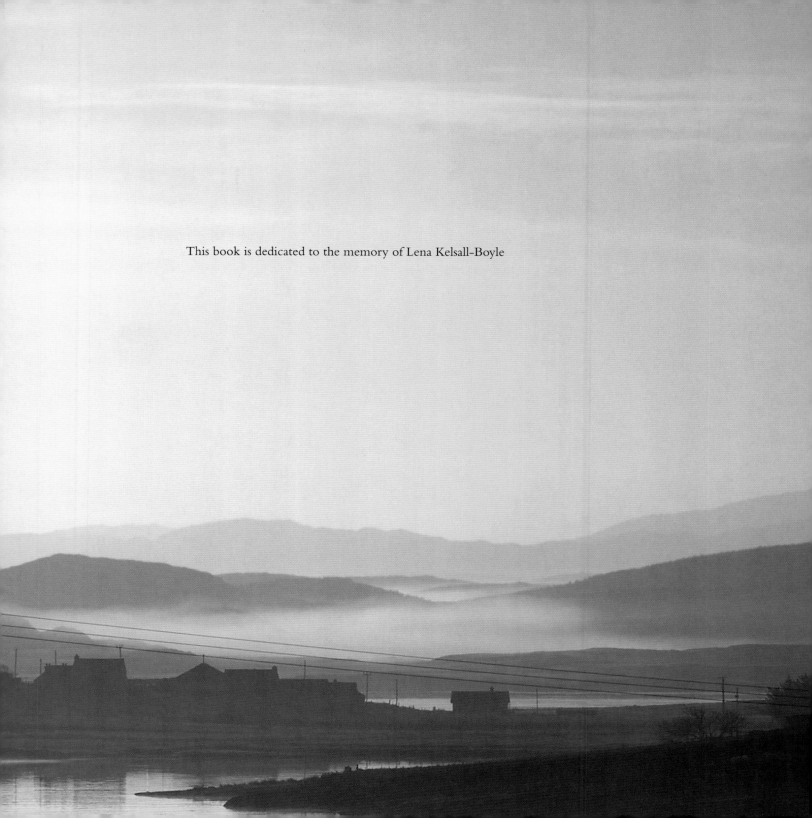

This book is dedicated to the memory of Lena Kelsall-Boyle

CONTENTS

Tong

This misty dawn over Tong to Tiumpan Head and Point might have looked just like this thousands of years ago – except for the houses we can see strung along the near horizon.

This is not an official travelogue taking you on a journey around the tourist high points of the Outer Hebrides. It is a highly personalized account of the islands as I experienced them. Although an outsider, I have lived and breathed these islands as both a television producer filming here in all weathers, and as a novelist whose dark crime thrillers set among them have become bestsellers.

Love them or hate them, once visited these Western Isles will stay with you for the rest of your life.

Dominated by the force of the weather and the power of the Church, they resemble very little to be found on the mainland. As a part of the 'British' experience they are quite unique, and are much further from London and the centres of political power than can be measured in miles alone. Gaelic language and culture prevail, influenced by centuries of Norse occupation. Its music is primal and distinctively Celtic – from the unaccompanied Gaelic psalm-singing that raises goosebumps on the arms, to the haunting Hebridean melodies of Karen Matheson and Capercaillie, Runrig or Julie Fowlis.

Everyone experiences the Outer Hebrides differently. This is the story of my relationship with the islands: how I first came here, how I spent my time here, and how after a ten-year absence I was drawn back to write the books that would become the most successful of my writing life.

The photographs have been taken by my good friend David Wilson. David was my designer on *Machair*, the Gaelic-language TV drama that I co-created and produced. David loved the islands so much that when *Machair* finished he stayed. He now lives out on the west coast of Lewis and spends his time capturing the magic of the land and seascapes for digital posterity.

I hope that you will join us and enjoy the journey on which *Hebrides* will take you, and that by the end of it you will have fallen in love with these islands, as I have.

Peter May

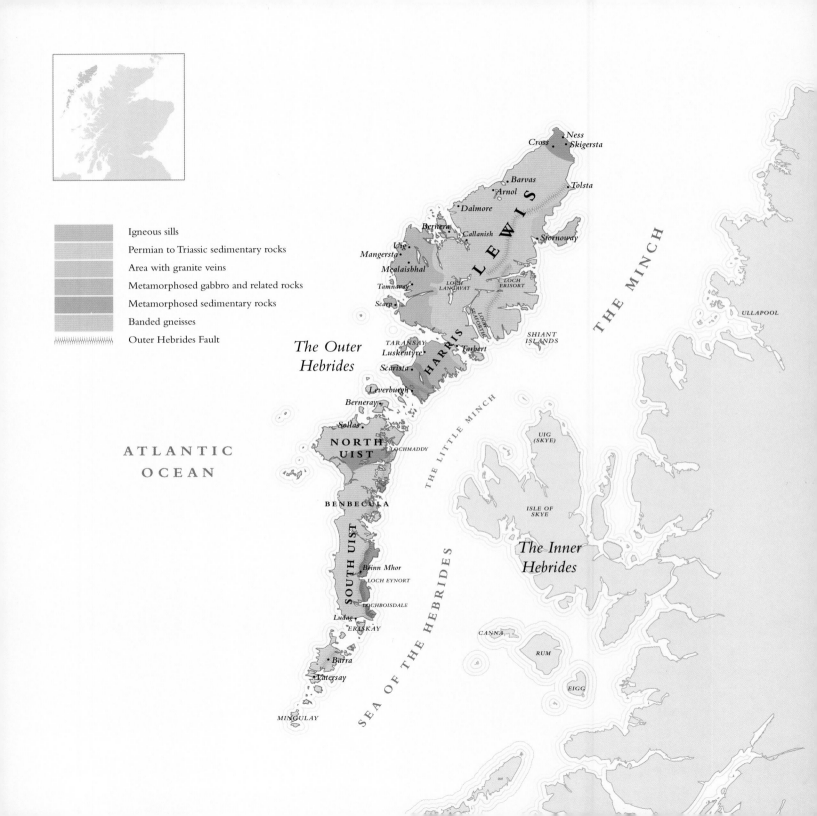

Igneous sills

Permian to Triassic sedimentary rocks

Area with granite veins

Metamorphosed gabbro and related rocks

Metamorphosed sedimentary rocks

Banded gneisses

Outer Hebrides Fault

ATLANTIC
OCEAN

*The Outer
Hebrides*

THE MINCH

THE MINCH

ULLAPOOL

Ness
Skigersta
Cross

Barvas
Tolsta
Arnol
Dalmore

LEWIS

Bernera
Callanish
Uig
Stornoway
Mangersta
Mealaisbhal
LOCH
ERISORT
Tamnavay
LOCH
LANGAVAT
Scarp
LOCH
SEAFORTH

SHIANT
ISLANDS

TARANSAY
Luskentyre
HARRIS
Tarbert

Scarista

Leverburgh

Berneray

Sollas

NORTH
UIST
LOCHMADDY

THE LITTLE MINCH

UIG
(SKYE)

ISLE OF
SKYE

BENBECULA

*The Inner
Hebrides*

SOUTH UIST

Brinn Mhor
LOCH EYNORT

LOCHBOISDALE

Ludag
ERISKAY

CANNA

RUM

Barra
Vatersay

EIGG

MINGULAY

SEA OF THE HEBRIDES

A GEOLOGICAL HISTORY
OF THE OUTER HEBRIDES

The Outer Hebrides is a 200 kilometre-long archipelago off the north-west coast of Scotland. It stretches from Lewis in the north to Berneray in the south, and includes outlying islands such as St Kilda and the Shiant Isles. The islands vary from the peat-covered uplands of Lewis and the mountains of South Harris, to the wonderful sandy beaches of Barra and the Uists and the breathtaking cliffs of St Kilda. The spine of the islands was formed by ancient gneisses while the Shiant Isles and St Kilda are quite young in geological terms, and were created when the Atlantic opened up around 55 million years ago. Since then the Outer Hebrides have been shaped by sea, ice, wind and rain, to present the starkly beautiful islands we see today.

The geological history of the Outer Hebrides can be read in the rocks and sediments that make up the islands. Their history dates from the Precambrian period more than 525 million years ago, when the Lewisian gneisses were formed, to the Quaternary

The Shiants
The Shiant Isles as seen from Lemreway on the east coast of Lewis. They are a comparatively recent geological creation. Beyond them we see the Isle of Skye.

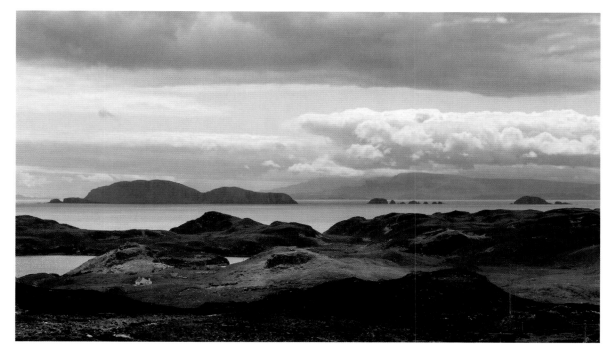

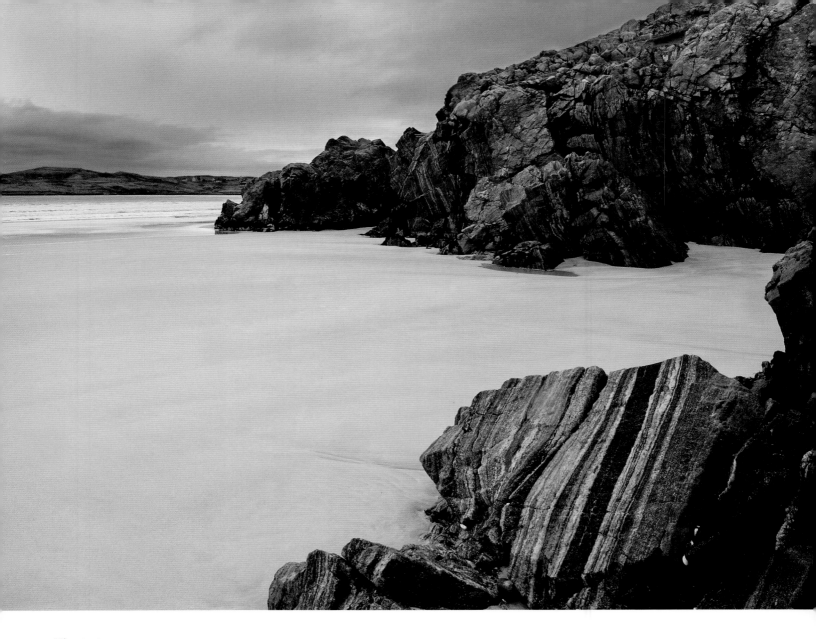

Uig strata
*The different rock strata and
colours can be seen very clearly
here in these outcrops of rock
at Uig, south-west Lewis.*

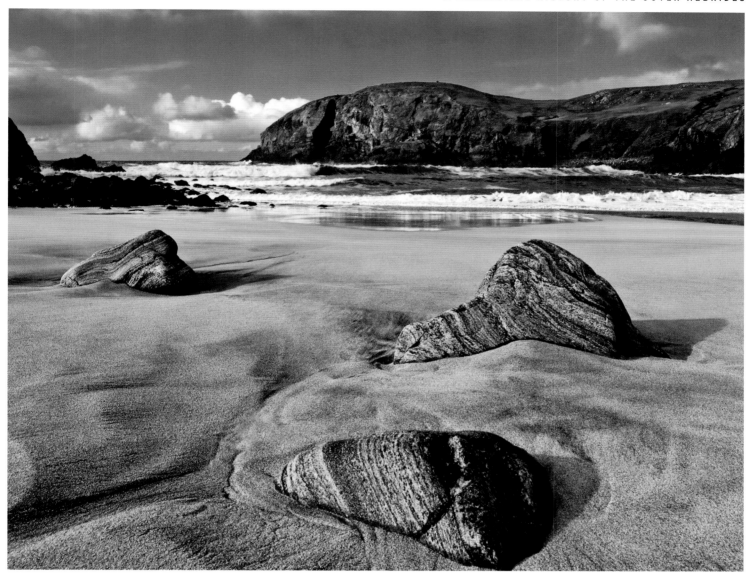

Rocks at Dalbeg
*The beach at Dalbeg on the
west coast of Lewis is littered
with giant pebbles that chart
the passage of millions of years.*

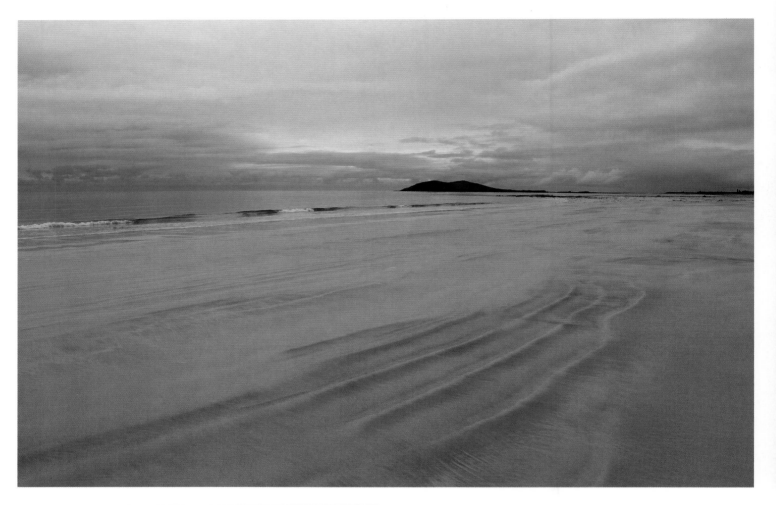

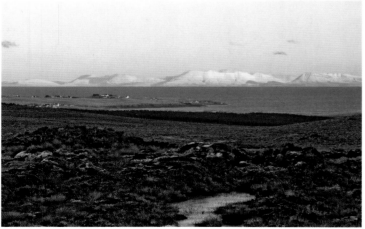

LEFT The mainland from beyond Tong
The distant snow-covered peaks. of the mainland seen from near Tong, north of Stornoway. Only the houses on the left show the presence of human beings in this timeless landscape.

ABOVE South Uist dawn
Early morning on South Uist could be mistaken for the dawn of time.

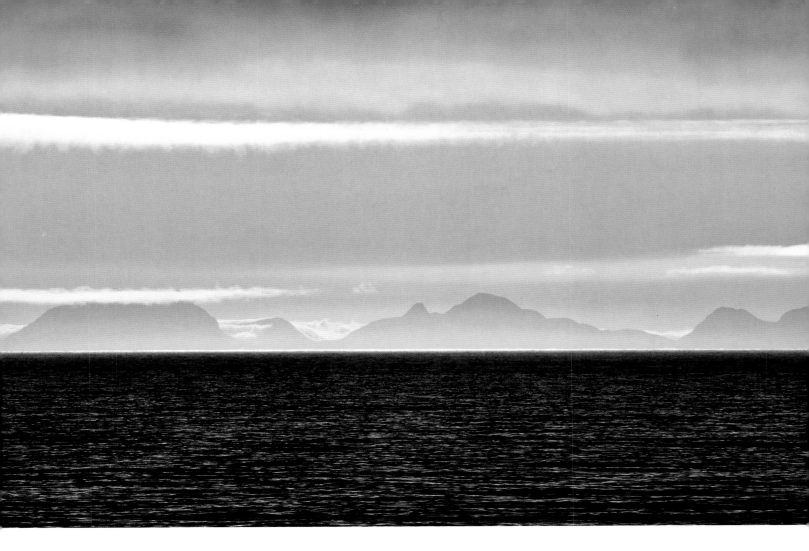

The mainland from Bayble

This picture has an almost prehistoric feel to it. These are the mountains of the mainland as seen across the Minch from Bayble on the Eye Peninsula.

period, which began around 2.6 million years ago, extending through the last ice age 11,500 years ago to the present day. In between there were major geological upheavals on Earth that changed and formed and shaped the islands. At one point they comprised part of a major land mass, before continents clashed and blocks of the Earth's crust moved against each other along the Outer Hebrides fault, throwing up the Caledonian mountains.

Hard to believe, but what later became Scotland once lay close to the equator. Tropical forests grew in low-lying areas, forming the deposits of coal that

were later mined in the central belt. As the continents moved, so Scotland drifted north. Its hot, dry climate produced sands and pebbles later forming rocks that can be found near Stornoway today.

At the time of what was known as the Laxfordian Event, 1,700 million years ago, molten rock was forced into the gneisses of South Harris and western Lewis, forming sheets and veins of hard pink granite. And since the granite was less easily eroded than the surrounding gneiss, these developed into the spectacular sea-stacks that can now be seen off the coast of Uig.

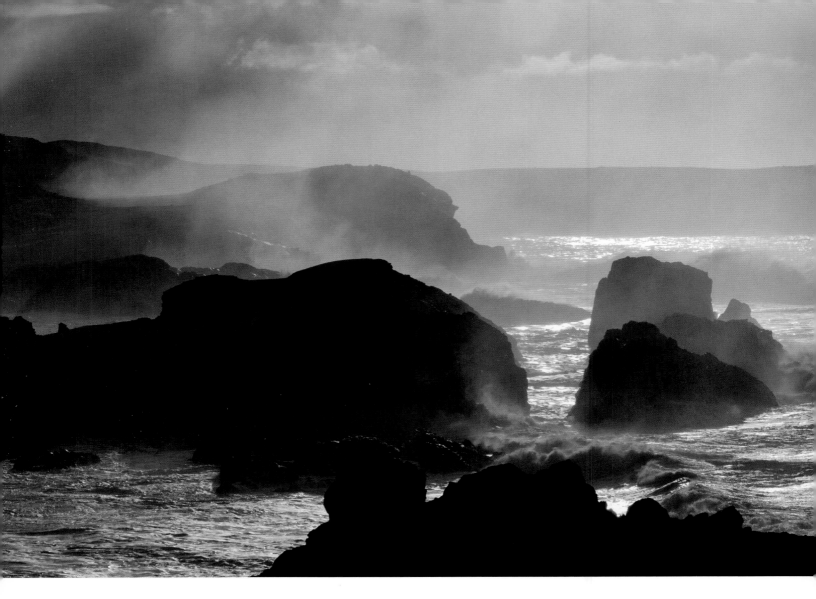

During the Jurassic period floodwaters filled the basin that now forms the Minch – the body of water between the islands and the mainland. It became a shallow sea supporting life of all kinds, and dinosaurs roamed its coasts. Between 23 and 65 million years ago erupting volcanoes along the west coast of Scotland forced molten rock into the layers of sediment in the surrounding seas and formed the magma chambers now exposed as St Kilda.

But the landscape of the islands as we know them today was really shaped by the cycles of freeze and thaw that occurred during the ice ages of the Quaternary period, when glaciers scoured and sculpted the mountains, valleys and plains that characterize the Hebrides. Seas rose rapidly during the sudden warming that accompanied the end of the last ice age, producing something that approximates the present-day coastline.

Sea-stacks, Uig
These rock-stacks at Uig demonstrate the different rates at which rocks are eroded.

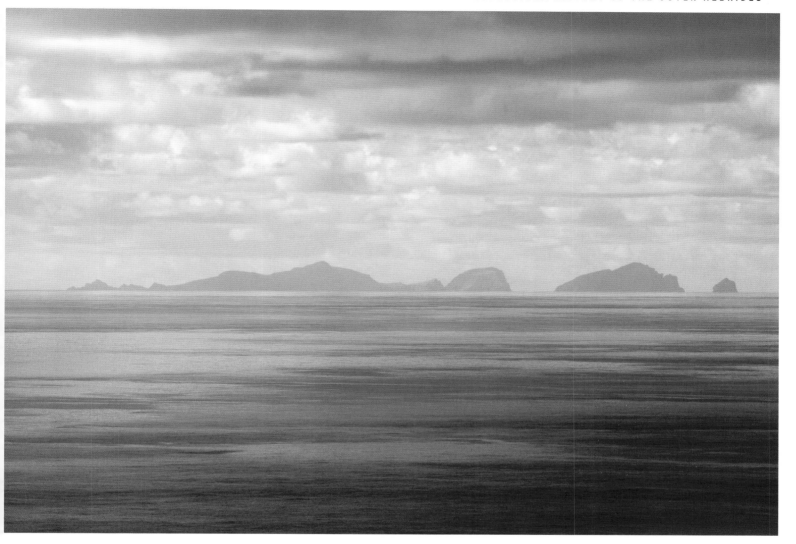

St Kilda
*The islands of St Kilda
shimmer on the horizon.*

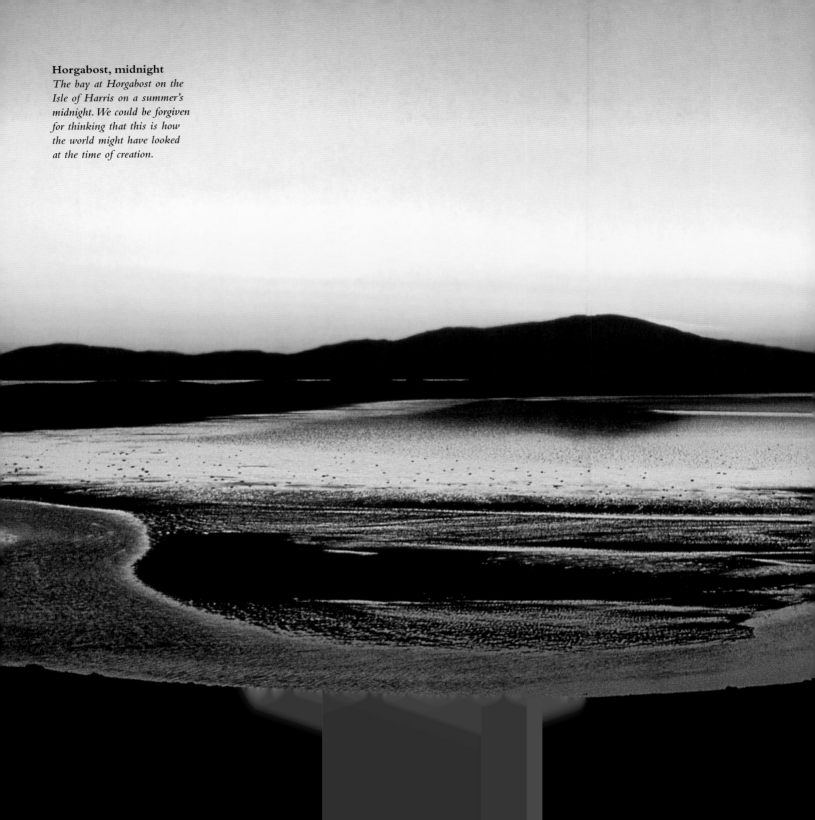

Horgabost, midnight
*The bay at Horgabost on the
Isle of Harris on a summer's
midnight. We could be forgiven
for thinking that this is how
the world might have looked
at the time of creation.*

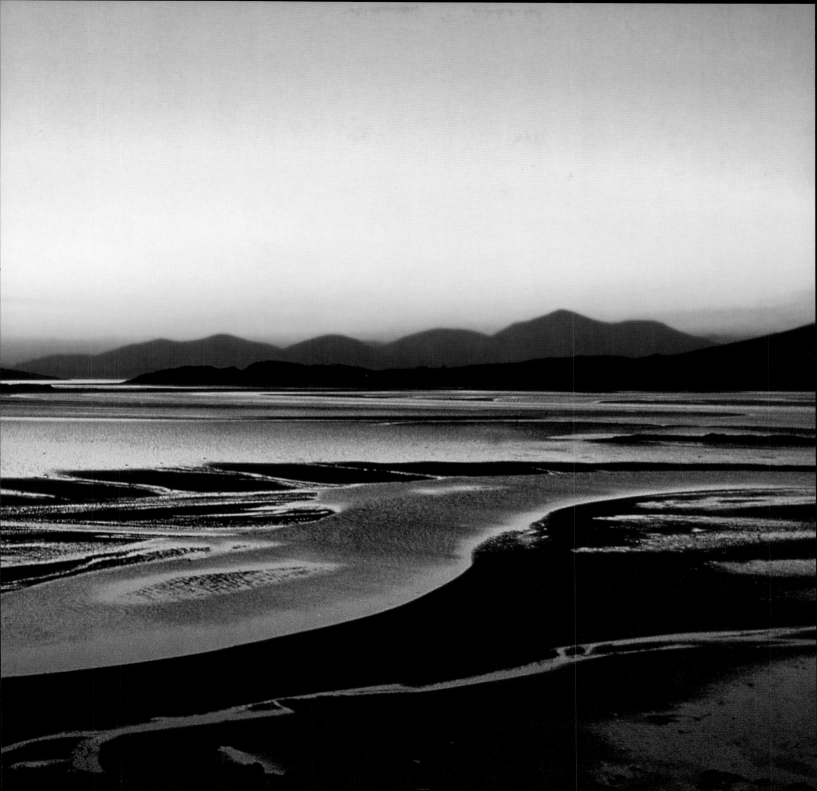

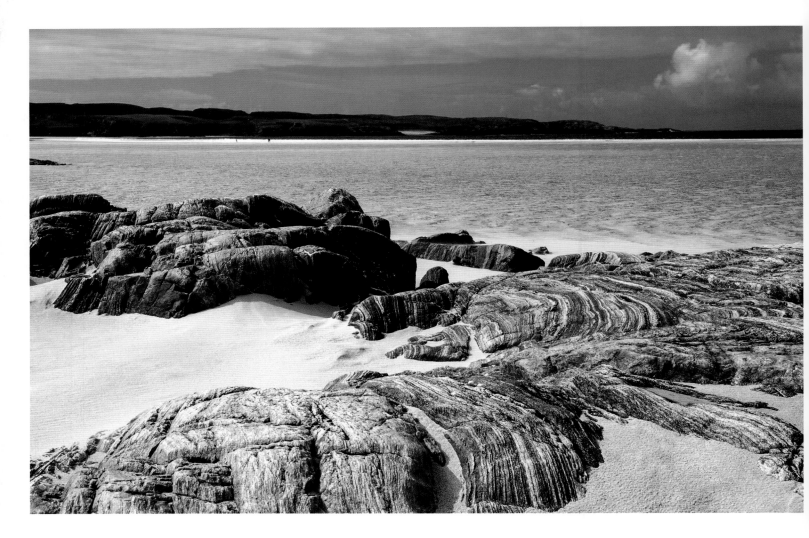

Stones and boulders deposited on the sea floor by melting glaciers were ground and polished over millennia by the ebb and flow of the sea itself, and washed ashore by storms as beach shingle along many shorelines. Although the creamy gold and silver beaches that distinguish the islands were also partly formed by glacial deposits, they are for the most part made up of the tiny crushed-shell fragments and skeletal remains of marine creatures and algae.

The coastal grasslands behind those beaches along the western seaboard of the Western Isles are known as machair, and are particularly rare in Europe. Largely composed of compacted shell fragments, their well-drained, lime-rich soil provides fertile ground for farming.

Again, it may be hard to believe, but the islands were then covered by forests, and it was not until humans began to cut down the trees and the land was taken over by peat, which started forming around 6,000 years ago, that the barren, treeless appearance of the archipelago as it can be seen today finally developed.

Rocks at Uig
Silver sands and rock strata present a natural time-map of the islands here at Uig in south-west Lewis.

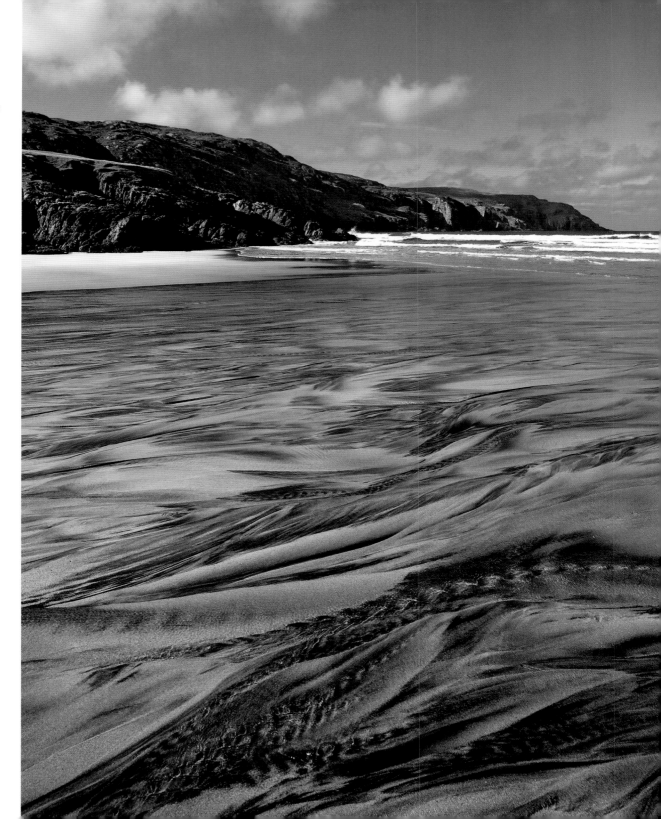

Mackerel stream
Wonderful golden and silver beaches characterize the western coastline of the islands in particular. Here a stream leaves 'mackerel' tracks in the sand.

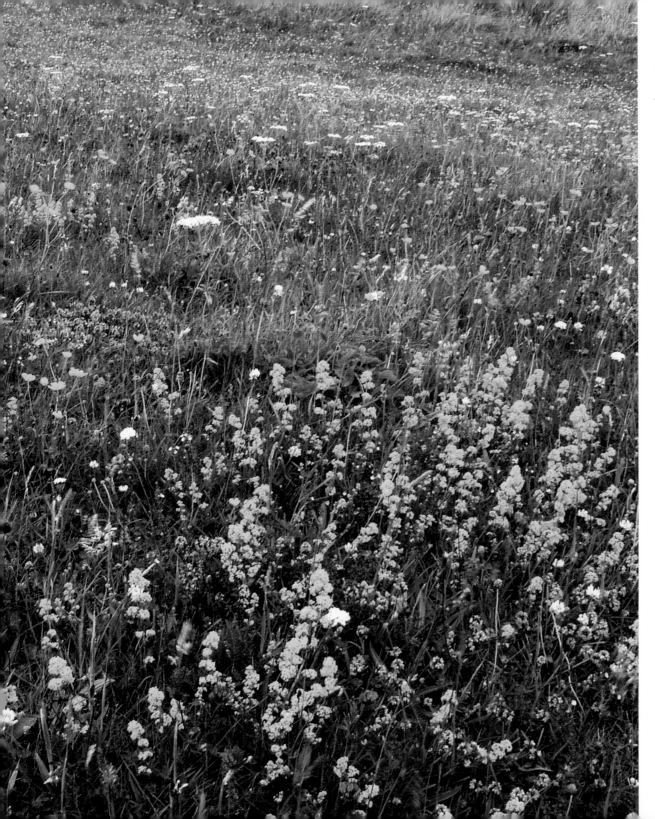

Machair land
Spring flowers and fresh grasses bring life to the coastal machair.

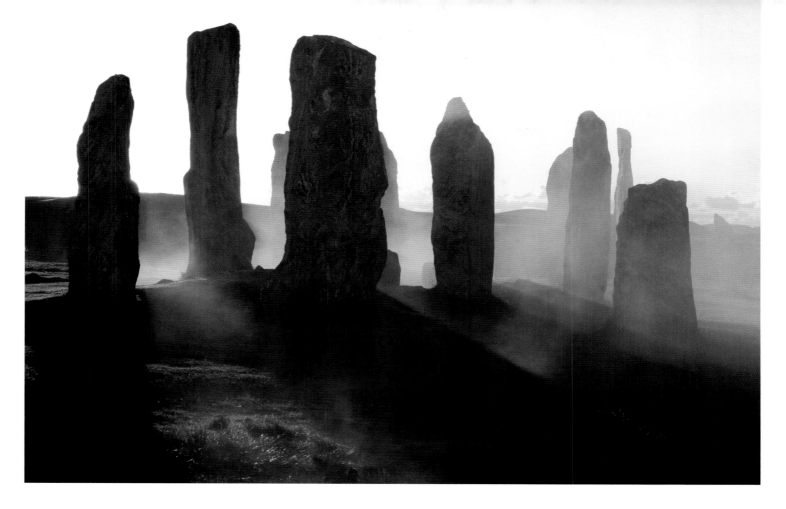

Callanish stones

These stones, hacked out of raw gneiss, present one of the great mysteries of the islands at Callanish on the west coast of Lewis. Raised there, even before Stonehenge, no one has yet been able to explain why. There are several other, smaller, stone circles in the vicinity.

Most of the gneisses that make up the islands were formed by cooling magma around 3,000 million years ago, and are among some of the oldest rocks on earth. Huge pressures exerted by subsequent upheavals on the planet, compressed and metamorphosed the gneisses and various sedimentary rocks creating the banded Lewisian gneiss found all over the islands today.

Gneiss is an extremely hard rock, difficult to break or fashion, and yet it has been worked and shaped by Hebrideans for millennia. The most spectacular example can be found in the standing stones at Callanish. This circle of thirteen stones, surrounding a central monolith ten metres high, all cut from slabs of local gneiss, has avenues that lead off north, south, east and west, and if viewed from above, bears a remarkable resemblance to a Celtic cross. The Callanish stones, however, were erected about 4,000 years ago, long before the birth of Christ. Why they were put there, no one knows.

Undaunted by the hardness of the rock, the islands' inhabitants split them along their banding to create the building-blocks used to construct dry-stone Iron Age 'brochs', including the famous Dun Carloway. These brochs were thought by some to be defensive military structures. They were later cannibalized for their stone, which was then used to build the blackhouses that became the standard island home for

centuries. However, the stone that was later used to build Stornoway, the largest town on the islands, was imported from the mainland during Victorian times.

While the igneous rocks that form the hills of South Harris and the mountains of South Uist consist of a substance known as gabbro, the peak of Roineabhal, and the outcrops of rock around Lingerabay are composed of a white rock called anorthosite. This anorthosite is extremely rare in the UK, but very common on the Moon, where it comprises a great proportion of the lunar highlands. So when sometimes we talk about parts of the Hebrides resembling a moonscape, we are not so very far off the mark.

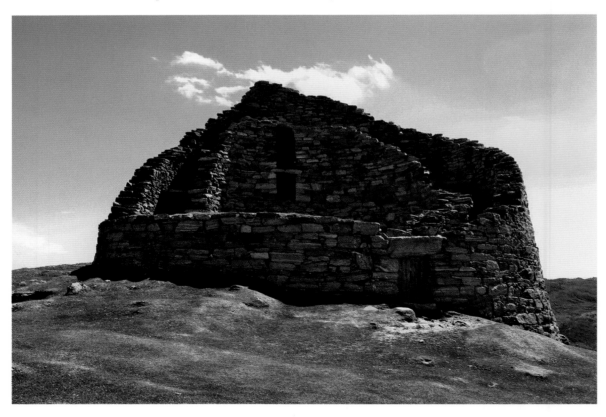

Dun Carloway
This fortified broch at Carloway on the west coast of Lewis was built around the first century BC and is remarkably well preserved.

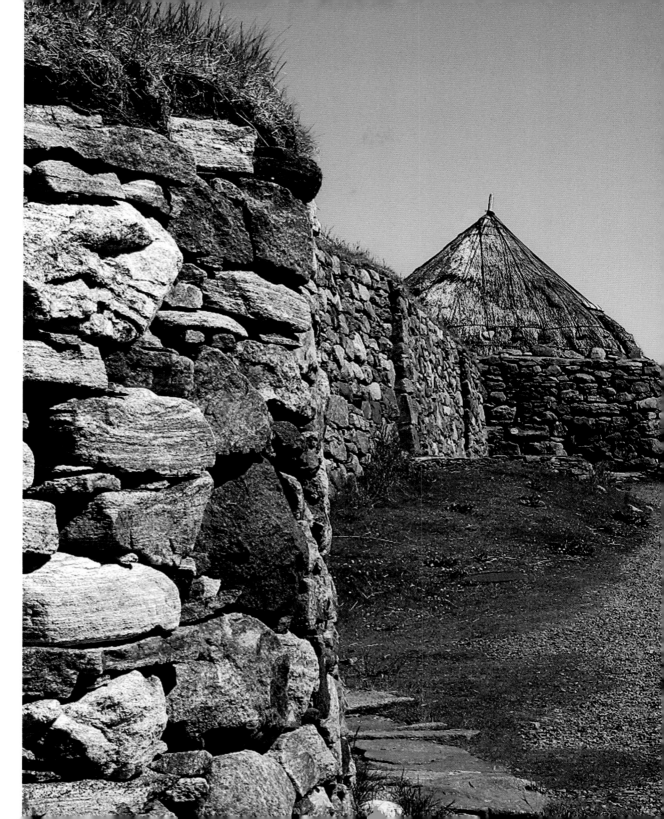

Stone walls

These stones, pillaged from the earlier brochs, were used to build the dry-stone walls of blackhouses in settlements all over the islands.

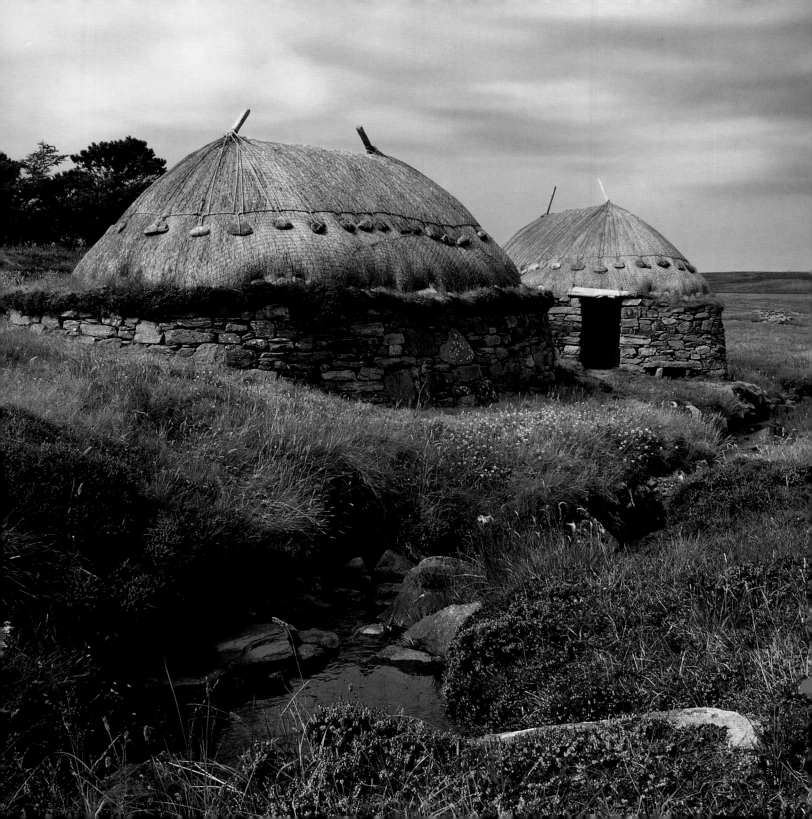

A PEOPLE HISTORY
OF THE OUTER HEBRIDES

LEFT **Norse mill
at Shawbost**
*This Norse mill at Shawbost
on the west of Lewis shows
how much the influence of the
occupying Vikings had on the
architecture of the islands. The
construction is very similar to
that of the blackhouses, which
became the ubiquitous homes
of the inhabitants. Every
village had a mill and a kiln
for processing grain crops.*

The earliest evidence of human habitation on the islands dates back around 8,000 years. It would appear that much of the forest which then covered the islands was burned to create grassland for deer. The oldest archaeological remains are around 5,000 years old, from a time when people began settling in stone-built houses and farming the land rather than

following their herds. Up until about 1500 BC the climate was warmer and drier, but when things began to get wetter and cooler the inhabitants moved to populate the coastal fringes where the machair offered the only remaining fertile land.

During the Iron Age, from around 500 BC, people left more permanent traces on the landscape,

FACING PAGE **Restored Iron
Age settlement, Bosta**
*This village at Bosta, on Great
Bernera off the west coast of
Lewis, was discovered in 1993.
Dating from the Iron Age, it
has been restored to how it was
believed to have looked in the
seventh or eighth century.*

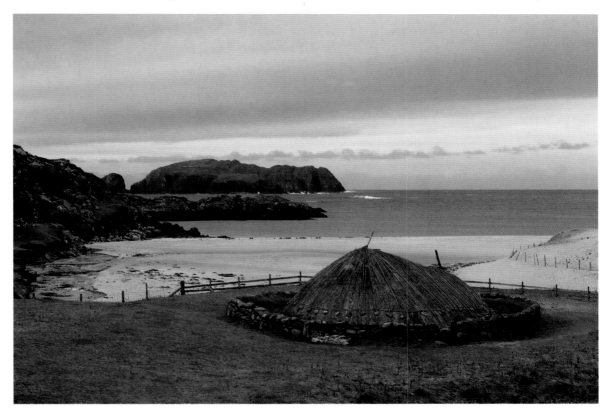

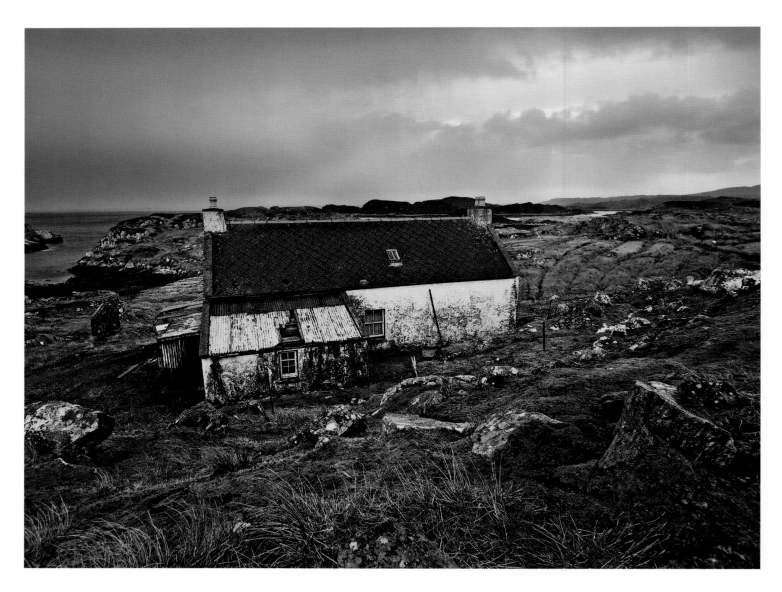

including brochs and stone-built settlements, fortified against attack from fellow islanders. When the Scots arrived from Ireland in the years after Christ, they brought with them the Gaelic language that would shape most of the future Scotland. And from the sixth century, Christianity made major inroads into the islands thanks to the work of the monks of St Columba. But in the ninth century the Vikings arrived, invading and conquering the islands. Two hundred years of occupation was brought to an end in 1263 when King Haakon IV of Norway was defeated by King Alexander III of Scotland, and the Outer Hebrides were returned to Scotland as part of the Treaty of Perth.

The following centuries were marked by in-fighting among the various clans over who ruled

On Golden Road

People forced from their homes on the west side of Harris during the Clearances struggled to get a foothold along the difficult east coast. This derelict house is surrounded by 'lazy beds' – used by crofters to cultivate potatoes.

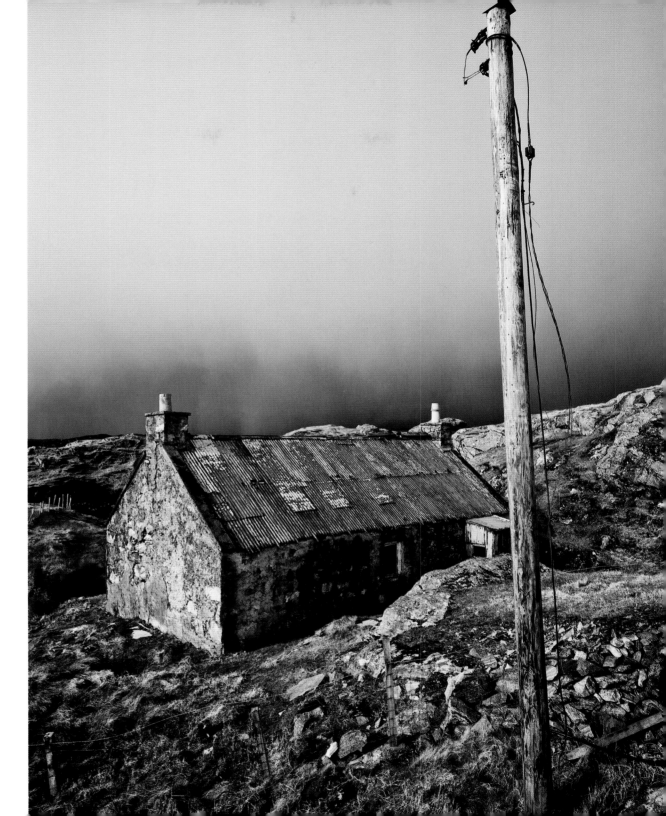

Snow coming

Snow is about to engulf this lonely croft house on Harris's east coast.

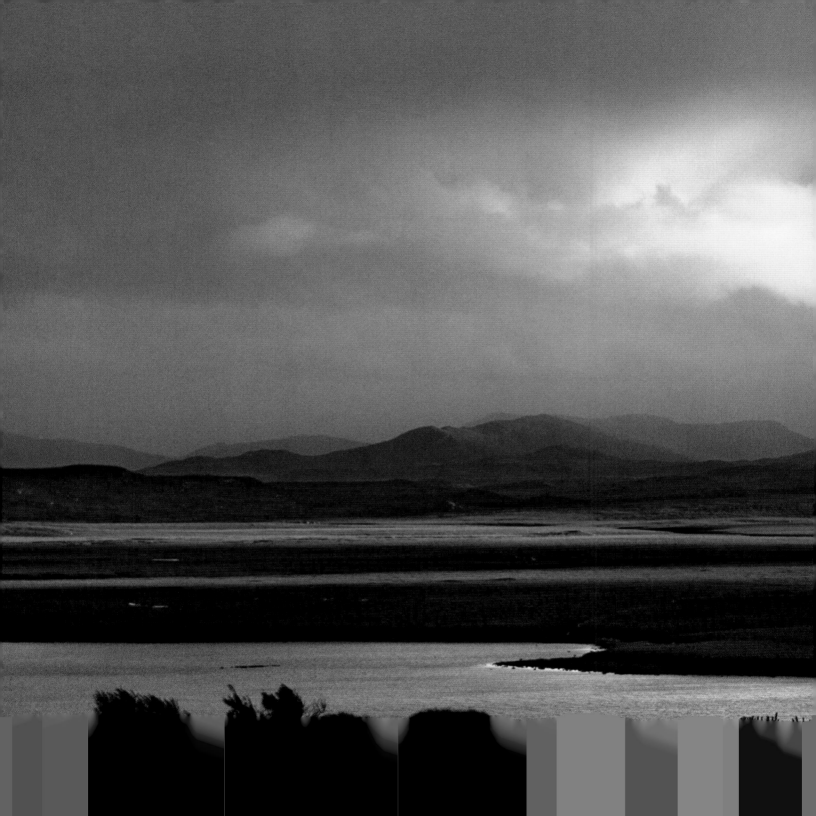

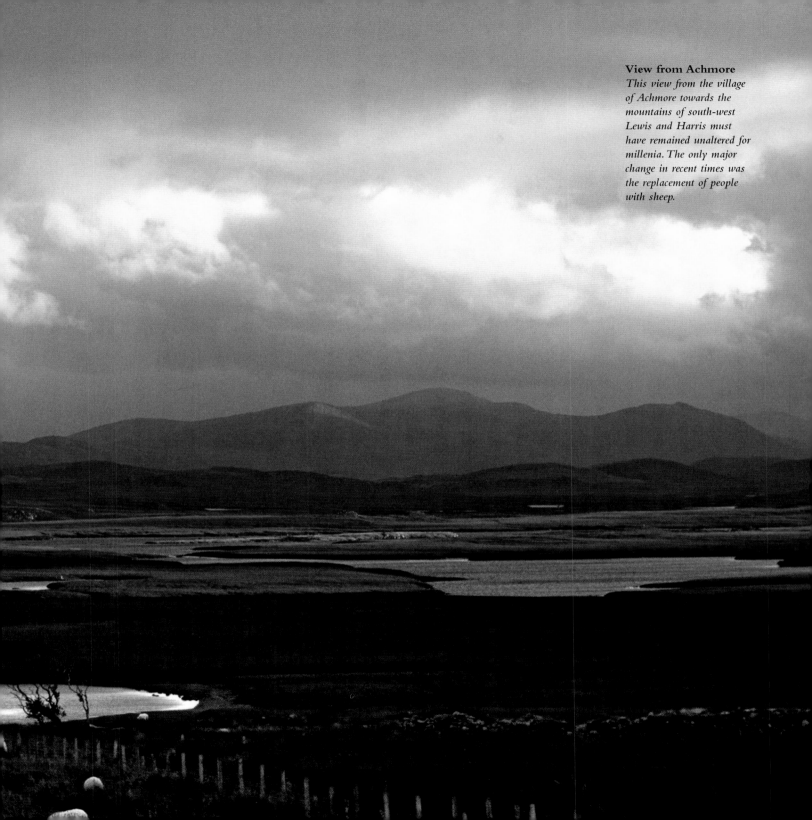

View from Achmore
This view from the village of Achmore towards the mountains of south-west Lewis and Harris must have remained unaltered for millenia. The only major change in recent times was the replacement of people with sheep.

Gershader

The remnants of curtains still hanging in the window of this abandoned shieling at Gershader, near Stornoway, suggest it might last have seen human habitation in the 1950s.

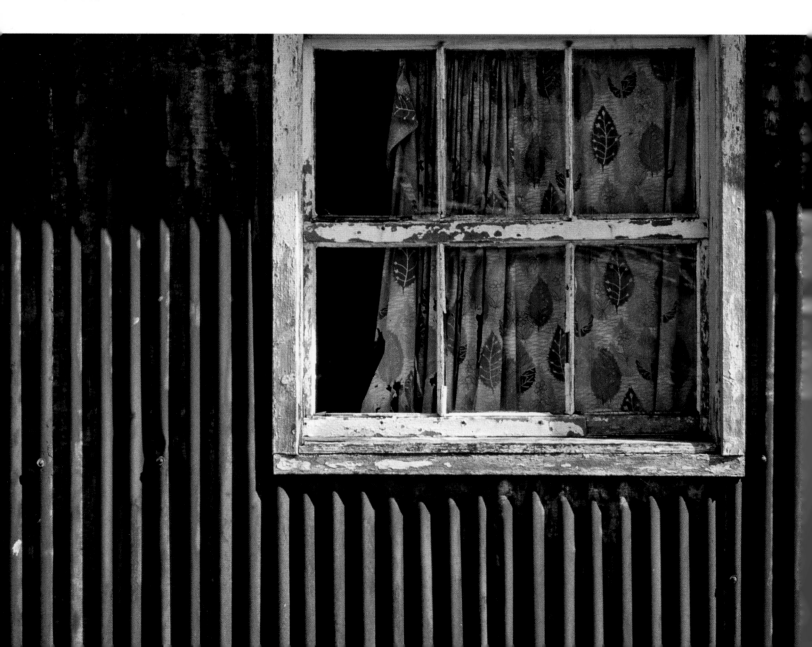

BELOW LEFT Old schoolhouse, Mangersta
Incredibly, this was once the schoolhouse at Mangersta in south-west Lewis.

BELOW RIGHT Loch Erisort at dawn
Dawn brings a frosty start to the day on the east side of Lewis at Loch Erisort.

what. Primary among them were the Macleods, the Macdonalds, the Mackenzies, and the Macaulays. But following the failure of the 1745 Jacobite rebellion and the break-up of the clan system by the British government, much of the settled land of the Outer Hebrides was cleared of its native inhabitants by a new breed of landowner who replaced them with sheep. These clearances led to the growth of the town of Stornoway on the east coast of Lewis, the development of its harbour and the fishing industry, as well as the establishment of regular links with the mainland. A new dawn for the islands.

The Isle of Lewis was bought by Sir James Matheson for £190,000 in 1844. He began building roads and developing industry. His successor Lord Leverhulme continued this work before finding himself confronted with islanders returning from the First World War. The so-called 'land raiders' started settling his land near Stornoway, proclaiming that they had fought for their island in France, and if necessary would fight for it on Lewis. He gave up and offered the land as a gift to the Lewis District Council. Incredibly, they turned it down on the basis that it would cost more than it would bring in. And so it was sold off in parcels that today comprise the various privately owned estates around the island.

Today, about 40 per cent of the population of the islands is employed in the public sector. Few now

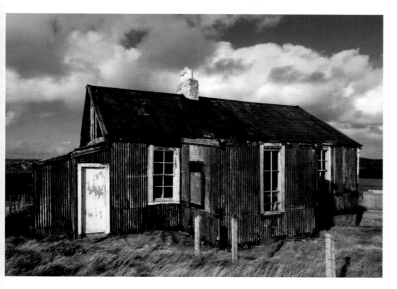

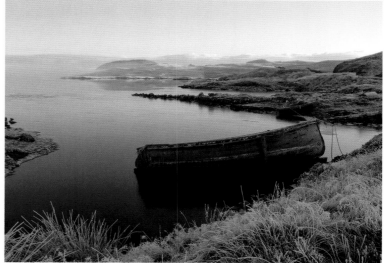

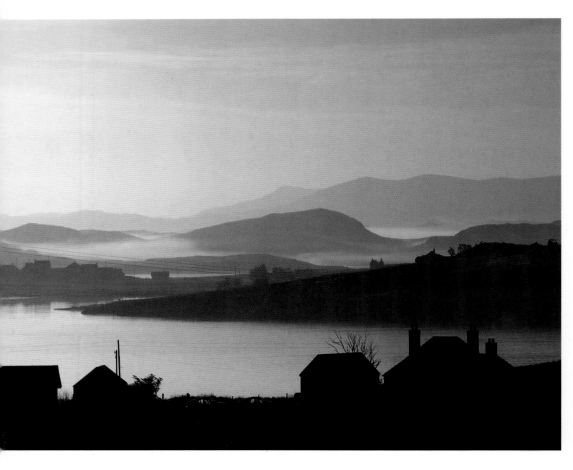

work in the much-diminished Harris tweed industry. But although it has contracted over the years, the fishing industry is still a major employer.

The Outer Hebrides are deeply religious islands, from the Presbyterian north to the Catholic south, and have retained their own distinctive language and culture, quite different from mainland Scotland.

Breasclete dawn
The settllement at Breasclete on the road to Uig in south-west Lewis faces a misty dawn.

Boats at Lemreway
Fishing boats at Lemreway in the Lochs area of Lewis rest in unusually still waters.

Garyvard

A solitary red tin hut is the only sign of human habitation on this freezing dawn at Garyvard on the shores of Loch Erisort on the east coast of Lewis.

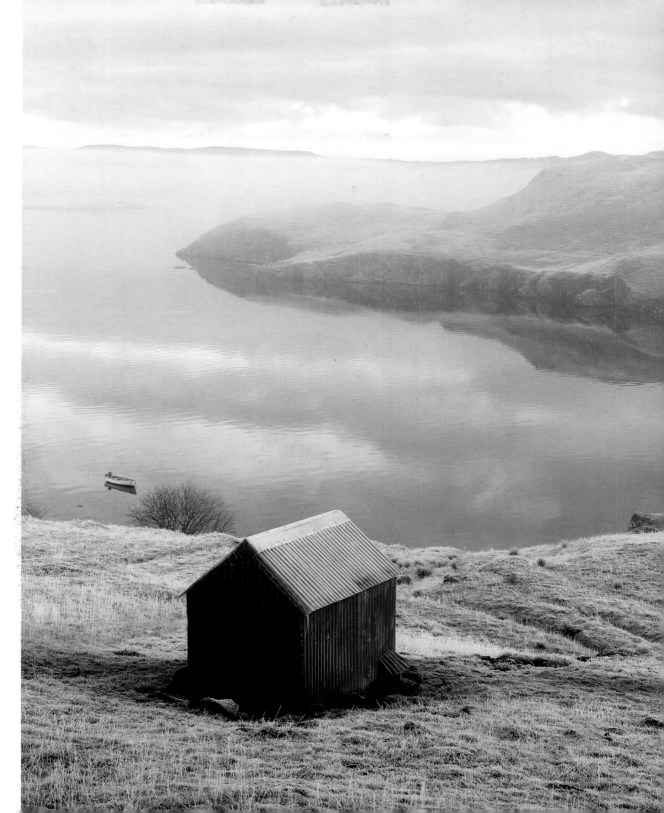

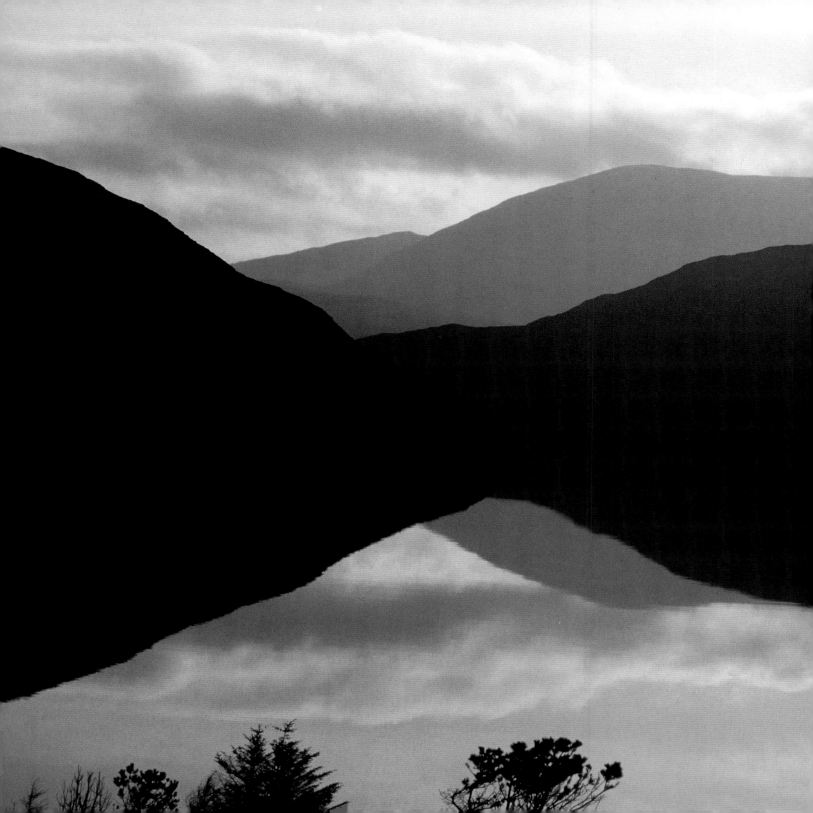

MY HISTORY WITH
THE OUTER HEBRIDES

Loch Seaforth

The character of this loch, at the point where Lewis meets Harris, changes with the light. Here, it appears in black and white, reflecting a sombre mood.

My relationship with the Isle of Lewis, and the islands in general, dates back to the start of the 1990s. During the 1980s I had been variously script writer, story editor and script editor on the top television show in Scotland, the long-running soap opera *Take the High Road*. In 1988 I quit the show, and the very healthy income it was providing, to try to develop new ideas. But the world of freelance writing is not an easy one, and selling an idea to a television company was even harder. Along with my wife, Janice Hally, a writer whom I had met during the *High Road* days, I developed various ideas for TV dramas – all of which were rejected. Our savings were running out and it was getting harder to pay the bills. We slashed our weekly budget to £40, and I found myself walking the length of Byres Road in the West End of Glasgow to buy potatoes at 2p per pound cheaper.

I remember very clearly waking up at 3 a.m. one morning, stressed by our situation and unable to get back to sleep. I wandered through to the living room and sat there in the dark watching the tail lights of the occasional car passing by in the street below. I was searching in my mind for an idea. This time not for a TV series, but for a book. I had recently read the ground-breaking thriller, *Gorky Park*, set in the freezing darkness of a Moscow still in the grip of the Communists. And I suddenly put that together with the interest I had developed for China during a visit

several years earlier. What about a Chinese Gorky Park? I thought. A thriller set in Beijing. No one had done that before. The idea excited me enormously. But there was one problem. I had no money to go to China to research it – and I never write about a place that I haven't been to. So I put the idea to one side and focused once again on developing a drama for television.

That spring, we decided to go and spend several months at our little holiday home in south-west France, which I had bought during more affluent times. We would save on heating in Glasgow, and the cost of living in rural France was considerably cheaper – as was the wine! In those days there were no mobile phones, no internet, and during our three months' absence we were unaware of the frantic attempts of Scottish Television executive Alistair Moffat to try to contact us. Until we returned home and found several messages on our telephone answering machine.

The government, it seemed, had decided to put up an annual sum of money for the production of television programmes in the Gaelic language – the ancient language of Scotland once spoken by more than half the population. By now the number of Gaelic speakers had dwindled to only two per cent, a mere 60,000 people, and it was felt that without a major presence on mainstream television it would be in danger of dying out altogether. Scottish Television

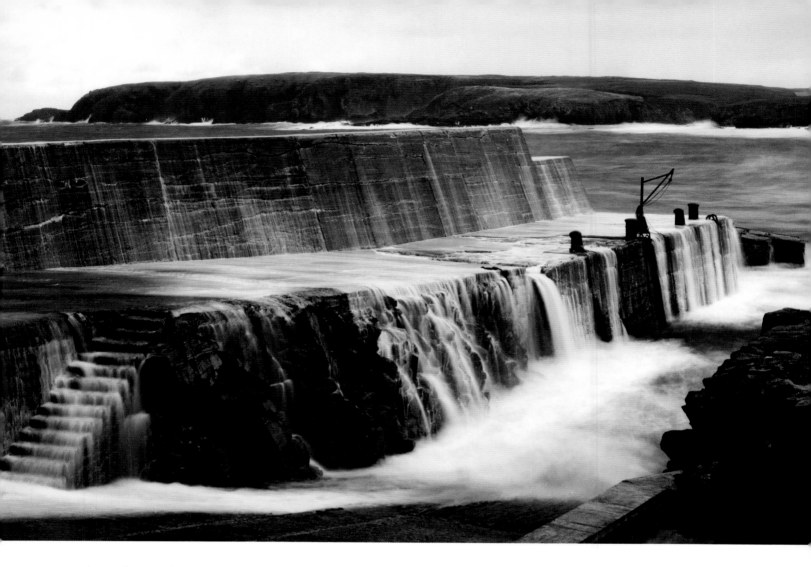

wanted to make a Gaelic soap opera, and given our experience with *Take the High Road*, believed that Janice Hally and myself were the people to create it.

The only problem was that neither of us spoke Gaelic. That didn't matter, we were told by STV. At this stage it was our expertise in long-running television drama that was important. There then followed a series of meetings to discuss the setting for this new Gaelic soap, and in the end it was decided that the Isle of Lewis was the obvious choice. It probably had the highest concentration of Gaelic

speakers and was in many ways the focal point of Gaelic-speaking Scotland. But it also had the added advantage of an infrastructure that would support the needs of television production – plenty of accommodation in Stornoway for cast and crew, a recently upgraded road network, regular ferry services and daily flights to and from Glasgow.

I had never been to the Outer Hebrides before, and it was agreed that we would need to make a research trip to the islands. It would be costly, of course. Transport, hotels, meals . . . Scottish Television

Harbour at Port of Ness
This harbour wall at Port of Ness has gradually succumbed to the onslaught of mountainous seas over many years. A slow-motion shot of a wave breaking 50 feet over the wall was used as a title shot for the Gaelic-language television drama, Machair. *This photograph was taken using a long exposure just after such a wave had broken over it.*

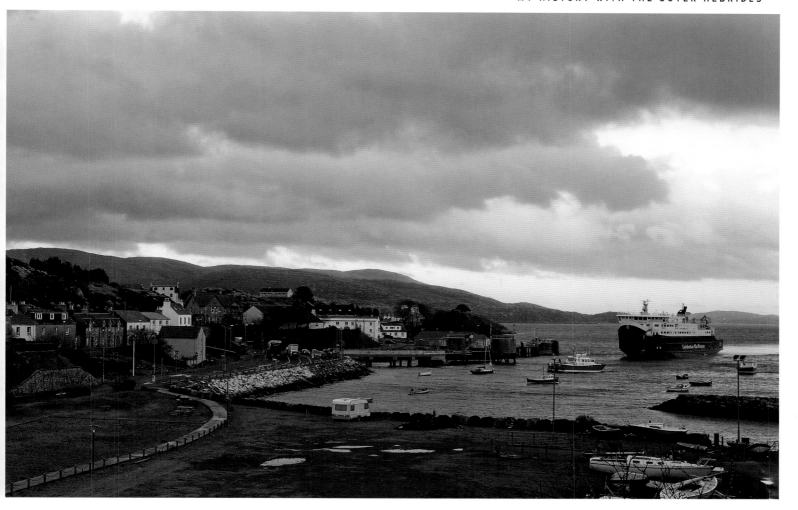

Ferry arriving at Tarbert
This Caledonian MacBrayne ferry arrives at Tarbert on Harris, from Uig on the Isle of Skye, which is in the Inner Hebrides. The crossing time is 1 hour 45 minutes, and is part of a triangular route that also takes in Lochmaddy in North Uist.

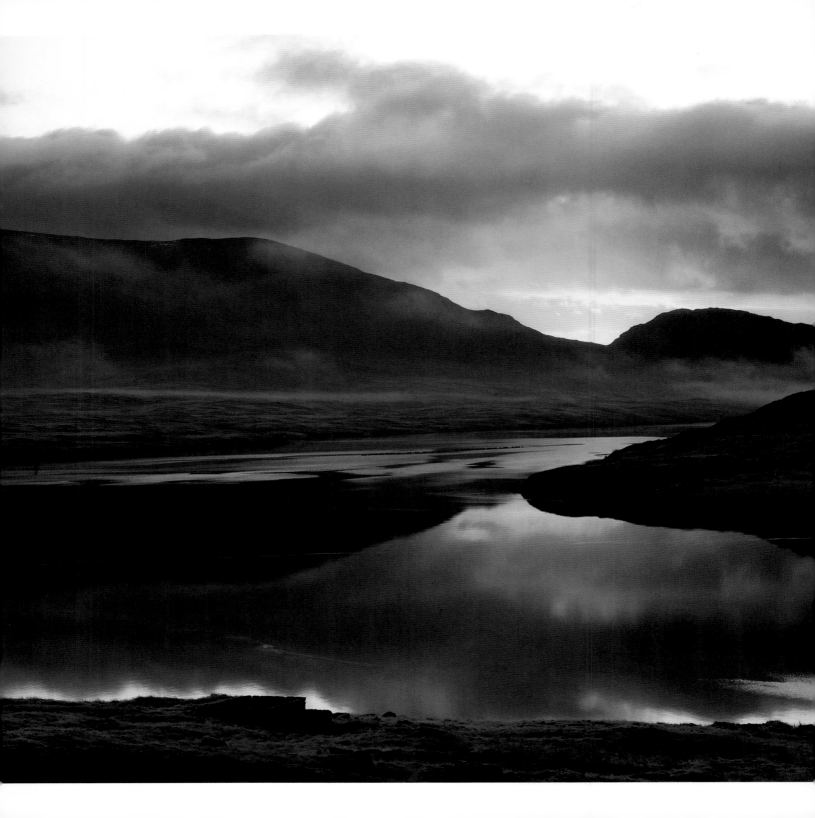

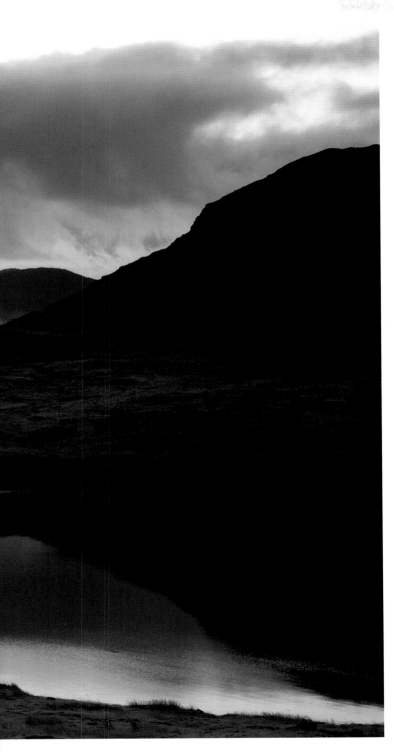

Dawn at Loch Seaforth

Loch Seaforth is one of the most important sea lochs on the east coast, and forms the boundary between Lewis and Harris, which are both part of the same island. This shot was taken looking east as the sun rises.

agreed to meet the expenses and asked us for an estimate. We produced a detailed costing for a sum in the order of £2,500. The company agreed and wrote us a cheque – and we immediately went to China!

Well, how else was I going to afford it?

This was not long after the events in Tiananmen Square, and I thought it might provide the background for the Chinese *Gorky Park* that I wanted to write. However, while we met many interesting people, and began to develop an understanding of the way China worked, I returned empty-handed. I had not found the story I was seeking. And we were left with the problem of how to finance our research trip to the islands.

We did it by taking our own car, financing the ferry crossing out of our savings, and staying in the cheapest holiday rental we could find. This turned out to be a cottage in Port of Ness, called 'Ocean Villa'. It was January 1991, and the cottage had lain empty for months. The mattress on the bed was so damp we had to drag it through to the living room and dry it in front of the electric fire. We then slept on it on the floor, with the fire burning all night. We couldn't afford to eat out, and so cooked on the peat-burning stove in the kitchen. It was a salutary introduction to life during a brutal Hebridean winter.

But what had struck us most on our arrival on that bleak January day, was the landscape. We had crossed to Tarbert on Harris from the Isle of Skye, and driven

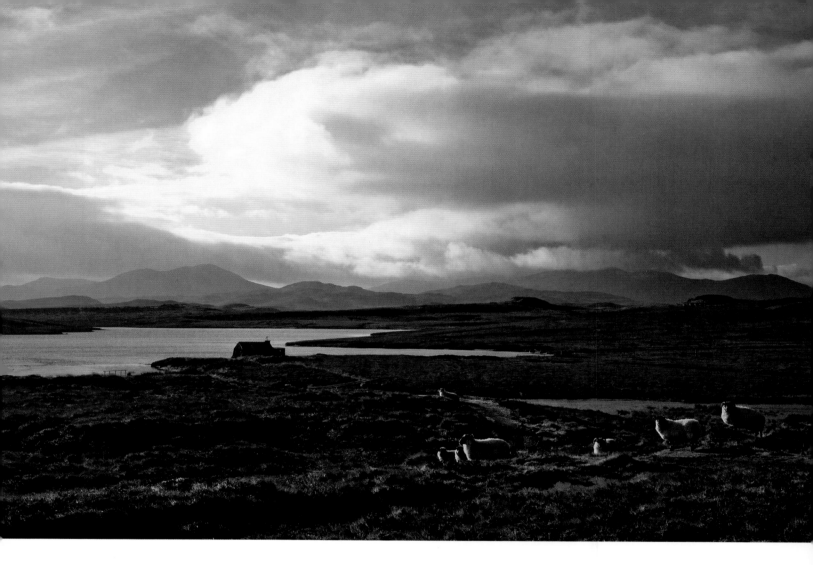

up through the mountains on a single-track road. There was snow on the Clisham, the highest peak on the islands, which cast its shadow over the mountain passes that led us down into the dark and brooding valley at the head of Loch Seaforth. There, on the shores of the loch, stood Ardvourlie Castle, a hunting lodge built in the nineteenth century by the then owner of Amhuinnsuidhe Castle and the pearl in the crown of the North Harris estate. Ardvourlie was now a hotel, and although we didn't know it then, it was to become a major location for our future soap,

housing the Gaelic-medium college, which would be the focal point of the drama.

As we drove north then onto the Isle of Lewis, the land began to level out. There were two features that struck us very forcibly: the large number of lochs, big and small, that broke up the landscape and reflected light even on the darkest day; and the complete absence of trees. We skirted Stornoway and headed out across the Barvas moor towards the west coast, a bleak wilderness of endless peat bog that seemed desolate and formidable on that first crossing. It was

Laxay
A view of the hills of Park taken from the village of Laxay on the route north. The River Laxay, on the right, runs into the loch here, and silhouetted against the water is a fisherman's bothy, or shelter.

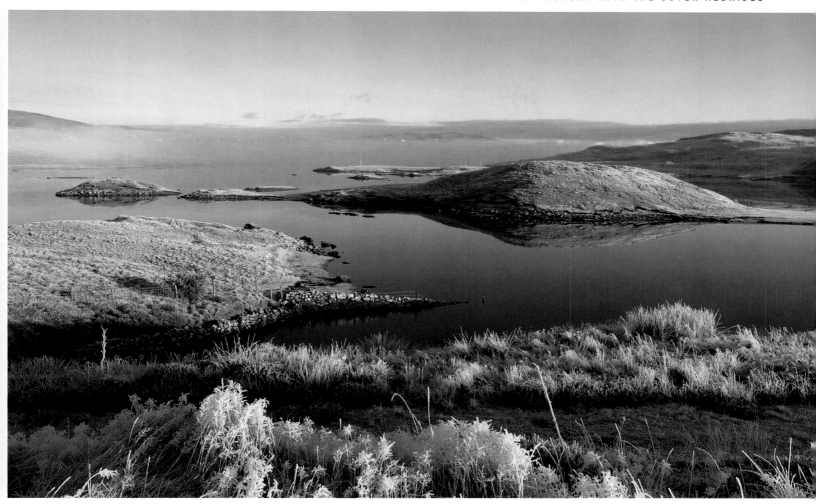

Morning near Balallan

Balallan is one of the Lewis townships that you will pass through on the road north from Harris. This photograph was taken on a clear, frosty winter's morning, looking out over Loch Erisort. The houses of the village can just be seen on the distant horizon.

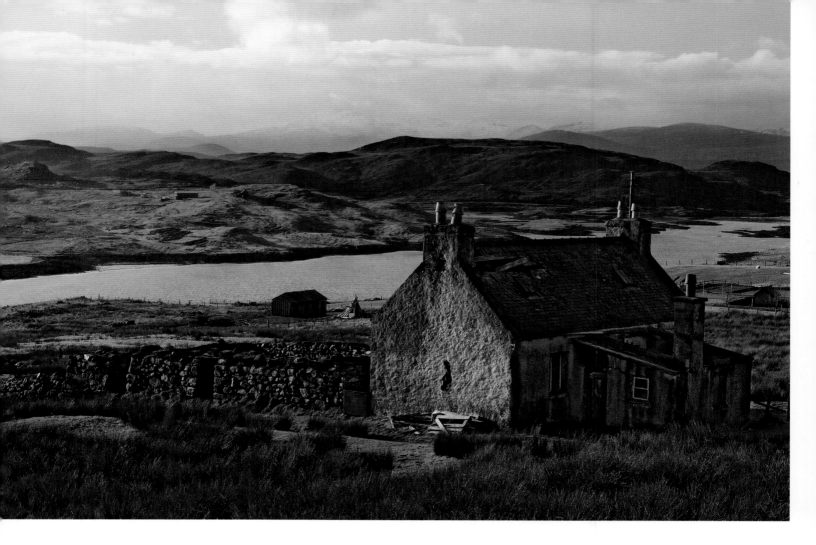

only during subsequent years when I drove that road many hundreds of times, that I saw it in all seasons, in all weathers, and in all lights, and grew to appreciate its stark and ever-changing beauty.

Even on that first trip, it was apparent that the west coast presented a savage beauty, a temperamental sea smashing into its rising cliffs of stubborn gneiss, unbroken by 3,000 miles of Atlantic Ocean. Hidden bays and sandy coves were not immediately visible, but would be discovered in years to come. First impressions, however, were alien to anything either of us had ever seen before. A seemingly endless

ribbon of tarmac followed the contours of the west coast, broken from time to time by settlements huddled along the roadside. Pink and white harled houses exposed to the full fury of the weather by the complete absence of trees. The wind was simply too powerful and too constant to allow anything to grow more than a couple of feet. As a result, these houses appeared stark and naked, like blocks of Lego strung along the horizon. The only thing that seemed to grow in abundance were churches – representing all the Presbyterian denominations. Every village had one or more.

From Balallan

This was taken from the township itself, looking across Loch Erisort to the hills of Park. A clear demonstration of the way the light and the weather change the landscape.

Bragar sunset

This was taken near the west coast village of Bragar at sunset, on the road north to Ness. The silhouette of a dun, a small fortified dwelling, can be seen on a tiny artificial island in the loch reached by a primitive causeway. There are perhaps a dozen of these buildings on tiny lochs up and down the west coast of the island.

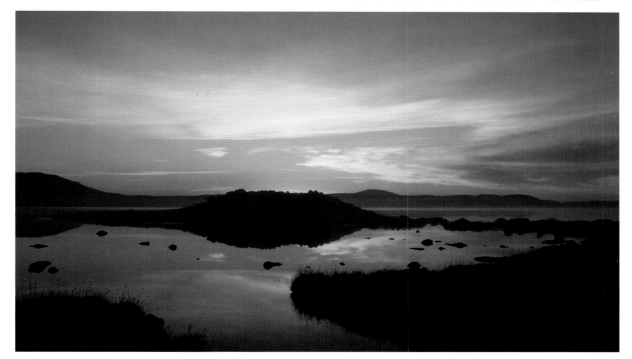

Bragar again

This is the same dun, viewed from almost the same spot at a different time of day. Another demonstration of how radically different the islands can look in the changing light.

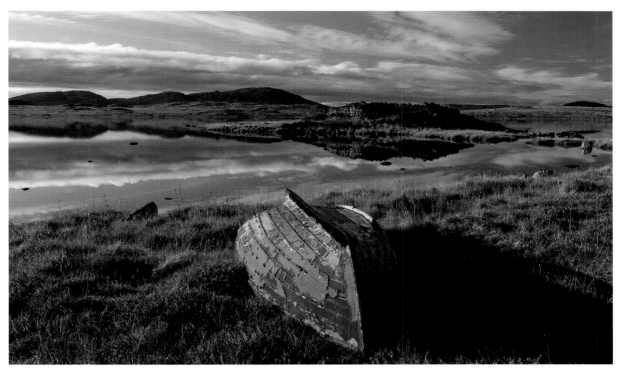

Still waters at Stornoway

The view we missed because we bypassed Stornoway on that first day. This was taken on one of those most rare of Hebridean phenomena — a windless day. The town is reflected perfectly in the still waters of the inner harbour.

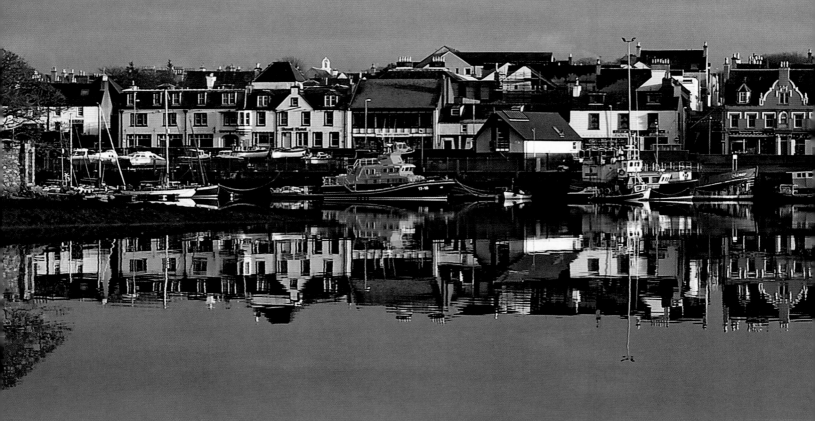

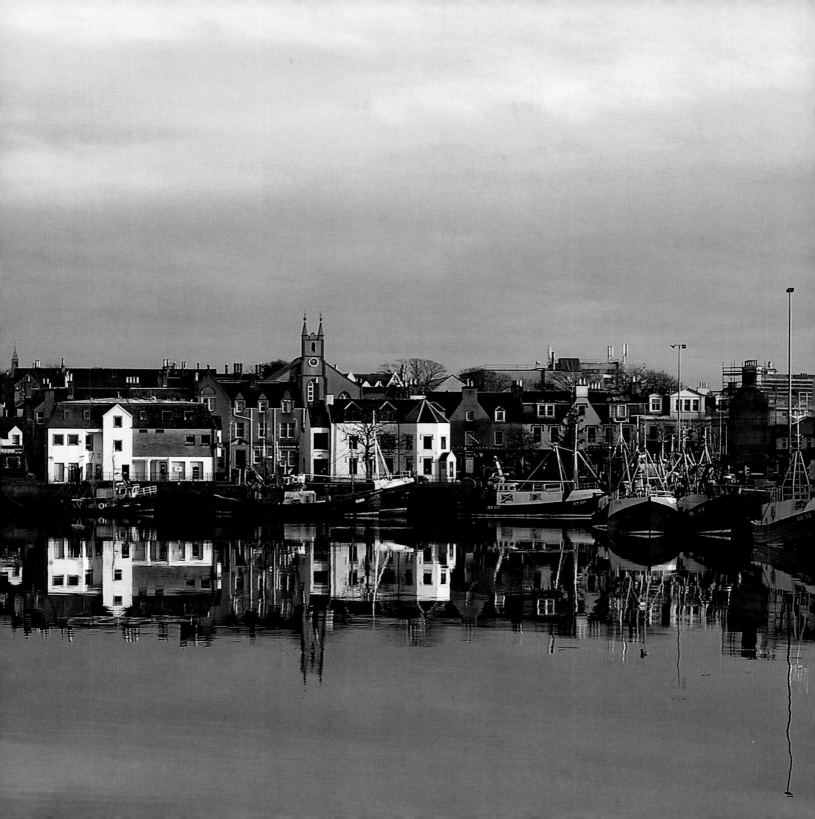

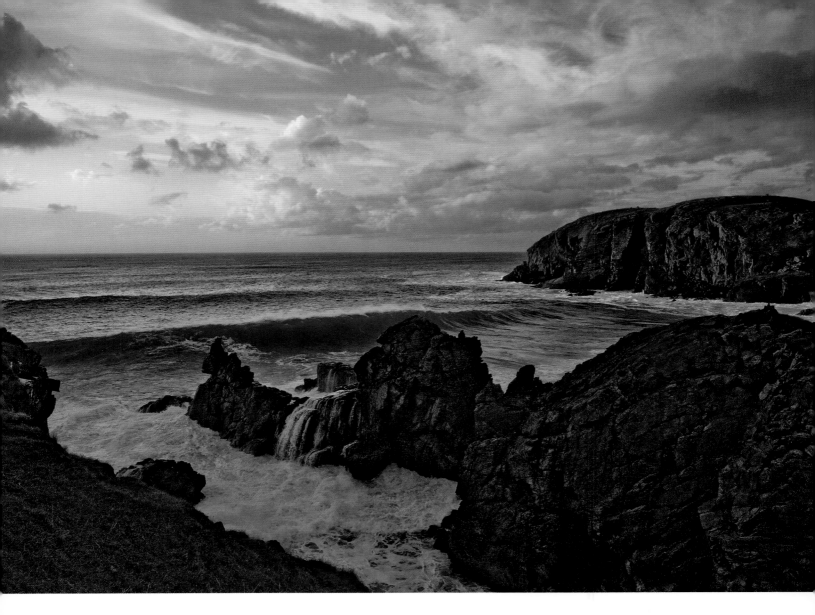

Incoming tide, Dalbeg

Dalbeg is one of those hidden west coast coves reached only by a narrow single-track road that winds down through the machair. Here we see its rocks, comprised of ancient gneiss, being washed by the incoming tide on a late evening.

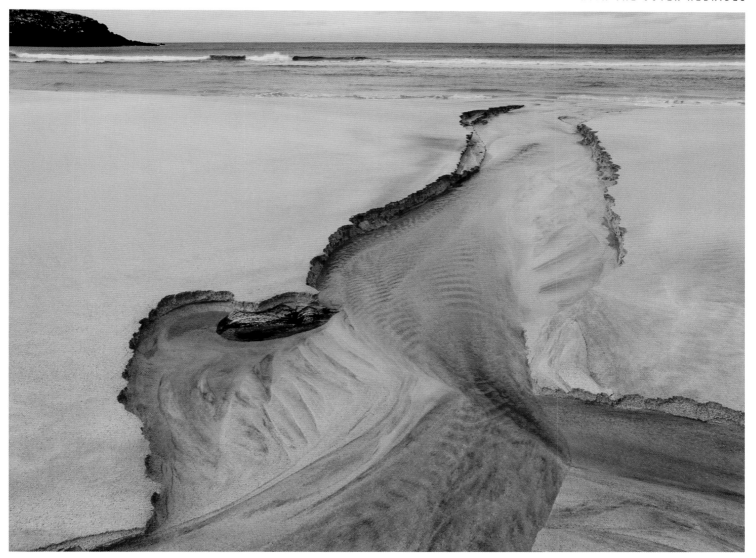

Dalbeg beach
Another face of Dalbeg. Soft golden sand has been cut through by a small peaty stream running off the machair.

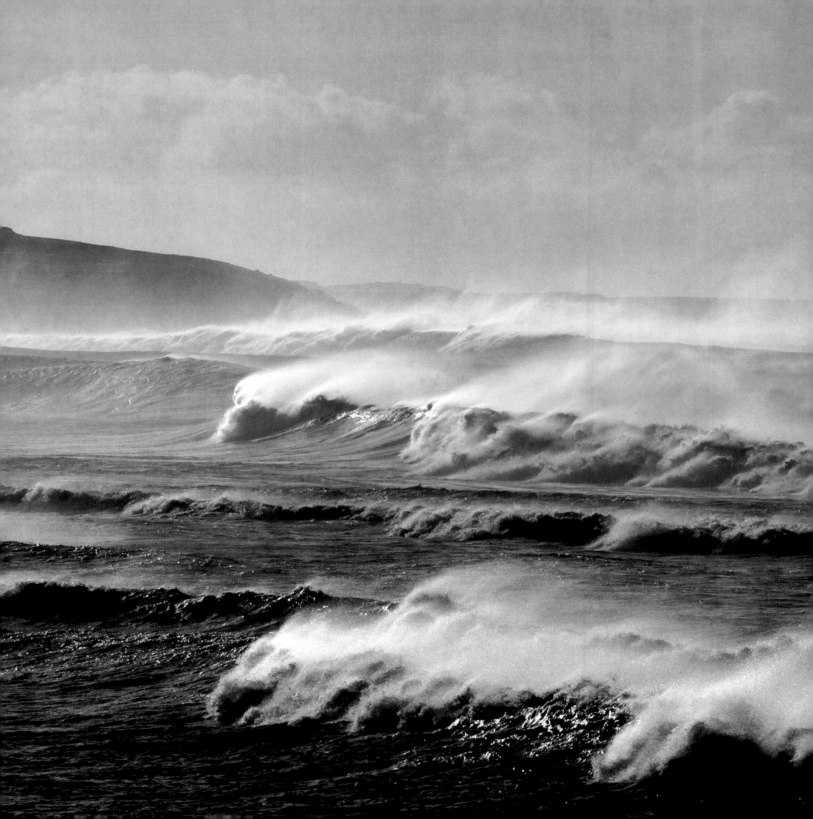

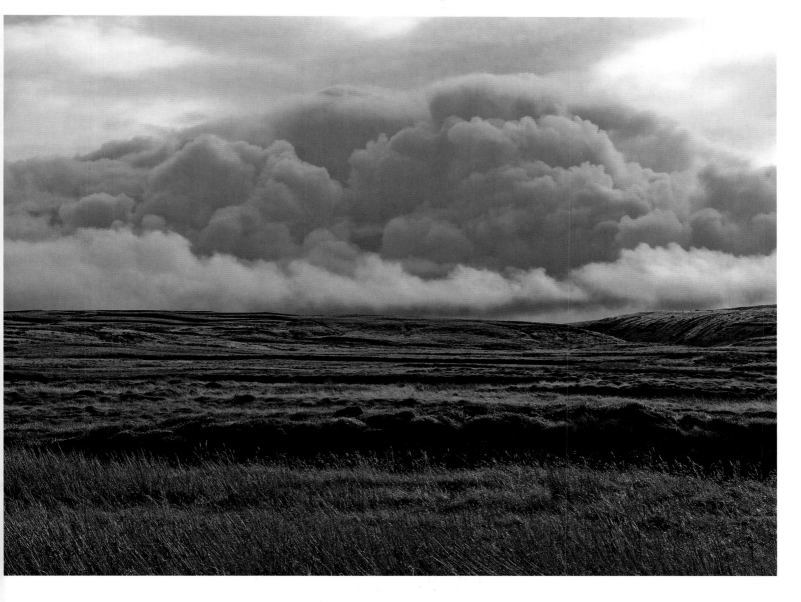

FACING PAGE **Bru shoreline**
*Weather dominates life on
the islands. Here, off the tiny
west coast settlement of Bru,
gale-force winds bring the
Atlantic Ocean crashing in all
along the shoreline. Mainlanders
rarely experience the ferocity of
weather that is commonplace
throughout the Hebrides.*

ABOVE **Gathering storm,
Galson**
*At yet another west coast
village, Galson, storm clouds
gather. Such is the openness of
the landscape and the vastness
of the sky all up the west coast,
that storms can be seen coming
from a long way off.*

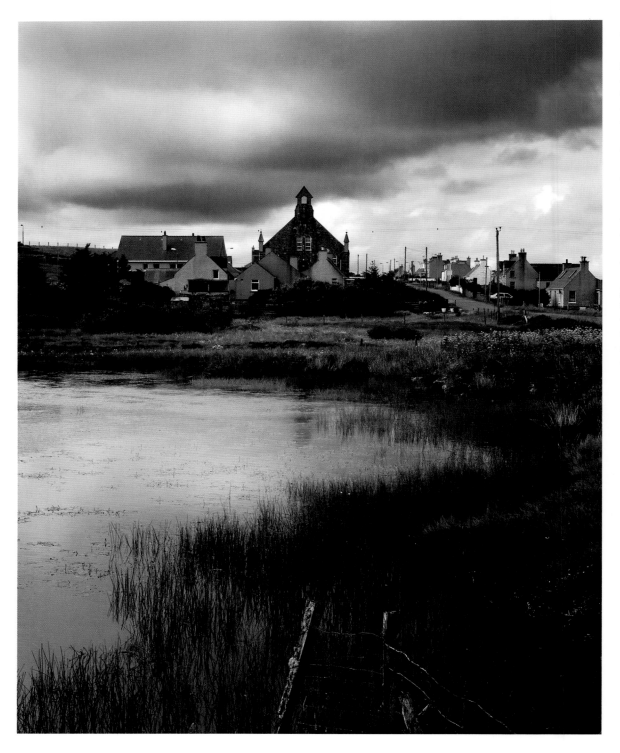

Cross Church

The church at Cross in Ness presents a distinctive skyline. Religious observance dominates cultural life on the Isle of Lewis, here reflected in the church's domination of the horizon. The denomination of this particular church is the Free Presbyterian Church of Scotland, also known as the Wee Frees. It is a plain, unadorned religion that rejects religious symbols, stained glass windows and music. Even bells are frowned upon, as witnessed by the empty bell tower. Psalms are sung unaccompanied, in Gaelic, with the singing led by precentors. It resembles a kind of tribal chanting, and is extraordinarily affecting – reflecting in many ways the landscape itself, and the lives of the worshippers who inhabit it.

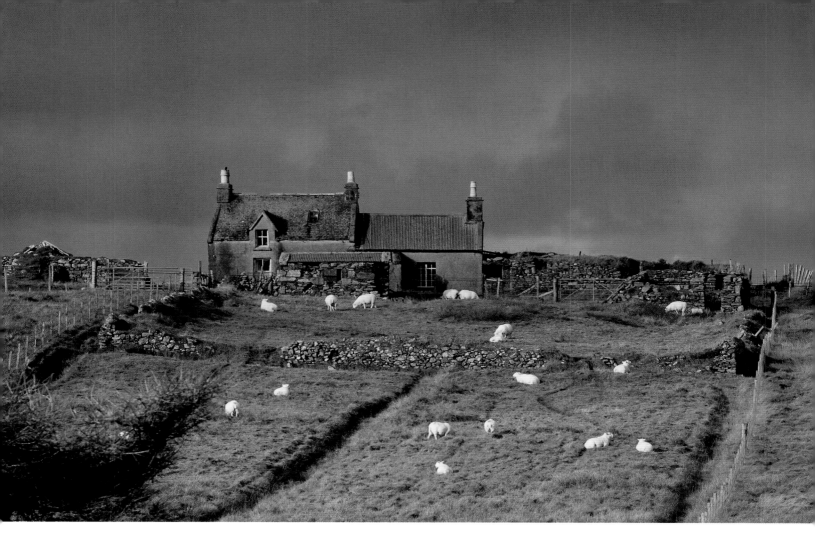

Dell croft

An abandoned whitehouse and derelict blackhouse at the head of a strip of croft land at Dell on the road to Ness. The texture of the stone, the white sheep dotted around the long grass, the geometric division of the land, along with foreground sunlight and black sky behind, make this a typical Isle of Lewis scene.

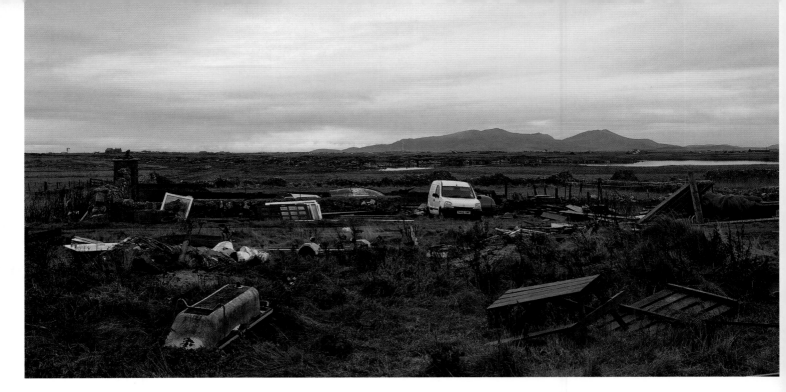

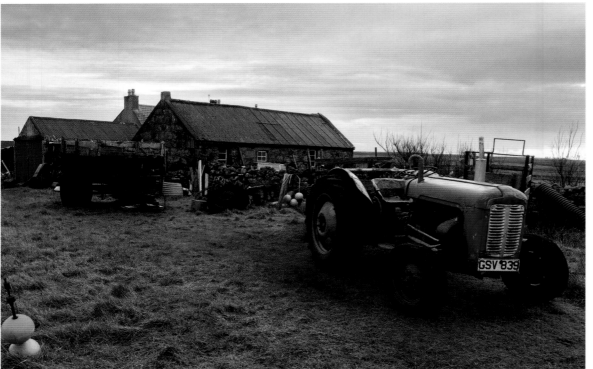

ABOVE **Deserted farmstead, Benbecula**
Scenes of desuetude can be witnessed throughout the islands. This one was shot at Nunton on the Isle of Benbecula, 120 miles south of the abandoned tractor at Borve, also pictured on this page. In the background are the hills of North Uist.

LEFT **Abandoned tractor, Borve**
At this typical croft near Borve on the west coast of Lewis, disused equipment is dropped, almost where it was last used, and left to rot. The number plate on this old tractor, now almost sixty years old, could fetch up to £10,000 in the crazy world of cherished number plates on the mainland.

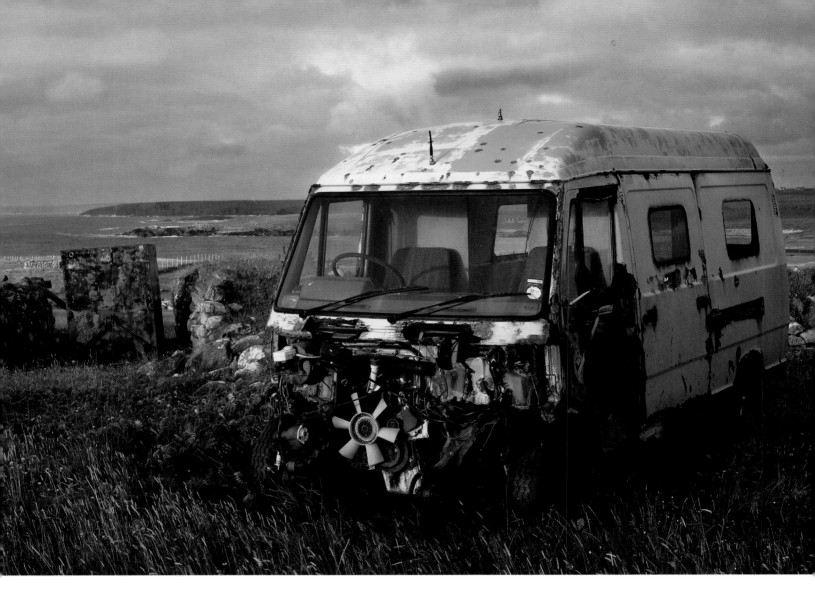

At Bragar

This old van at Bragar on Lewis might only have had one careful owner, but he clearly abandoned it a long time ago.

The detritus of past lives lay discarded in gardens and crofts – old tractors, tyres, rusting cars and lorries, like the carcasses of long-dead animals. I suppose that the practice of leaving the past to rot all around is not uncommon in many rural areas. But here, the absence of trees and foliage made it all particularly visible, and a distinctive feature of the Lewis landscape.

Another feature that we noticed on that first journey were the number of abandoned and decaying cottages, and the broken-down stone walls that almost always accompanied them. It was only later that we would discover that these abandoned houses were the so-called 'whitehouses' which had displaced the traditional stone dwelling that had sheltered the people of Lewis for centuries – the blackhouse. Blackhouses provided accommodation for both man and beast. Peat fires burned all day every day throughout the year, with smoke left to escape

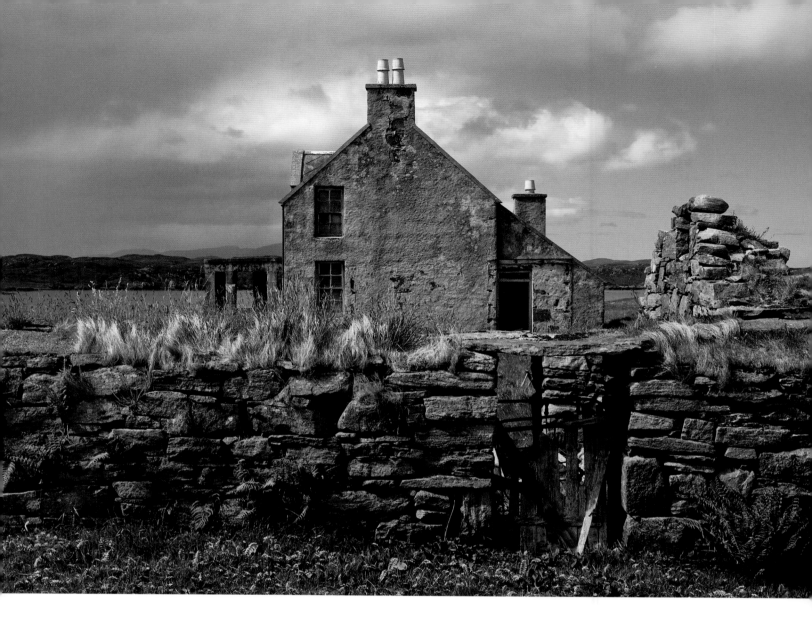

through thatched roofs that were replaced annually. When the whitehouses were introduced, they were built next to the old blackhouses which were simply abandoned and cannibalized for their rafters and stone. With the introduction of more modern houses, many whitehouses were also abandoned, hence that characteristic landscape of decaying whitehouses next to the remains of their blackhouse predecessors.

When we arrived at Port of Ness, we discovered a charming village built around a harbour that had once provided a safe haven for the fishing fleet from Ness. There were only a few boats anchored there, a decaying old boatshed, and a harbour wall that had finally succumbed to the ceaseless assaults of the sea. It was broken down, and barely serviceable. I later filmed the opening shots of our Gaelic drama *Machair* there.

Blackhouse, Tolsta Chaolais

This photograph taken a few miles down the road from Ness in the isolated village of Tolsta Chaolais, captures the architectural history of the island very neatly. Ruined blackhouse in the foreground, abandoned whitehouse beyond it.

Phonebox, Ness *The old phonebox in this picture looks to have been abandoned as long ago as the house itself. Both are to be found on the Cross–Skigersta road in Ness.*

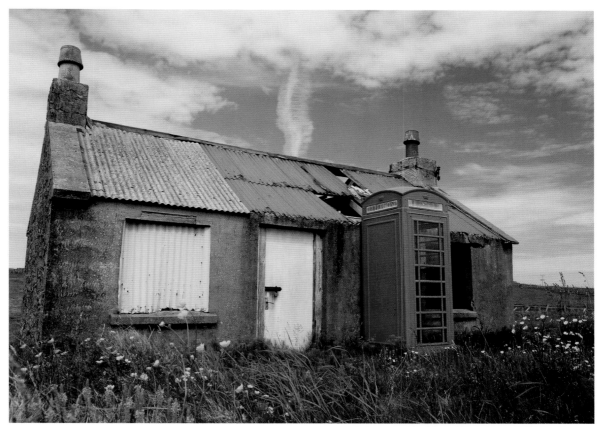

Whitehouse and blackhouse, Garenin *At Garenin, on the west coast of Lewis, this is a typical example of an abandoned whitehouse next to the ruined blackhouse once lived in by generations of the owner's ancestors.*

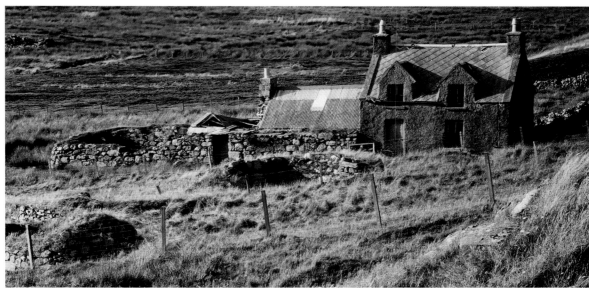

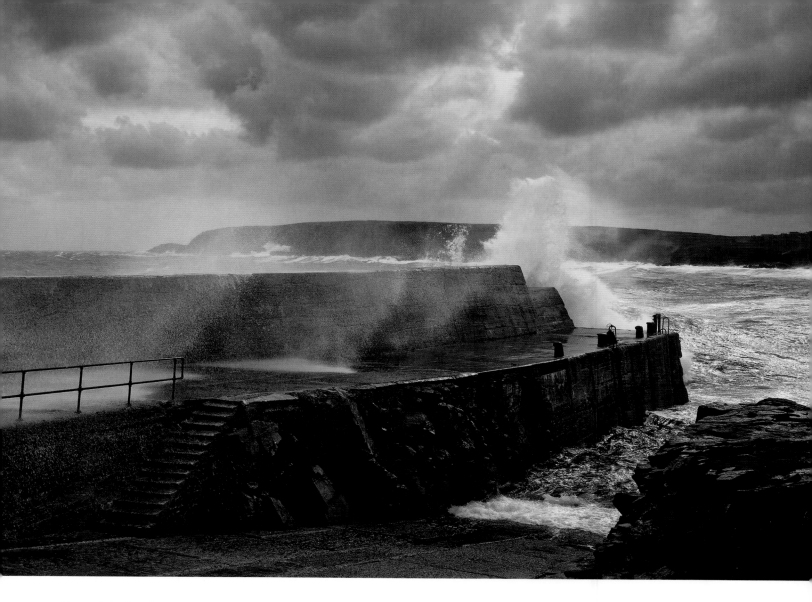

Beyond the boathouse, a beautiful beach of golden sand curved away towards distant rock-stacks, and low cliffs crumbled beneath the machair land that sloped up towards the village of Adabroc. I would later use Adabroc as a model for the fictitious village of Crobost, where Fin Macleod, the central character of the Lewis trilogy, was born and raised.

They were great days spent in Ocean Villa on that first trip to Lewis. A real taste of island life. And when our 'sherpa' for the trip, Gaelic writer Donald Ruadh, finally showed up three days late, we also got a taste for the different pace of life in the Hebrides.

Donald took us all over the island, introducing us to some wonderful characters, and gradually the idea for our Gaelic soap began to take shape. We made many return trips, seeking out writing and acting talent on the islands, as well as locations for shooting the drama. And so *Machair* was born. Although

Port of Ness, harbour wall
Here, the ferocity of the seas that inflicted their damage on the harbour wall at Port of Ness is only too visible.

56

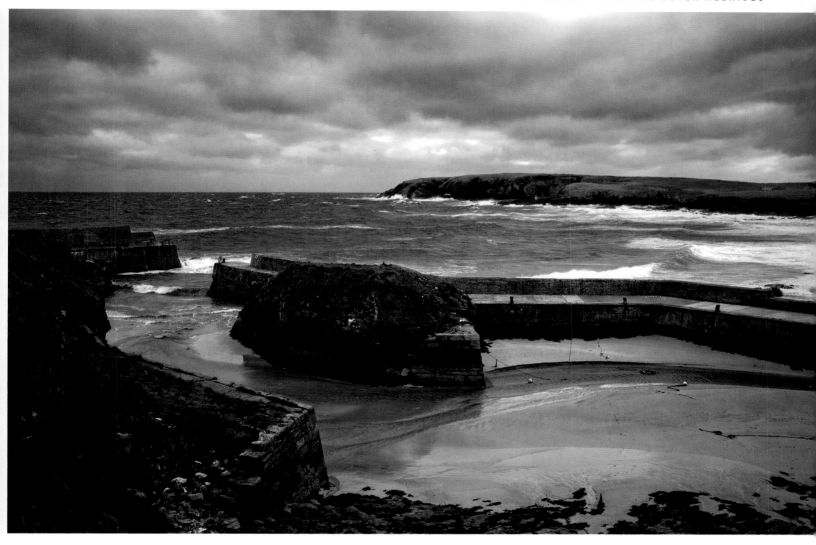

Port of Ness
This shot nicely encompasses the harbour at Port of Ness, once home to the fishing fleet that plied its trade in and out of Ness. Host now to only a few crabbers and pleasure boats, it is little used following the storm damage to its main wall on the left.

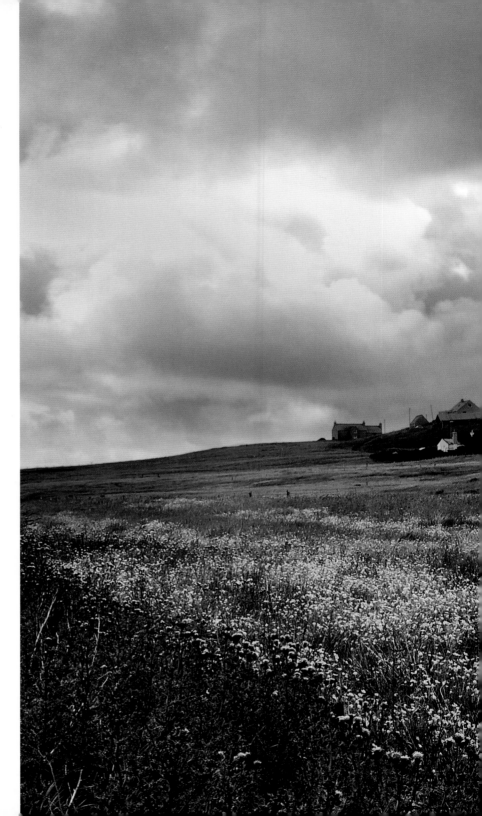

Adabroc
The houses of the settlement of Adabroc are strung along the hill above the cliffs at Port of Ness.

machair is a Gaelic word describing the low-lying fertile land around the coastal fringes of the islands, it had also passed into the English language in the context of 'machair erosion' – the problem of this fertile land gradually being eaten away by the encroaching sea, something which had become the focus for frequent conferences. We saw it as a perfect metaphor for the Gaelic language and culture (the machair) gradually being swamped by the larger, more powerful, English language culture (the ocean).

The machair land is a wonderful feature of the islands. Not only is it fertile and fruitful ground for growing crops, it provides perfect grazing for the spring lambs whose meat, as a result, comes ready-salted, and is sweet and delicious. It also gives access to some of the most wonderful beaches in the world, and in springtime is covered with beautifully coloured wild flowers. We discovered very quickly that the machair additionally provides perfect burial grounds for those peoples who have long settled along the coastal fringes. Soft, sandy soil, dry and easy to dig. And so most of the island cemeteries provide spectacular sea views that the dead take with them for eternity. In recent years, however, the problem of machair erosion has disturbed that eternal sleep, the sea devouring land and exposing old bones. Sturdy shoring-up of cemeteries in several places has been required to keep the resting places of the dead intact.

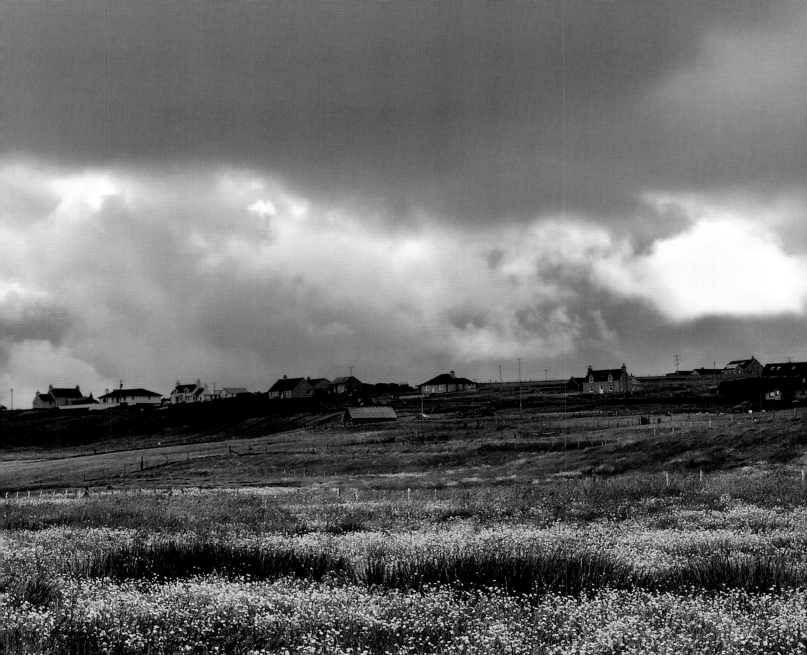

The major culture shock to hit us when we first arrived on the Isle of Lewis was the island sabbath. It was inviolate! Oddly, the Outer Hebrides divide almost precisely halfway down their length – Protestant in the north and Catholic in the south. And Sundays were very different on either side of that dividing line.

Coming as I did from the city of Glasgow, where on Sundays shops, cafés and restaurants were all open, I took badly at first to the Lewis Sunday. Nothing was open. No pubs or restaurants, no shops or filling stations. If you forgot to fill your tank on the Saturday, you would be stuck on the Sunday. There were no Sunday sailings or flights. If you didn't manage to get off the island on the last boat on Saturday night, you were stranded there until the Monday, when Sunday newspapers would arrive on the first flight. Children's swings were chained up, public toilets locked. It was even frowned upon to hang out your washing on a Sunday, and almost nobody did.

My first Sunday in Stornoway was spent walking the streets in a fruitless search for lunch. We went hungry that day. Although, to our frustration, we would hear voices and laughter coming from behind the locked doors of several of the public houses in town. It was only later we learned that the faithful would emerge from their church services at midday to slip straight into the pubs via the back door. You live and learn!

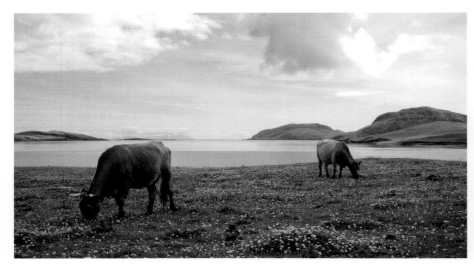

Salt–marsh lamb
Here we see sheep grazing on salt marshes along the coastal fringes at Northton on South Harris. Lambs that have fed on this salty grass are much sought after.

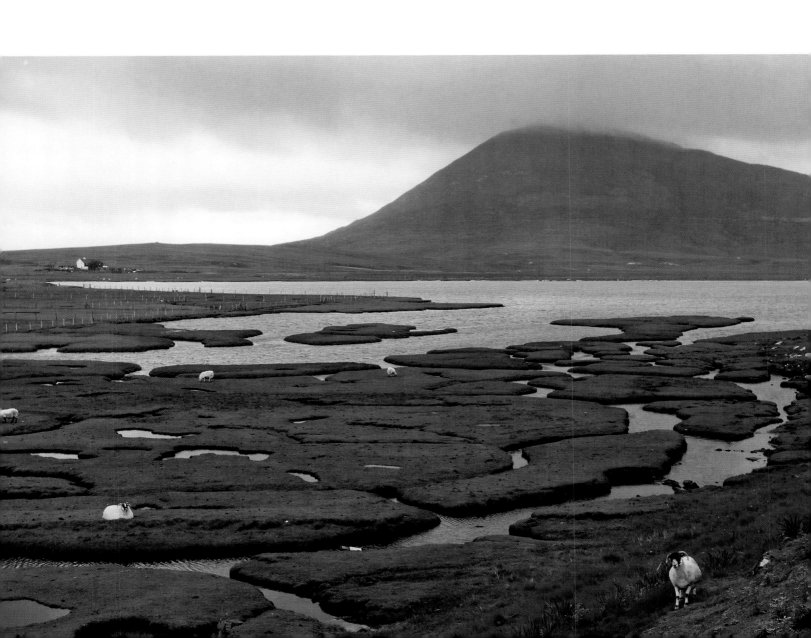

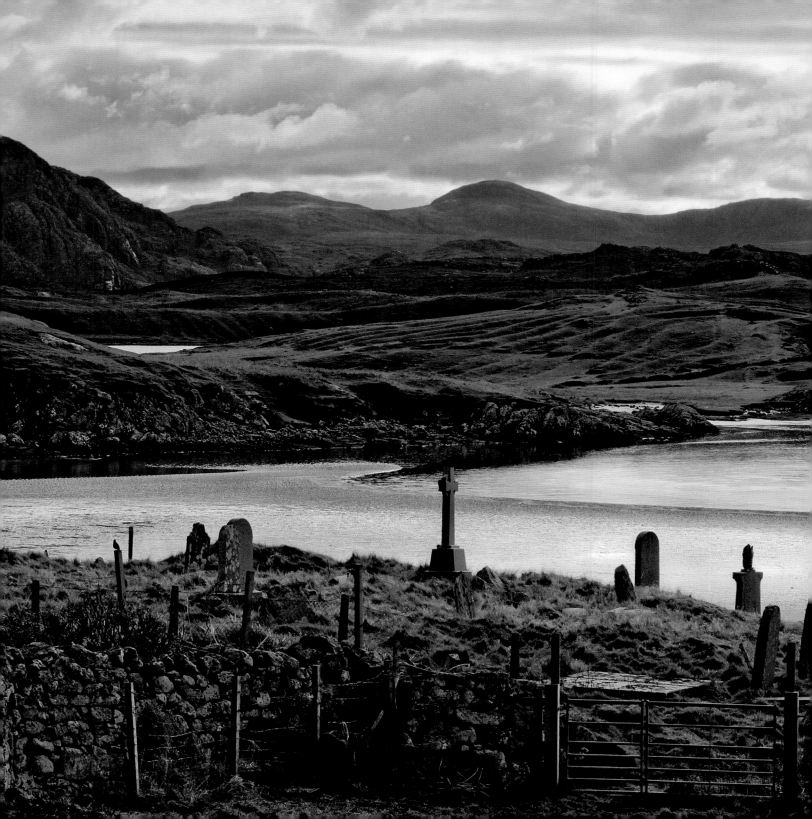

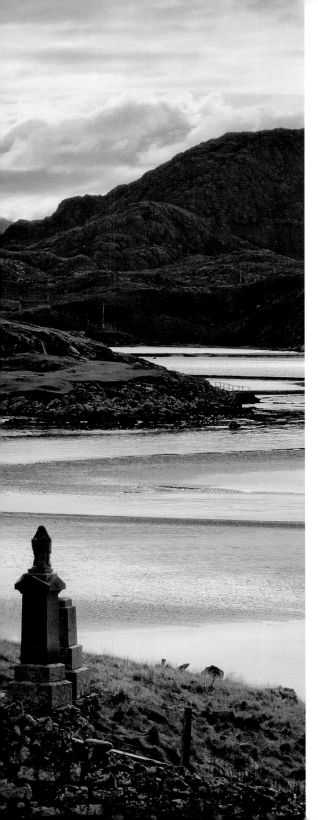

Cemetery, Baile na Cille
Perhaps the most spectacular view of all is afforded those buried here at Baile na Cille at Uig in south-west Lewis. The cemetery looks out over the vast expanse of Uig beach. The water is only about a foot deep when the tide comes in, and is pure turquoise.

Ludag cemetery, South Uist
The residents of this sombre graveyard at Ludag on South Uist face the incoming weather with the fatalism of the dead.

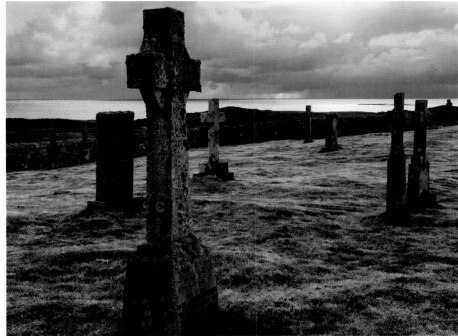

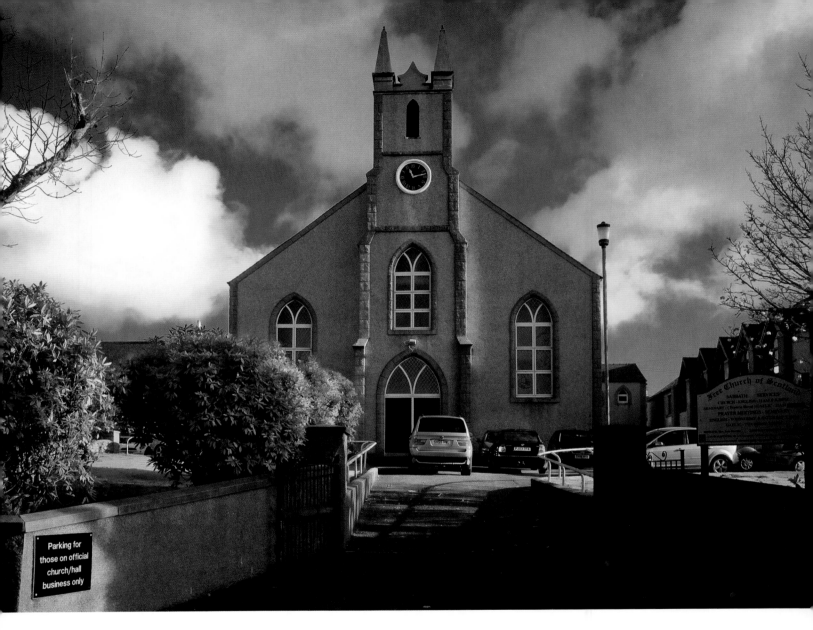

Parking for those on official church/hall business only

I spent five months a year for the next five years producing *Machair*, which was shot entirely on location. So I had to find myself a house to rent, which I did in McLean Terrace in Stornoway. And it was there that Janice and I would spent half of each of those years with our two cats, living and breathing island culture, getting to know the islands in all their

faces, filming in all weathers in every nook and cranny. And amazingly, that initial shock at the Lewis sabbath gradually gave way to appreciation.

Sunday was a day when we simply couldn't work. When no demands were made of us. When the phone never rang. And we took the opportunity to explore the islands of Lewis and Harris, following

Wee Free Church, Kenneth Street, Stornoway
This impressive home of the Free Presbyterian Church of Scotland in Kenneth Street, Stornoway, stands solid and square against a changeable sky, a bulwark against modern changes that would affect the sabbath as a day of rest.

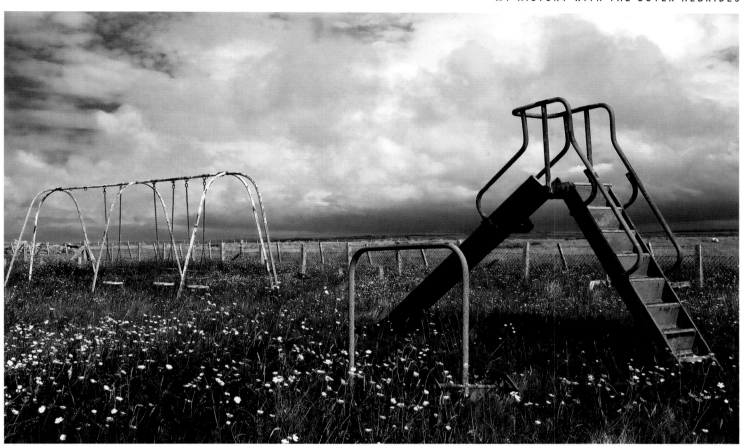

ABOVE **Borve playground**
The swings in this children's
playground in the west coast
village of Borve would once
have been chained up on a
Sunday. Now they have
simply been abandoned.

RIGHT **Leaving Stornoway**
The last ferry used to leave
Stornoway late on a Saturday
evening. If you missed it, there
was no way off the island until
Monday morning. Here, the
ferry is seen departing past the
lighthouse at Arnish Point.

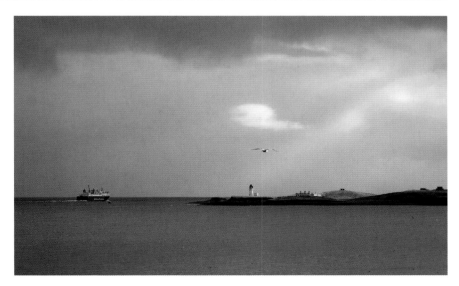

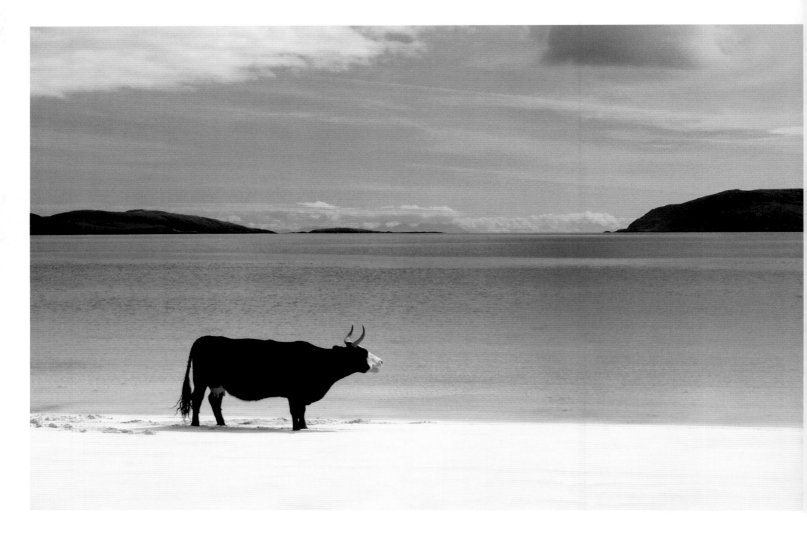

every single-track road down to dead-end coves and unexpected beaches. Picnicking in sheltered spots among the cliffs, or on some hidden and deserted stretch of silver sand. We discovered the joys of flying kites on the vast expanse of Uig beach when the tide was out, and the challenge of lighting barbecues on a rocky promontory in a gale-force wind.

I recall one Sunday during filming, when Janice and I, along with several members of the cast and crew drove down to the extraordinary beach at Luskentyre in Harris. Turquoise waters, acres of soft golden sand. Gentle dunes providing a barrier between the beach and the machair. We all settled ourselves among the dunes on a beautiful sunny afternoon. The wind had dropped, for once, and the sun was warm on our skins. We laid travelling rugs on the sand and began unpacking our picnic lunches. Which was when the midges descended!

Anyone who has travelled around the west coast of Scotland during the summer months will be acquainted with the midge – a tiny little fly that loves to feed on human flesh. They arrive in black clouds

Vatersay beach
Most beaches visited on those Sunday outings would be wonderfully deserted. It is a great feeling to have a summer beach all to yourself when almost anywhere else in the world would be packed with sunbathers. Very occasionally, as here on the beach at Vatersay, you found that someone else had beaten you to it.

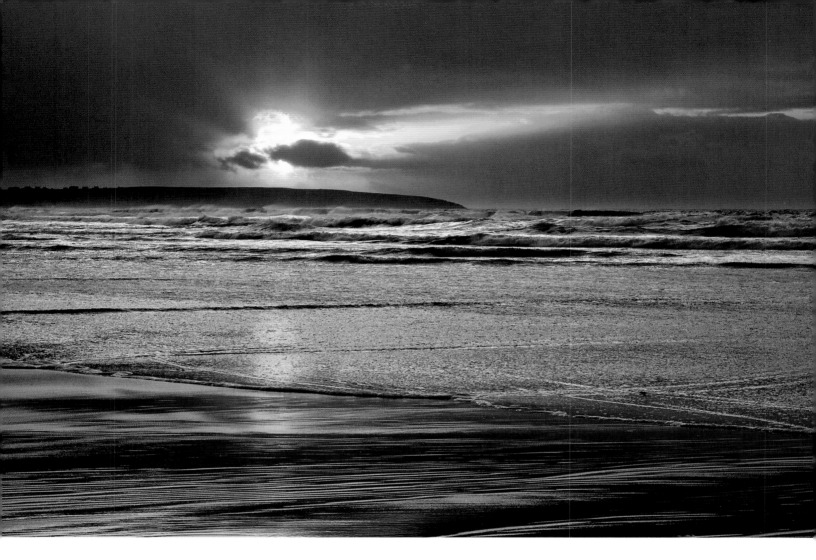

Eoropie sunset
Had we driven up to Ness to find a remote spot to picnic, we might have witnessed a sunset like this one at Eoropie.

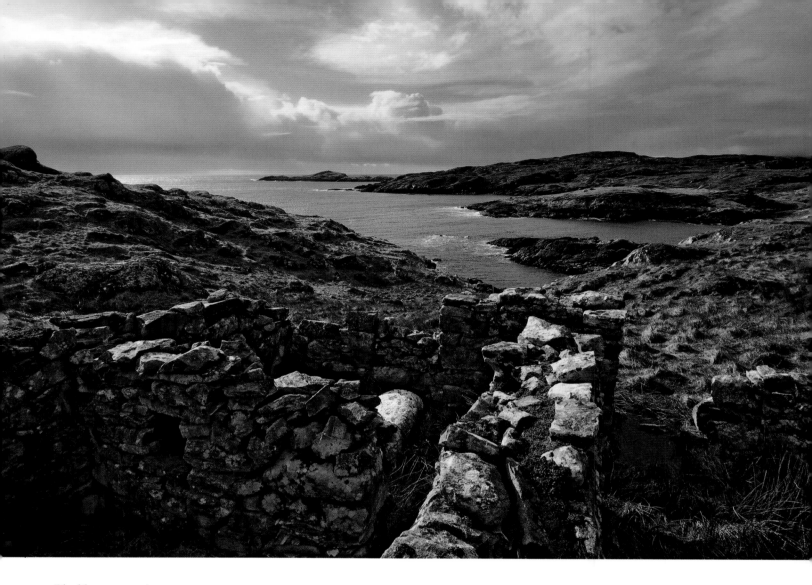

**Blackhouse remains
overlooking a rocky inlet**
*This is something we would
typically see on a Sunday
drive along the so-called
Golden Road on the east
coast of Harris.*

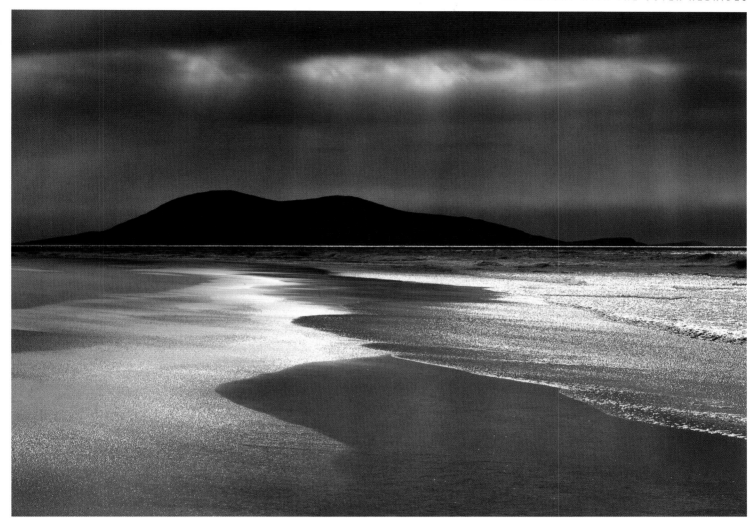

Luskentyre beach

At Luskentyre, on the west coast of Harris, is one of the most beautiful beaches in the Outer Hebrides. The light that breaks suddenly from a sullen sky can transform the landscape in the blink of an eye.

on still days and feast on unsuspecting humans. They get in your hair and your clothes, in your eyes and your mouth. And they bite and bite and bite.

Our little gathering among the dunes was soon thrown into disarray. At various times one or other of us would stand up, waving his arms around his head, shouting imprecations at the wee biting beasts, and then sit down again to grab another mouthful of sandwich. Then at one point, two of our number decided to go for a walk along the shore to try to

escape the midges. As they walked along the soft sand left by the outgoing tide, they met two tourists coming in the opposite direction. Pleasantries were exchanged, and then the tourists issued a dark warning. They nodded towards our little gathering in the dunes and said, 'Might be a good idea to give that lot a wide berth. They keep standing up and waving their arms around. We think it might be some strange religious sect.'

Our fellow *Machair*ites didn't let on.

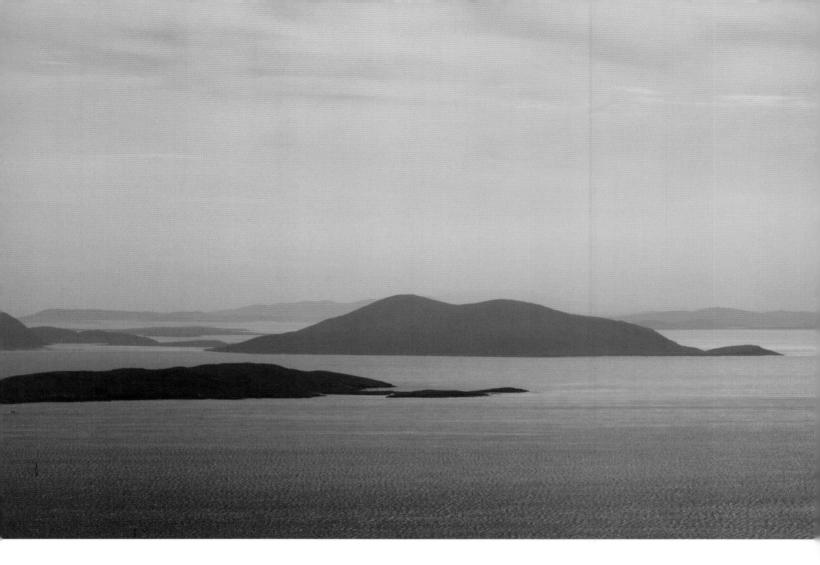

From Oreval, North Harris

Some of the most stunning views we encountered were to be found on the west coast of North Harris. This was taken looking south from Oreval. Toe Head is on the right, Taransay on the left, with the hills of North Uist in the far distance.

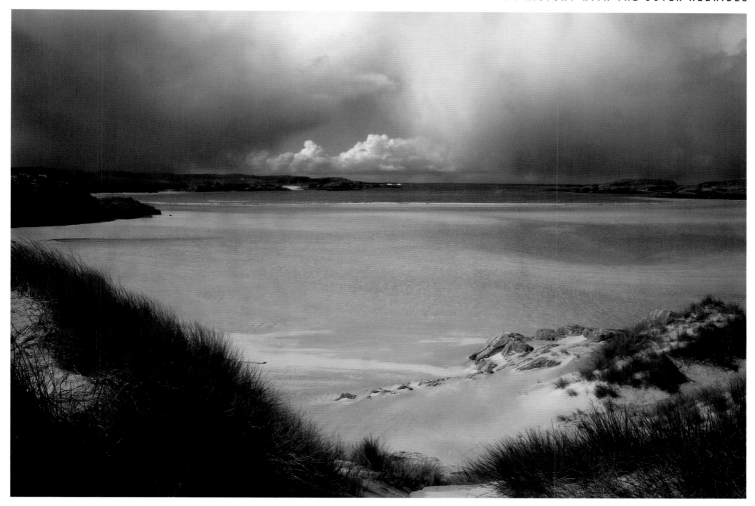

Uig beach

I spent many a happy Sunday flying my kite here on the beach at Uig, south-west Lewis. You could run for miles across the flat, compacted sand when the tide was out, and you could see any incoming bad weather from a long way off.

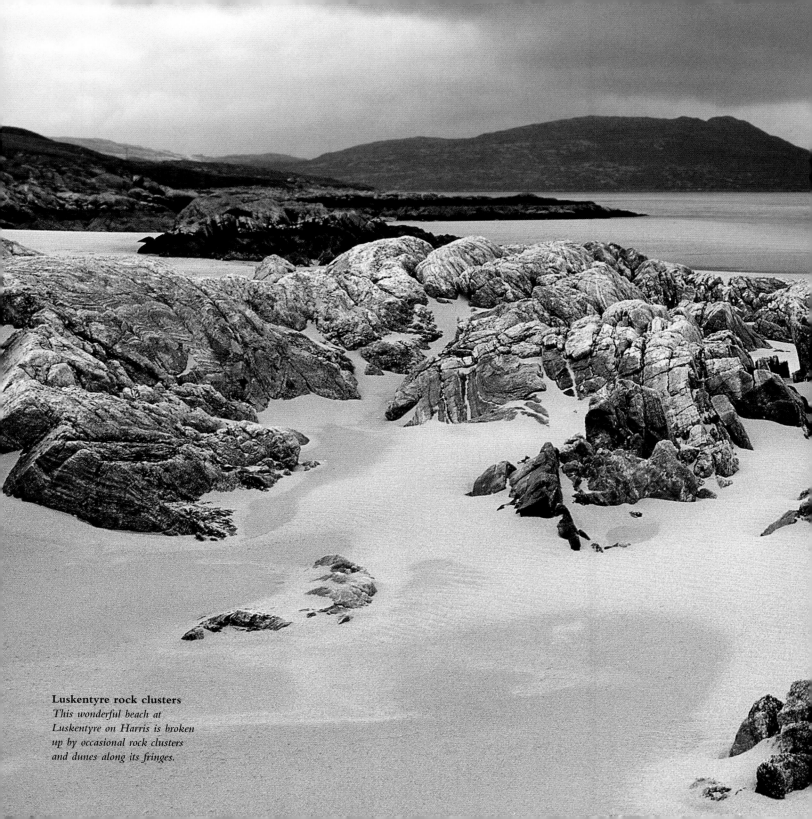

Luskentyre rock clusters
*This wonderful beach at
Luskentyre on Harris is broken
up by occasional rock clusters
and dunes along its fringes.*

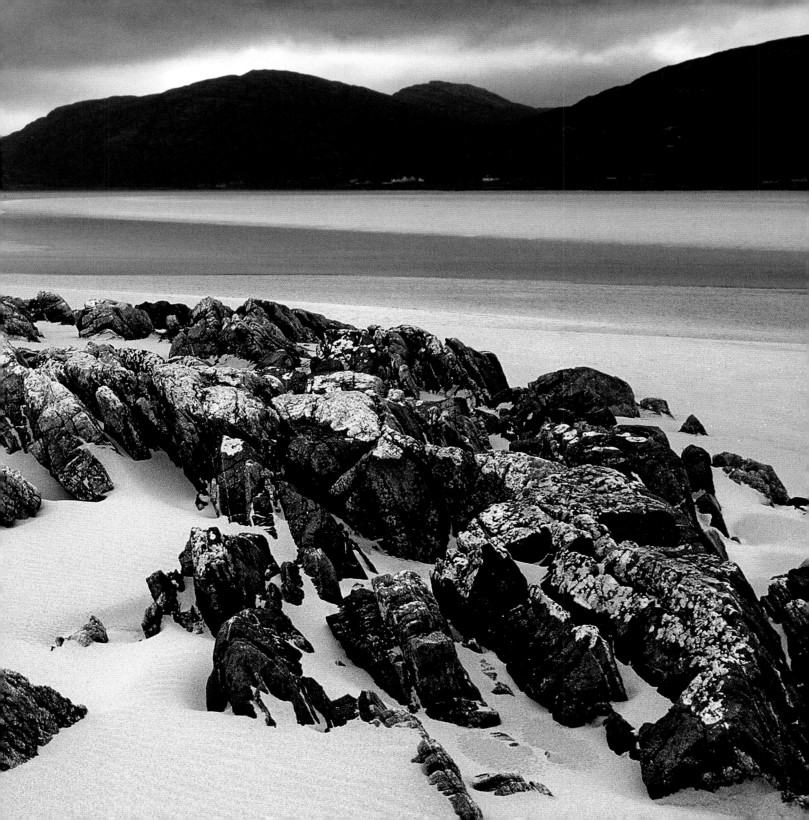

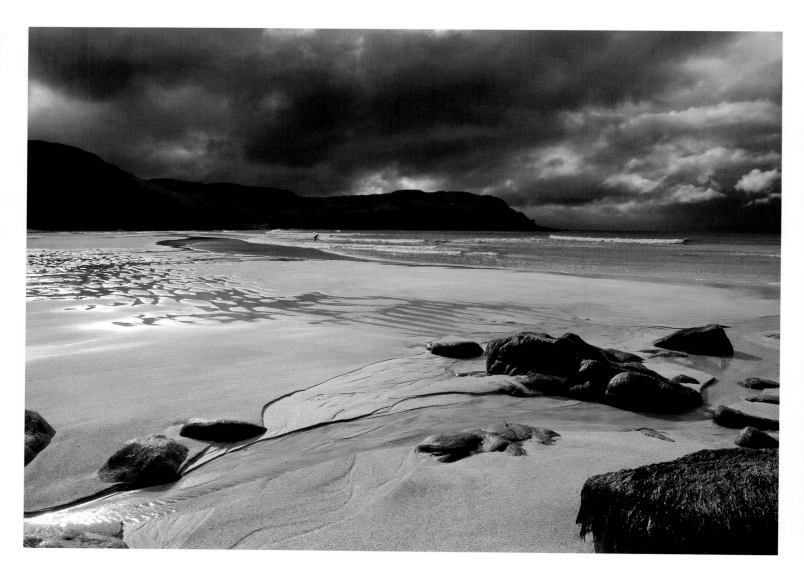

Sundays became a day we looked forward to. Our day. A chance to be alone or with friends, and at one with the islands.

Since those halcyon days of the early nineties, the taboo on Sunday transport links between the islands and the mainland has been broken. There are now Sunday flights and Sunday ferries. Some pubs and restaurants are open. And although this perhaps offers more convenience for the tourist, I can't help feeling that something has been lost. During those five years of filming, I found myself exploring every corner of Lewis and Harris for good locations within striking distance of our production base in Stornoway. Some days the production team would spend up to three hours just travelling to and from location. We went to such diverse places as Skigersta in Ness at the extreme north end of the island, to Uig down in the south-west and Ardvourlie across the border in Harris.

Dalmore beach
The beach at Dalmore on the west coast of Lewis was another favourite Sunday haunt. The occasional surfer, as seen here, only added interest to the view. But the waters are treacherous; a strong undercurrent created by a steeply shelving beach can drag careless swimmers out to sea.

Tràigh Mhòr, Tolsta

Another of those Sunday beaches was to be found near the settlement of Tolsta on the east coast of Lewis. Tràigh Mhòr means, literally, Big Beach. And it is, stretching for miles along the north-east coastline, and almost always deserted.

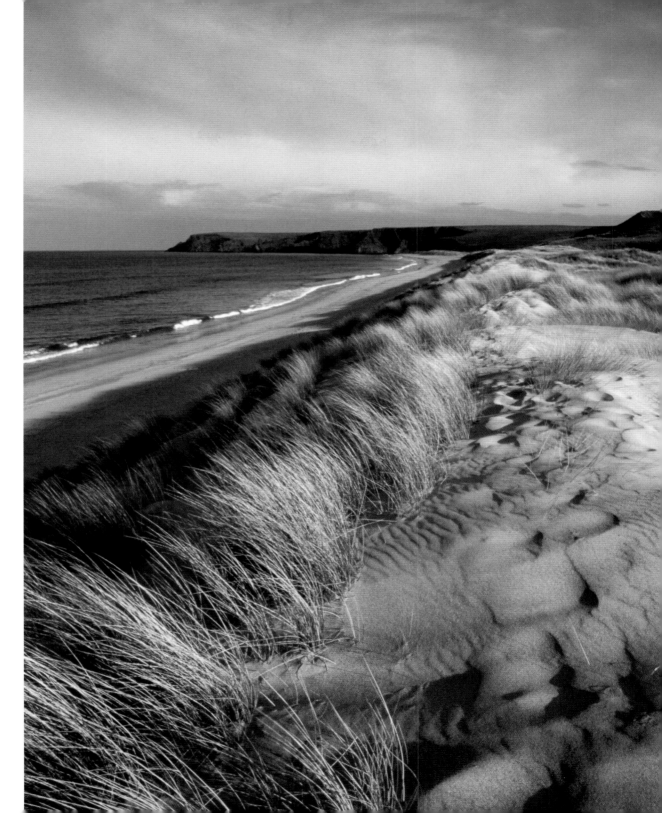

Broadbay dawn
Still on the east coast, an early morning drive out of Stornoway towards the Barvas moor could reward you with this kind of sunrise. Here, we are looking towards Broadbay and Point from Newmarket. Silhouetted in the distant background are the mountains of the mainland – a rare sight. It is said that when the mainland is visible to the naked eye, bad weather is imminent.

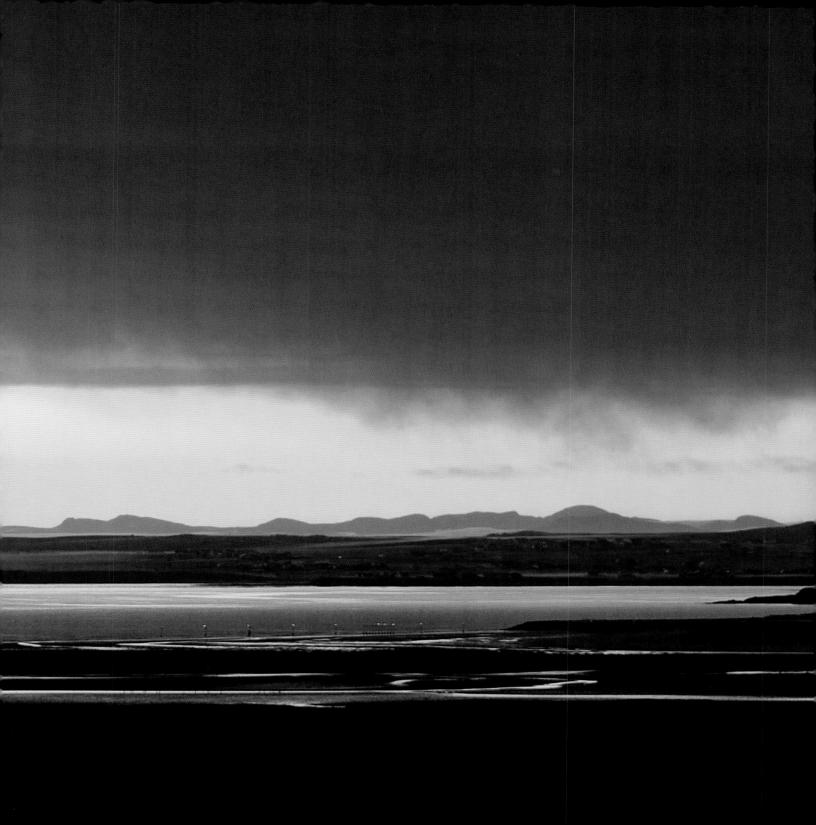

I had always admired Uig beach, and in particular the outstanding Uig Lodge, which stood up on the machair looking out over the sands. It was built in 1876 by the then owner of the Isle of Lewis, Sir James Matheson. It was later sold to his successor, Lord Leverhulme, who gifted it to his niece Emily Macdonald as a wedding present. She described the location as a 'scene which surely has few equals in all Britain for sheer breathtaking loveliness'. The celebrated English author Arthur Ransome stayed at the lodge for two years at the end of the Second World War. Its unrivalled setting was said to have been the inspiration for the final book in his Swallows and Amazons series, *Great Northern*.

We used it as the new home of the college featured in *Machair*. To this day I find it hard to imagine a more stunning setting for any TV drama anywhere in the world. The turquoise colour of the crystal-clear

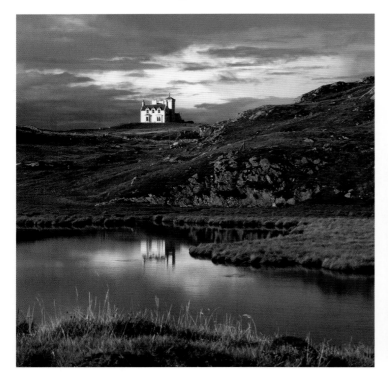
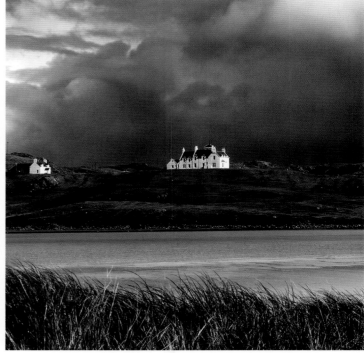

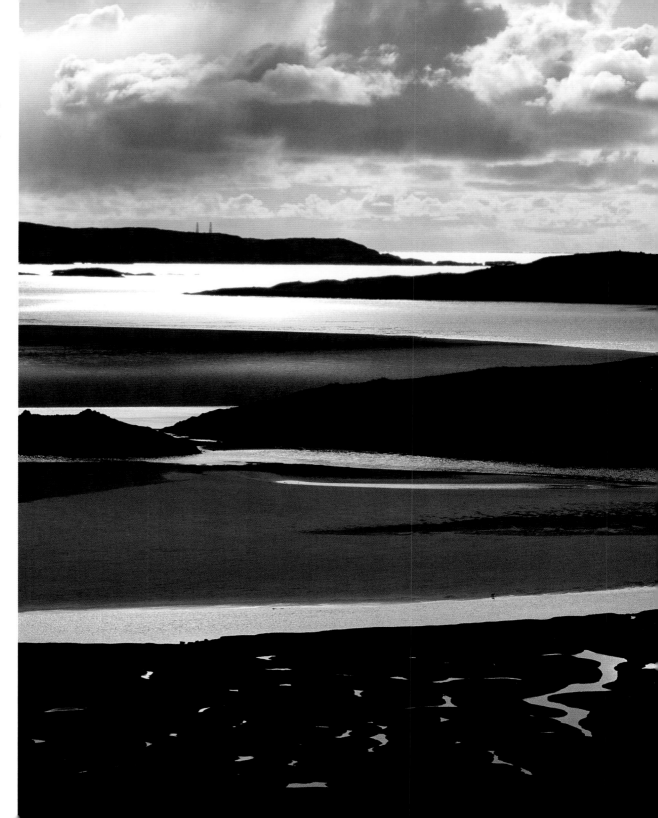

RIGHT View from Uig Lodge

Here is a view from the lodge across the salt marshes below to Uig beach. When the tide is out, the sand stretches for miles.

FAR LEFT Uig Lodge from the south

This view of Uig Lodge was taken from the south side. It sits up on a promontory looking west over the beach below. From the north side, it is set against the impressive mountains of the south-west. Our lighting director on Machair *loved the lodge so much that he lived in it while we were filming.*

LEFT Uig Lodge from the beach

Here the lodge is seen from the beach, sunlight picking it out against the black sky behind it. The lodge now also incorporates a smokery, smoking salmon and organic sea trout.

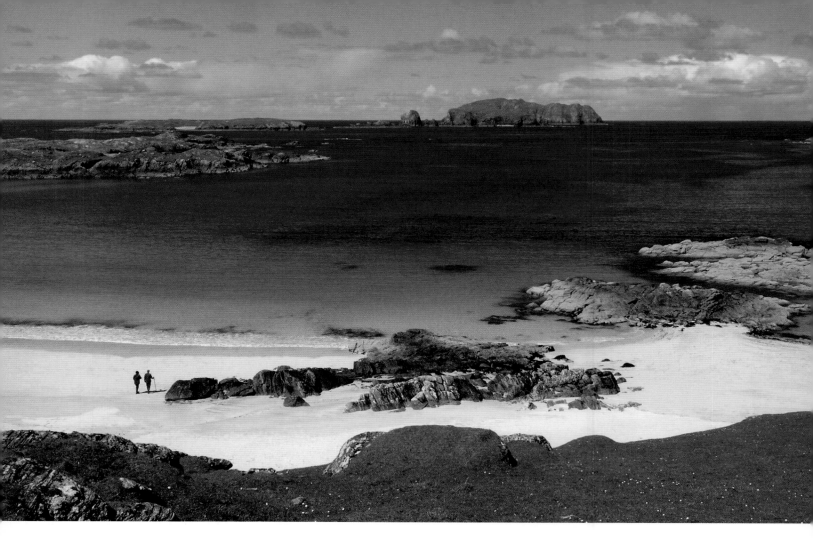

waters, the silver of the sand, the cloud-ringed mountains rising to the south – this was later to become a major setting of my book, *The Chessmen*.

I remember very well driving down to location at Uig Lodge one beautiful spring morning. The moor was alive with fresh colour, Little Loch Roag was the deepest, sparkling blue. Our sound recordist, who hailed from London and was more used to working on the long-running TV show *The Bill,* turned to me and said, 'Just think, I could be sitting on the M25 right now!' People in cities everywhere are commuting to work, sitting in lines of fume-belching cars on city ring-roads – the Beltway in Washington, the Périphérique in Paris – when just a new life perspective away another existence awaits for those brave enough to make the change. Our sound recordist came back year after year!

The most inescapable feature of island life, as I discovered, was the weather. I have been no place else on this earth where the weather has so dominated daily life. Not because of any extremes of temperature – the average temperature range on the Isle of Lewis, for example, is between around 4°C and 16°C – but because of its changeability. The two

Bosta, Great Bernera
This view out across the beach at Bosta, Great Bernera, over a turquoise sea sprinkled with islets is typical of the sudden vistas to be found around every other turn in the road that winds down the west coast.

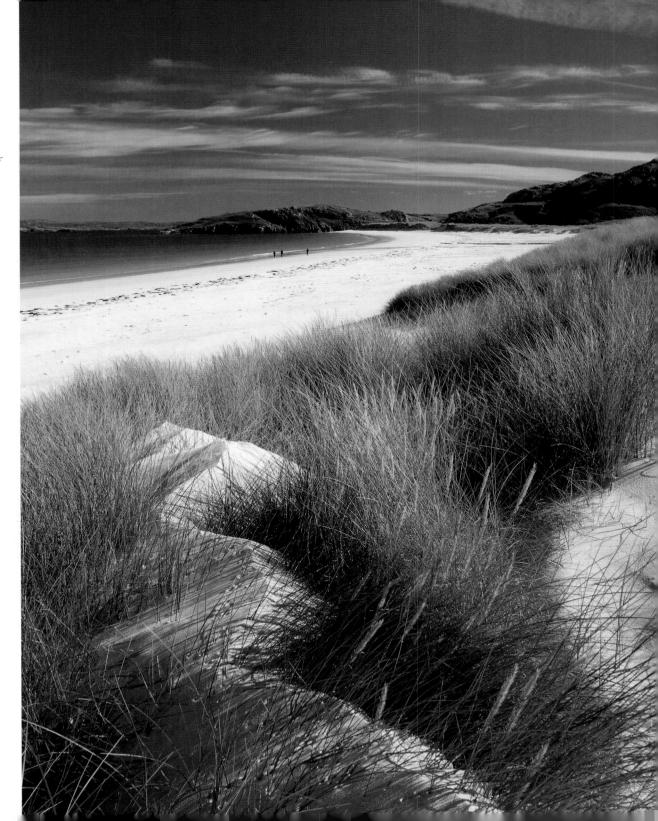

Reef beach, Uig

Another of the beaches to be found at Uig is Reef beach. I recall returning by helicopter on a Saturday from Uig after shooting aerial sequences for the opening and closing titles of Machair. *We flew over Reef beach and filmed a solitary figure walking a dog. It turned out to be our wardrobe assistant.*

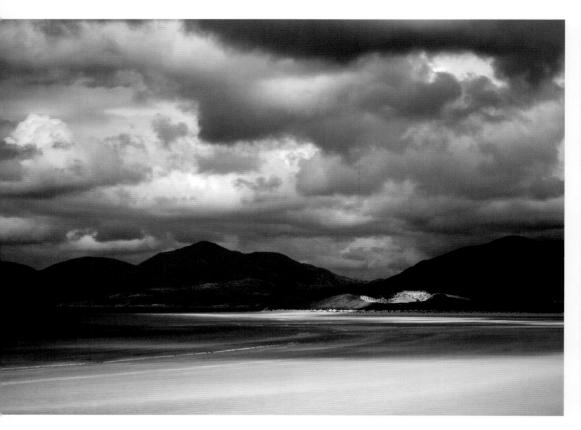

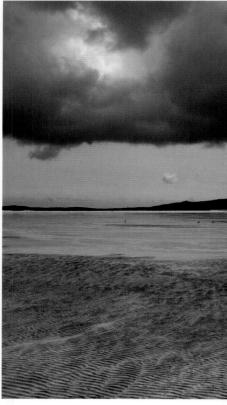

Luskentyre from Seilebost

Yet another example of contrasting light in an ever-changing sky. This time over the beach at Luskentyre as seen from the tiny settlement of Seilebost on the west coast of Harris. Seilebost primary school sits out on the machair, and this is the view that the children have from their classrooms. What a place to grow up!

Sollas, North Uist

This wonderfully ominous sky hangs over the beach at Sollas, North Uist, and is typical of the startling contrasts offered by Hebridean skies.

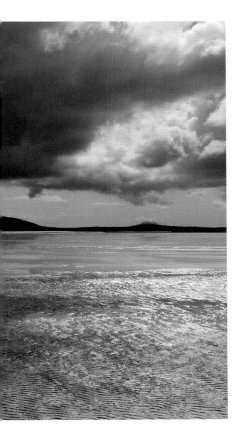

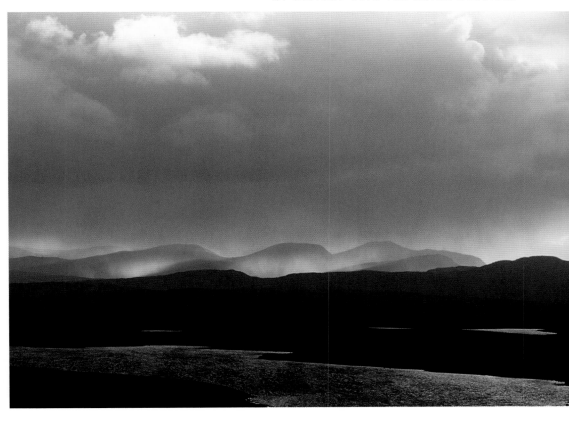

ABOVE RIGHT **Lochganvich, Garynahine**

The west coast of Lewis offers something special during a winter sunset. Rain falls from a leaden sky, backlit by a sun dropping low beyond the hills.

things you notice when you first come to the Hebrides are the wind and the sky. The wind hardly ever stops to draw breath. It blows constantly. Sometimes softly, and sometimes with such force that it can blow waterfalls back up mountains. As a result, the sky is ever-changing. And it's a huge sky, presenting itself as about three-quarters of your field of vision. The sky dominates the landscape, and because it never stops changing it is like a kaleidoscope that offers morphing vistas to hold the attention and challenge the imagination. Sunsets and sunrises are often breathtakingly spectacular, displaying light that reflects off the Minch to the east, or the Atlantic to the west. And at all points between you are offered constant change. I vividly recall driving to or from location and seeing rain

falling distantly in the east, sunlight slanting through the mountains in the south, a bank of black cloud gathering storm forces for attack out over the ocean and providing a perfect backdrop for a double rainbow just out of reach.

It was wonderful to experience, but a nightmare for filming. We shot *Machair* using a single camera. This meant that most scenes involving two characters would have to be shot three times. The first time both characters would be included in a wide shot. The second time the camera would be on a close-up of character A and then on character B. This would be cut together back in the edit room. But the weather changed so quickly I have seen the master shot filmed in sunshine, character A shot in a hail-storm, and character B against a blue-black sky.

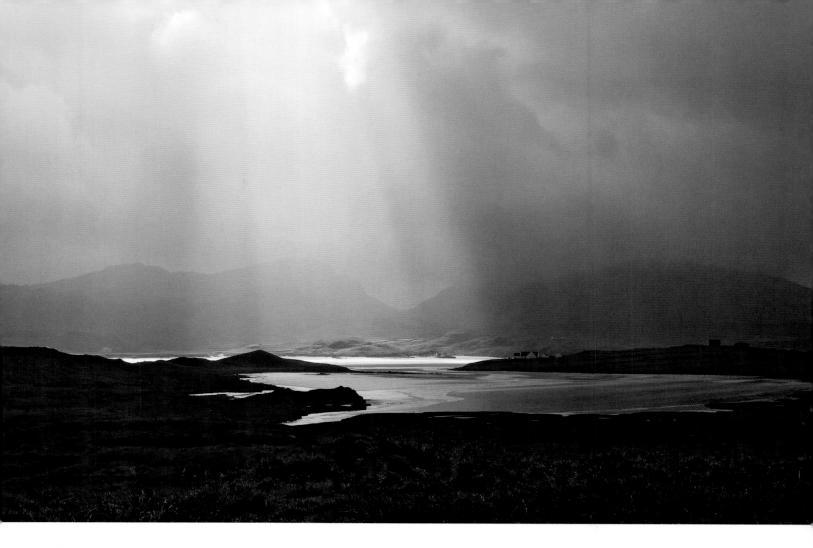

The editor used to tear his hair out trying to match the shots for continuity.

Something I noticed on my very first trip, while staying at Port of Ness, was repeated often during my years on the island. It was a strange, mechanical chattering sound that would issue from behind closed garage doors and tin huts as you walked through villages, or even past isolated crofts. It was a while before I caught my first glimpse of the chattering beasts that lurked behind these doors. They were hand-operated looms for weaving the wool of indigenous sheep into the world-famous Harris tweed. There was a time, when it was commonplace for homes all over the islands to have looms in them. In the eighteenth and nineteenth centuries cloth was woven primarily for domestic use, with surpluses sometimes used to pay rent, or bartered for goods. But while weaving became largely mechanized on the mainland, hand-looms persisted in the Hebrides, and Harris tweed gained something of a caché in international fashion markets during the twentieth century. Production reached a peak of nearly eight million yards a year in the mid-1960s, before falling into decline as the fashion gurus turned to other

Shaft of sunlight, Uig
In a moment, a bleak, dark landscape smothered in black cloud can be transformed by a single shaft of sunlight. In this photograph, taken at Uig, Mealaisbhal, the highest peak on Lewis, looms in the background. It as if God had suddenly shone a spotlight on His work.

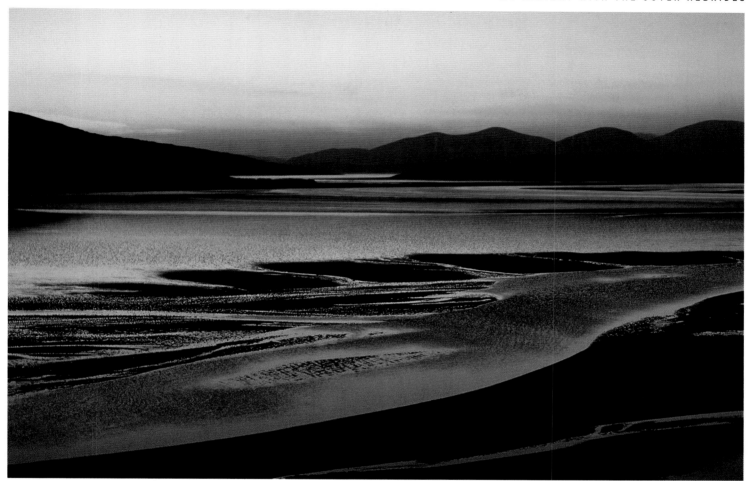

Seilebost at midnight

Here at Seilebost a landscape is transformed by a midnight sunset. Many people assume that all photographers routinely 'doctor' their photographs with clever software. But this is the genuine article, as only the Hebrides can offer up.

Rainbows on the road to Ness

In all my life I have never seen so many rainbows as I did during my time in the islands. The ever-shifting weather and light is the perfect breeding ground for them. 'Doublers' are a common sight. This one was spotted arching over the road north to Ness.

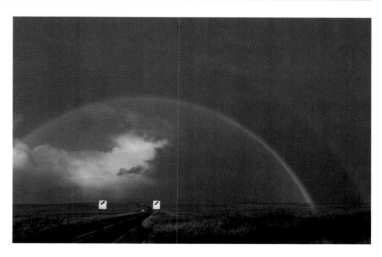

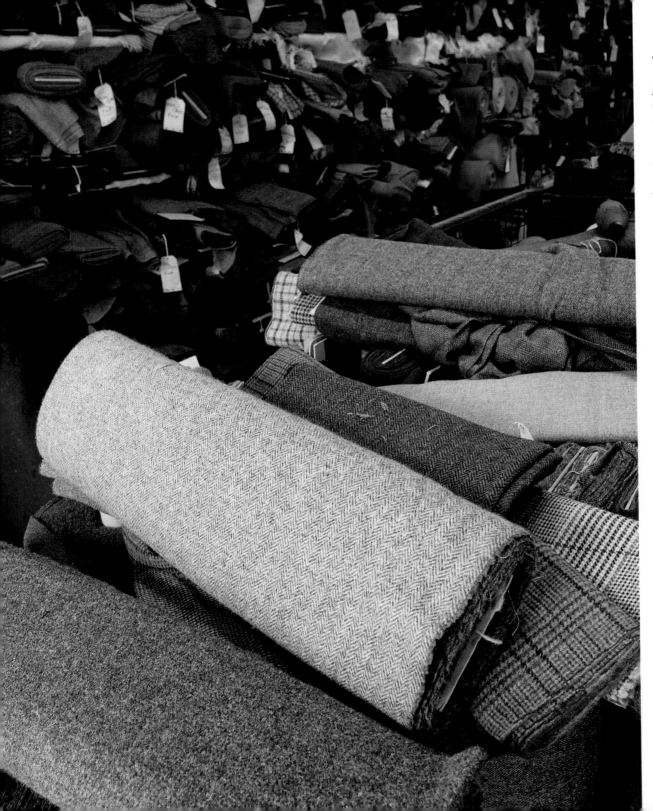

Tweed shop, Tarbert
These rolls of tweed were purchased by the canny owner of a tweed shop at Tarbert in Harris when Mackenzie's mill in Stornoway closed down. She bought the entire stock. And with the resurgence of interest in the fabric, now gets large orders from all over the world.

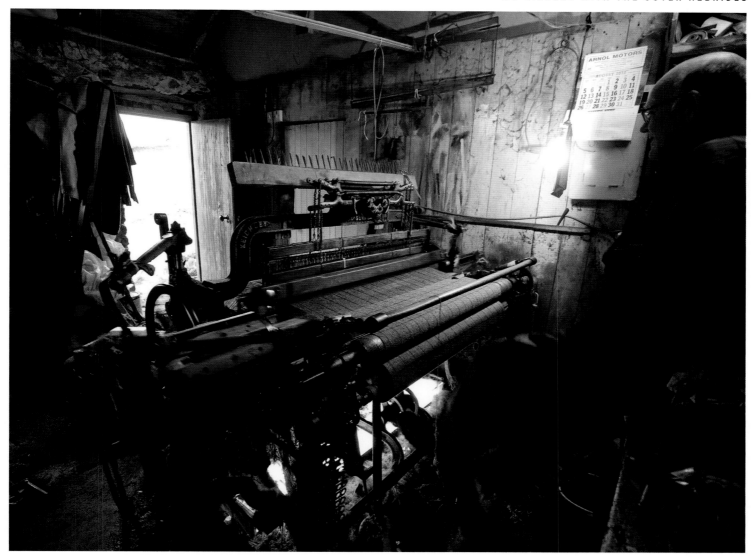

Adabroc weaver
Murdo Macleod, a crofter at Adabroc in Ness, pedals his loom in a cluttered loom shed next to his house, in a tradition carried on for centuries. The fact that it is in motion can be seen by the blurring of the shuttle that flies back and forth across the weave at incredible speeds.

materials. However, in many villages weavers continued to produce their yarn for the big island mills, working for a pittance in cold and cramped sheds and garages.

An Act of Parliament in 1993 defined what constituted genuine Harris tweed. It stated: 'Harris tweed means a tweed which has been hand-woven by the islanders at their homes in the Outer Hebrides,

finished in the islands of Harris, Lewis, North Uist, Benbecula, South Uist and Barra and their several purtenances (the Outer Hebrides) and made from pure virgin wool dyed and spun in the Outer Hebrides.' And so the practice of home weaving never died out, surviving to see a renaissance in recent years, with production rising to more than one million metres in 2012.

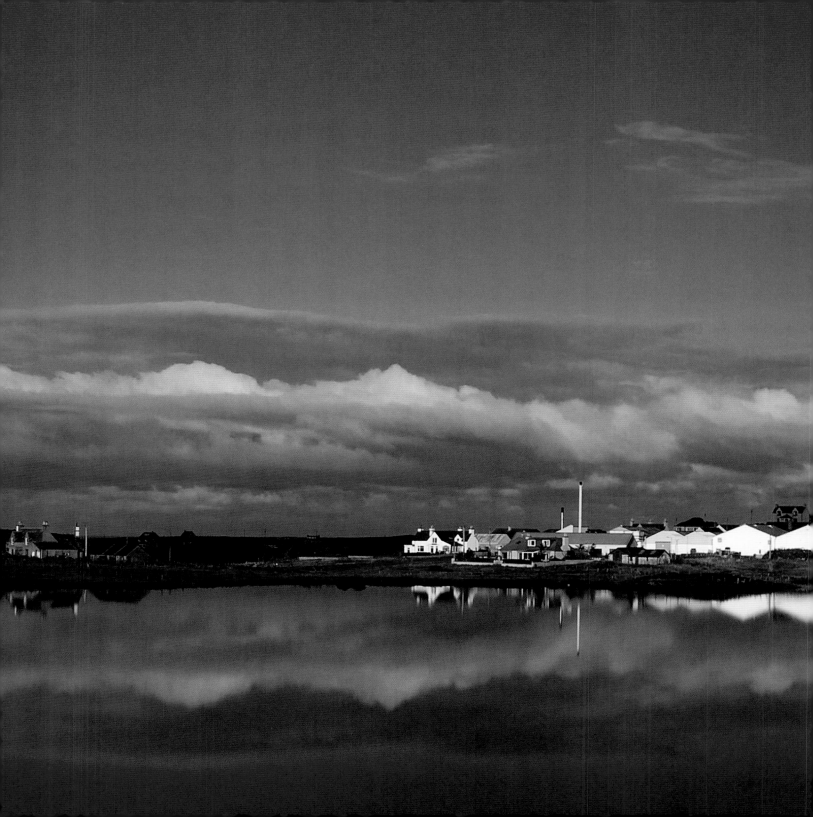

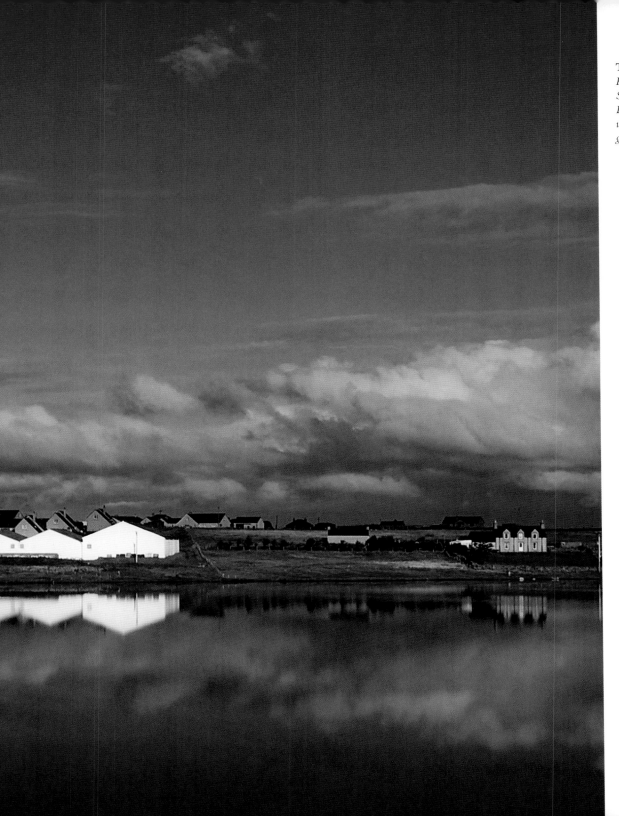

Tweed mill at Shawbost
Here is the tweed mill at Shawbost on the west coast of Lewis where yarn is produced, warps set out, and the fabric given a final check.

I recall offering a commission to write a *Machair* script to a promising young Gaelic writer who was barely scratching a living spinning tweed in a leaky, draughty, corrugated-iron shed on his mother's west coast croft. On the telephone I told him that the fee would be 'two thousand'. There was a perceptible pause at the other end of the line before he said, with incredulity in his voice, 'Pounds?' It probably constituted more than a third of his annual income.

Another feature of the landscape with which I became very familiar during those *Machair* years was the clearly delineated strips that divided up the fertile machair land around the coast. This was strip-crofting, a croft being a fenced or enclosed area of arable land rented by a tenant crofter whose dwelling would be built upon the land. In practice, on the islands these tended to be long, narrow strips. Townships comprised houses that were not generally huddled together in villages, but strung out along the road and the coast, separated by their land. For centuries, crofters eked out a subsistence living on their crofts growing potatoes and other root vegetables, and a few cereal crops. A cow or two provided milk and butter, and a few sheep the wool for weaving and knitting.

Crofts at Bru

Here at Bru, sunlight falls from a pewter sky to sprinkle light across the strips of land that delineate the crofts of this tiny community.

Croft strips, Carloway

Strips of croft land can be seen running down the hill to the shore from these dwellings strung out along the rise at Carloway on Lewis's west coast.

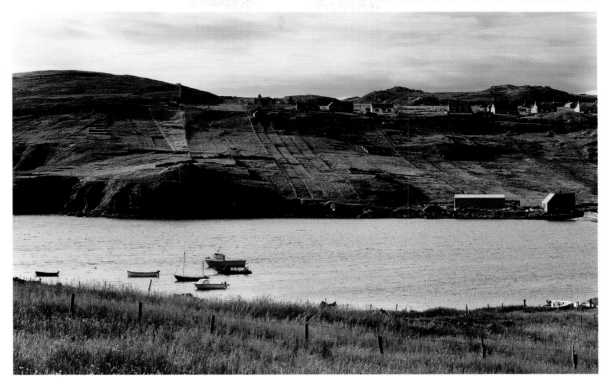

Highland cattle at Bragar

Blood taken sparingly from cows kept starving crofters alive during the potato famine of the mid-nineteenth century. These Highland cattle were pictured taking a dip in Loch Urghag at Bragar, on the west coast of Lewis. Notice the bog cotton in the foreground.

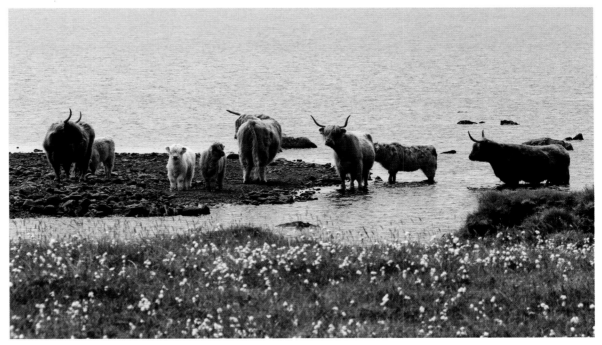

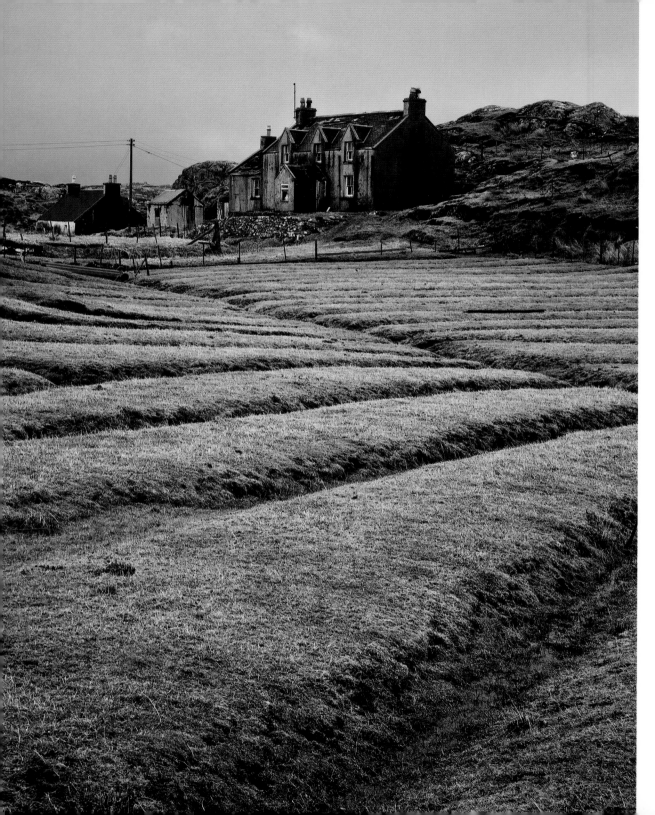

Lazy beds at Manish
These old 'lazy beds' are clearly delineated on this croft at Manish on the Golden Road that winds up the east side of Harris. Evidence of this ancient method of cultivating potatoes can be seen all over the islands.

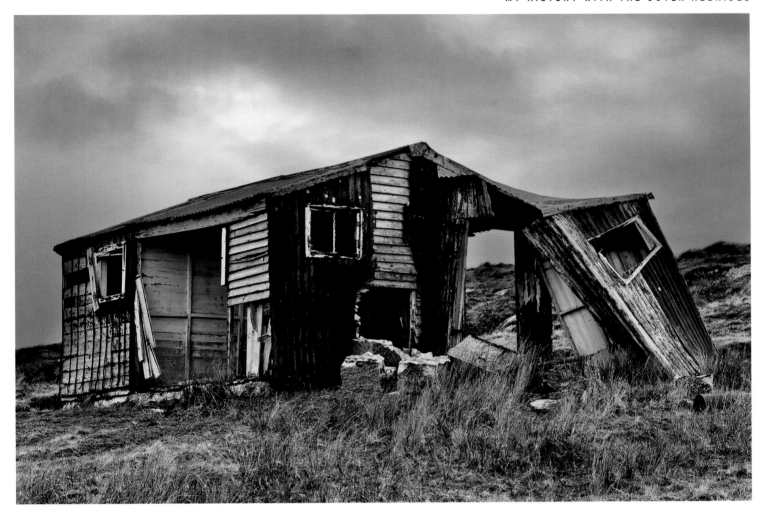

Shieling, Pentland Road

This is a shieling of relatively recent vintage, built of wood and corrugated iron, long since abandoned. It was spotted off the old Pentland Road, which used to be the main cross-island thoroughfare from Stornoway in the east to Carloway in the west.

During the potato famine in the mid-nineteenth century, people were reduced to milling a weed called silver leaf to provide a basic flour, and 'bleeding' their cows for protein. To make the blood more palatable, they mixed it with a little oatmeal, creating what we now know as black pudding.

Potatoes were cultivated in what were called 'lazy beds', and evidence of them can be seen everywhere in long parallel lines of raised earth, now covered in grass. The crofter dug long channels, piling the earth up in between them to create well-drained mounds.

In these they planted their potatoes and fertilized them with kelp gathered along the shore, or the soot-blackened thatch removed each year from the roofs of the blackhouses.

During the summer months, the livestock were driven inland to fresh grazing on the moor, and the women of the household lived in primitive dwellings known as shielings – tiny houses with stone walls and thatched roofs, later replaced by corrugated iron. The remains of these structures can still be seen all over the islands today.

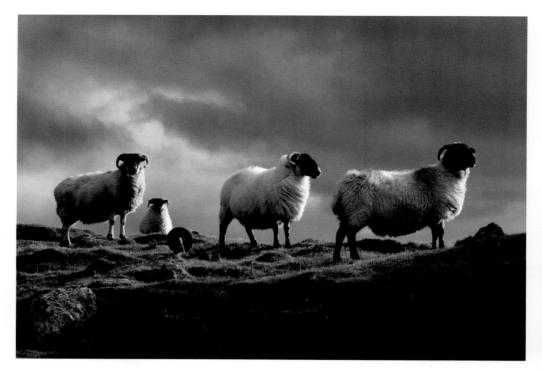

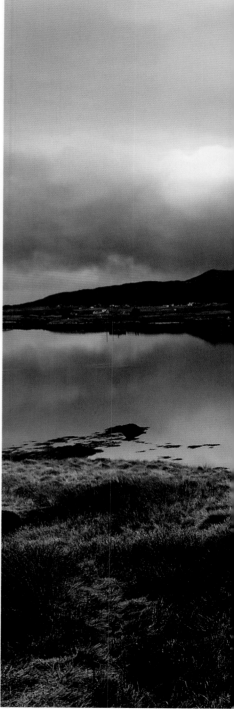

However, following the battle of Culloden in 1746, the British government set about dismantling the old Highland clan system, and in the process set off a chain of events that destabilized the comparatively secure tenures enjoyed by crofters under their old clan chiefs. New landowners believed that there was more money to be made in turning the land over to the raising of sheep. Many of them evicted their tenant crofters, displacing them to the coastal fringes, or forcing them aboard ships bound for the New World. This was known as the Clearances, and it blighted life in the Scottish Highlands for more than a century, coming to an end only in 1886 with the passing of the Crofters Act, which for the first time gave crofters heritable security of tenure with controlled rents.

Crofting is still a feature of island life today, but crofts tend to be a labour of love more than a source of income.

Sheep

It is hard to believe now that landowners valued sheep above people, throwing crofters off land worked by their ancestors for centuries, in favour of these creatures. Sheep are to be seen everywhere on the islands, and will wander on to the roads without warning.

Shieling, North Uist

This shieling, long ago fallen into disuse, looks out across a still loch in North Uist. One of the downsides of life in these inland summer dwellings was the curse of the midge, which bred by the million in the damp, still conditions. Today, when driving along the unfenced roads that criss-cross the islands, you often see sheep gathering on the tarmac – a sure sign that the midges are out in force on the moor.

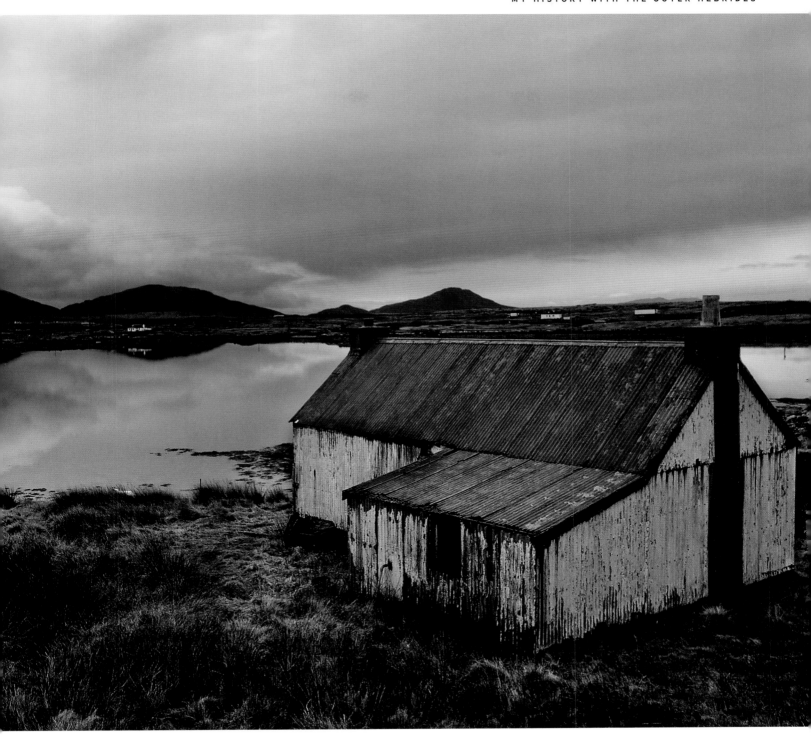

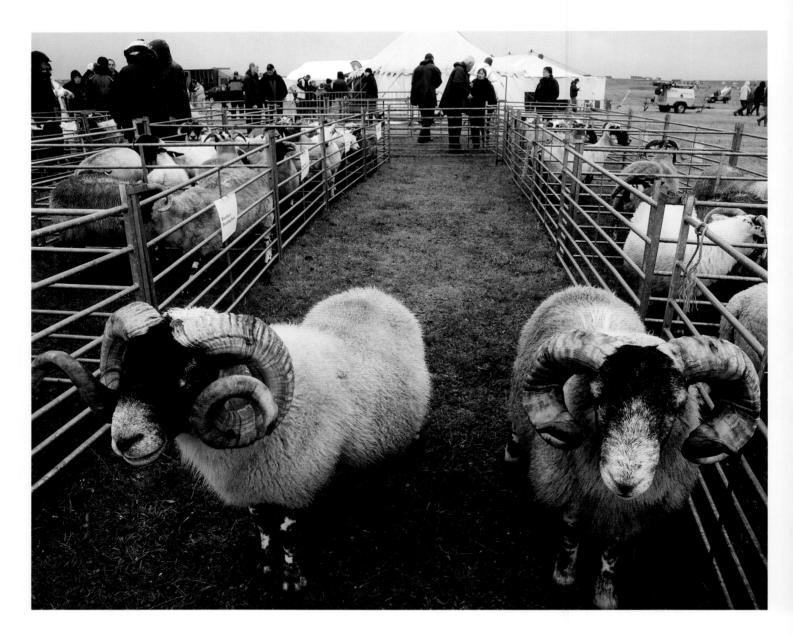

ABOVE AND FACING PAGE **The West Side Show**
Nowadays, sheep get bathed and blow-dried for the
West Side Show, and paraded in all their splendour.
But while the sheep don't seem to mind the weather,
their owners are huddled up in waterproofs against
the cold and the wet.

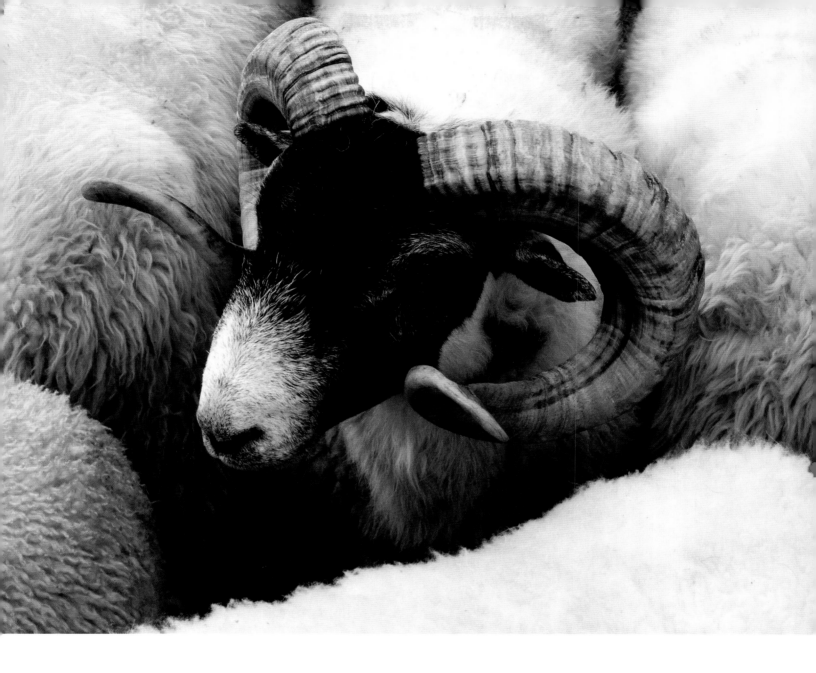

Bog cotton

Bog cotton smothers the moor. This photograph was taken in 2012, the driest spring and summer on the islands in living memory. Although it normally favours damp conditions for growing, bog cotton was particularly abundant that year.

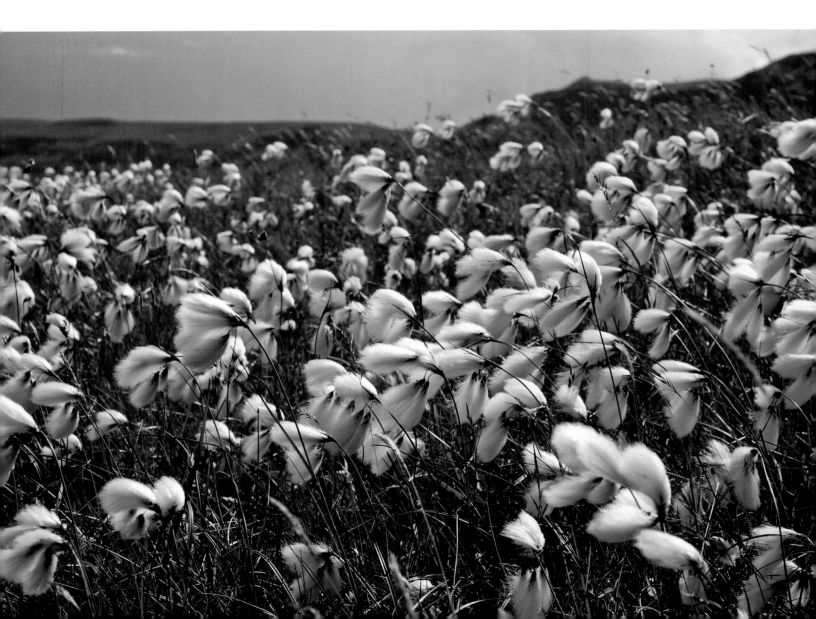

BELOW LEFT **Peat cutting**
Here, an elderly couple perform the centuries-old ritual of cutting the peats. You can see the wet slabs laid out in the foreground, and along the top of the bank. They will be dried in stacks and gathered weeks later. This photograph was taken at Leurbost, a few miles south of Stornoway.

BELOW RIGHT **Peats drying**
Along a peat bank at Shawbost, small stacks of peat 'bricks' dry in the warm spring winds.

Of course, I was aware from day one of peat as the main fuel throughout the islands. It is what has kept islanders warm against the cold winter winds for centuries. You can't go anywhere on the islands without breathing in that distinctive, toasty scent of peat smoke. But it wasn't until the first time that I flew into Stornoway that I realized the extent of the peat workings, and how hundreds of years of cutting has scarred the landscape. From the air the peat banks look almost like the aerial photographs my grandfather took of the trenches during the First World War. But no matter how much peat has been cut, and will be cut, it is hard to imagine it ever running out. The islands are smothered in peat bog, and the peat in places can be very deep. Peat 'grows'

at the rate of around one millimetre a year, so to produce a peat bog ten metres deep would take 10,000 years.

The peat is normally cut out on the moor around the month of May. It is one of the most spectacular times of year on the islands, with spring flowers bursting into colour, and the bog turning snow-white under its carpet of ubiquitous bog cotton. Most families have their own peat bank, established often for generations. They cut the peat with a special spade, called in Gaelic a *toirsgir*. It has a long wooden handle and an angled blade at one end. After the heather turfs have been cleared, the peat is cut down on the vertical into slabs called peats which are stacked in small piles to dry. An experienced cutter

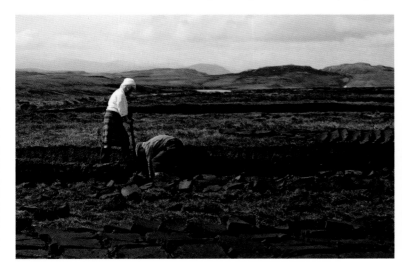

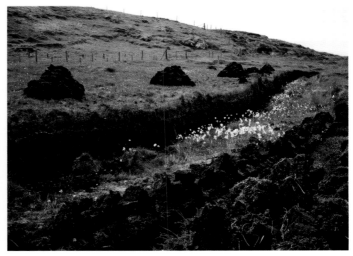

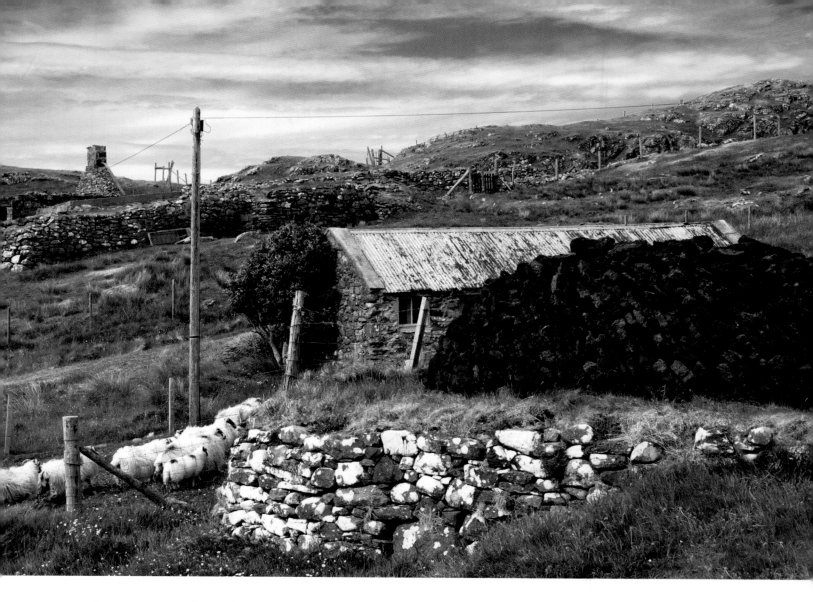

can produce as many as a thousand peats a day. Once dry the peats become brick hard and impervious to water. They are carried back to the croft and built into a stack which then feeds the fire for the next twelve months. The average croft can burn anything up to 18,000 peats a year. But it is absolutely free, the only cost being your own labour.

In 1996, after five years at the helm of *Machair*, I decided it was time for a change. I packed my bags and said goodbye to the islands. I quit *Machair*, and I quit television. I was determined to try to make my living doing what I had always wanted to do from the earliest age – writing books. With money put aside to keep me afloat for the next three years, I returned to China and finally found the story I had been looking for. I wrote *The Firemaker*, the first of what turned out to be a series of six thrillers set in China, and for the next seven or eight years my life was taken up

Lewis landscape

This is a typical Lewis landscape dotted with the remains of old blackhouses, broken-down sheep fanks, and stone-walled sheds with tin roofs. Sheep and an untidy peat stack in the foreground complete the picture.

100

Rounded rocks, Dalmore beach

This treasured spot at Dalmore on the west coast of Lewis was just one of the plethora of island beaches where I spent many a happy Sunday. The wonderful foreground pebbles show in their strata the millennia it has taken for the Atlantic Ocean to round off their edges.

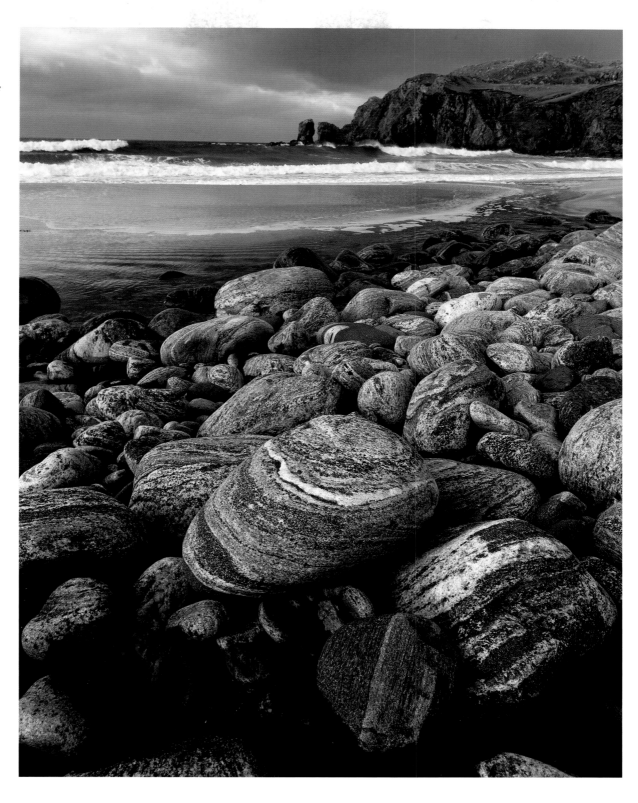

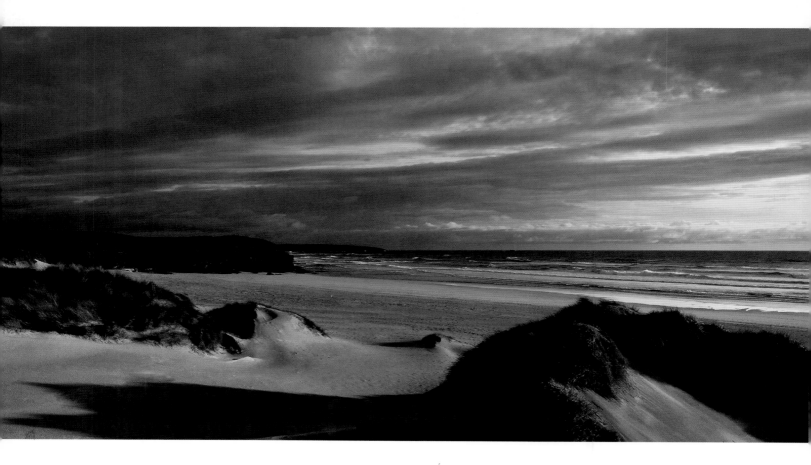

Eoropie, Lewis

*Eoropie in Ness, was a starting
point for the first in what would
turn out to be three books – the
Lewis trilogy. Sky, beach and sea.
Three vital ingredients in an
incomparable landscape, and
a unique setting for what the
French would call my* romans
noirs *(black novels). The first
book was entitled simply,*
The Blackhouse.

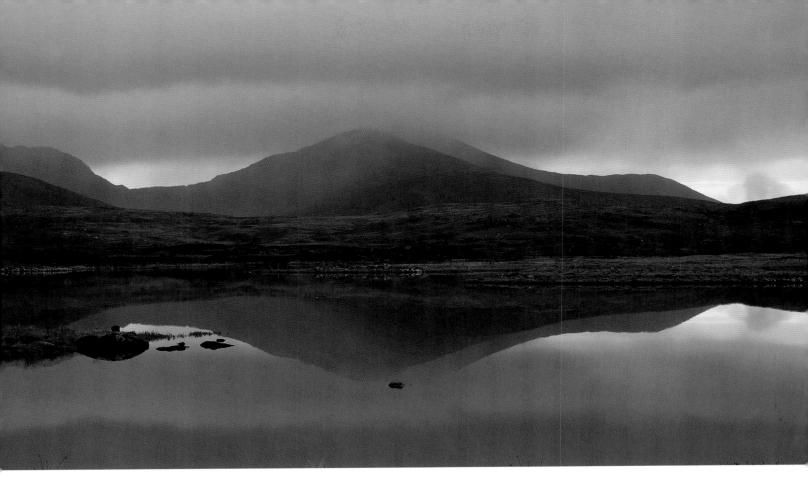

Beinn Mhòr, South Uist
*Fin Macleod, the central
character in the Lewis trilogy,
journeyed south through the
mysterious hills of South Uist.
I, of course, preceded him on
several research trips. This
photo was taken looking across
Loch Druidibeg to Beinn
Mhòr, the highest point on
South Uist at 620 metres.*

with travelling back and forth between Scotland and
China, researching and writing my books. During
that time I also sold my house in Argyll and moved
full-time to the south-west of France, an area with
which I'd had a love affair for decades. The Hebrides
faded into a pleasant memory, and it never occurred
to me then that I would ever be back.

But these islands have a way of getting under your
skin and into your blood.

We were halfway through the first decade of the
new millenium. I had finished my Chinese series and
was wondering what to write next when I came
across a photograph in a drawer taken during my
time on *Machair* ten years earlier. It reminded me that
the walls of my house were like a memorial to those

days. Almost every wall was hung with photographs
or art from the Isle of Lewis. They were so much a
part of my life I had simply stopped seeing them. I
went round them all, then, spending minutes at a
time gazing at those images, and it became clear to
me that here was the setting for my next book.
A wild, wind-blasted corner at the extreme north-
west of Europe that no one had ever used as a setting
for a crime novel. A place I knew so intimately it was
almost a part of me.

I racked my brains for tales I might have heard
during the years I had spent there, and one kept
coming back, and back. It was the story of ten men of
Ness, at the northernmost tip of the island, who set
off each August to slaughter 2,000 young gannets on

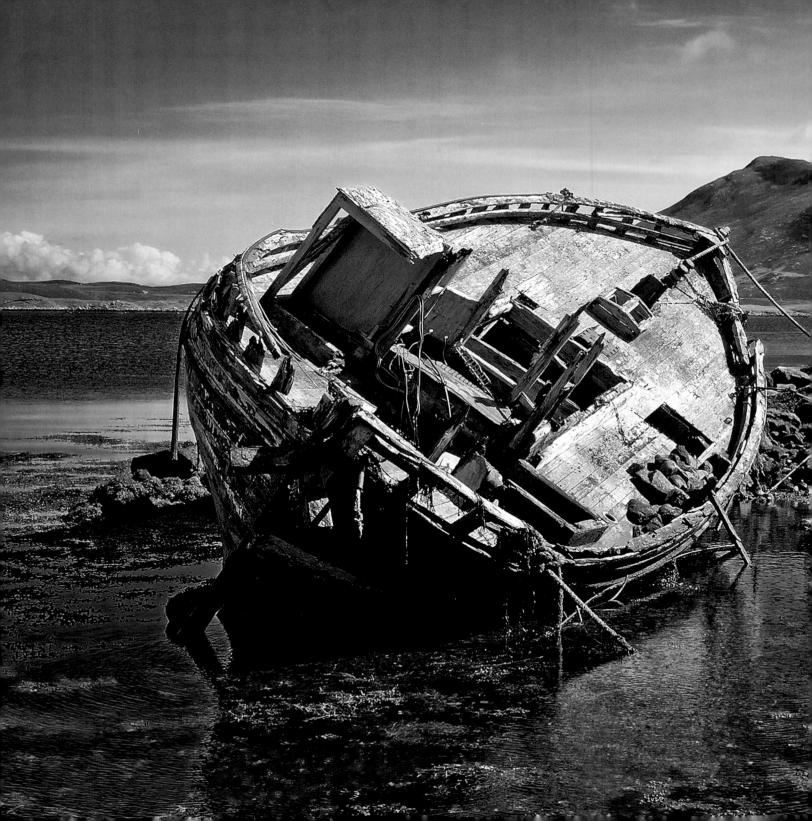

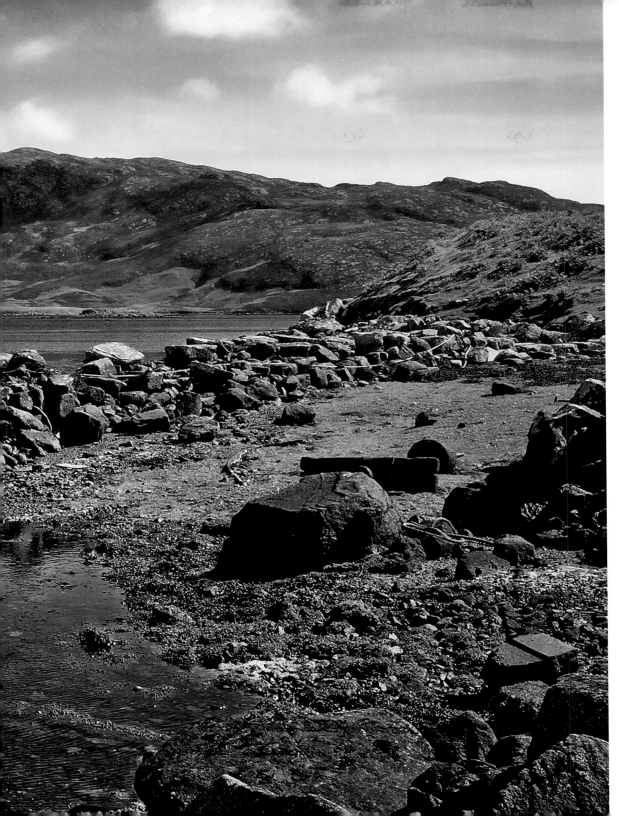

North Uist

The journey south would take my hero in The Lewis Man *through this bleak, dark landscape that so characterizes the island of North Uist. Abandoned and decaying boats can be found in almost every corner of the islands.*

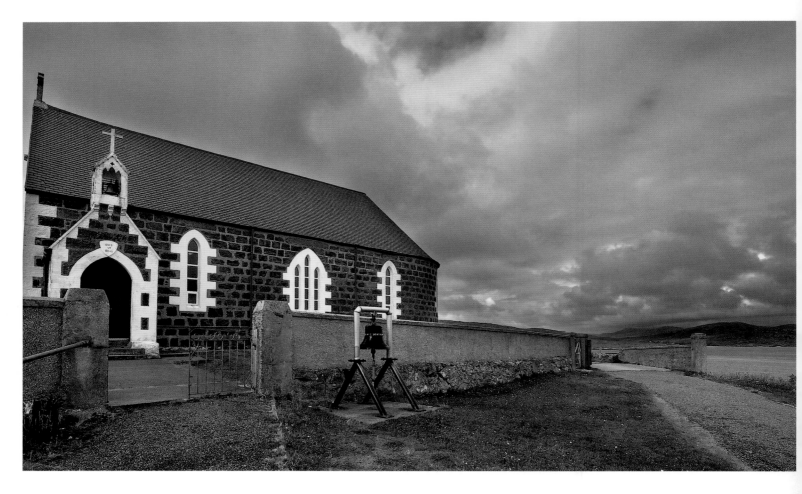

an inaccessible and inhospitable rock in the North Atlantic called Sula Sgeir. A 400-year-old tradition initiated in the beginning as a desperate search for food but developing over the years into what had become almost a rite of passage for young men. And I knew that this could provide the basis for my novel.

So almost ten years after I had left the island, I returned in search of my story. It was to be the beginning of the most successful period of my writing career, and would take me from Lewis in the north to Eriskay in the south, and all points between.

It was an emotional return to the islands after so long. I was almost overcome with memories. I had all

but forgotten just how beautiful they were. The beaches and the mountains, the stormy seas, the sunsets and sunrises. Even the junkyard gardens and abandoned vehicles had their own beauty. They had almost become landmarks, as familiar and forever as the rock of the islands themselves. I spent the first day or two simply driving around reacquainting myself. Driving the west coast from Uig to Ness. Following the road south to Harris, the wonderful beaches on the west coast, and the winding Golden Road that snakes its way among the fjord-like inlets of the east coast.

I wandered the streets of Stornoway, following in the footsteps of my past. Nothing, it seemed, had

St Michael's Church, Eriskay

St Michael's Church, constructed by fishermen on Eriskay with the proceeds of a single night's catch, plays a vital role in the resolution of the mystery in The Lewis Man. *The story took me to the island to research the history of orphans from the mainland handed over to island families during the 1950s and 60s.*

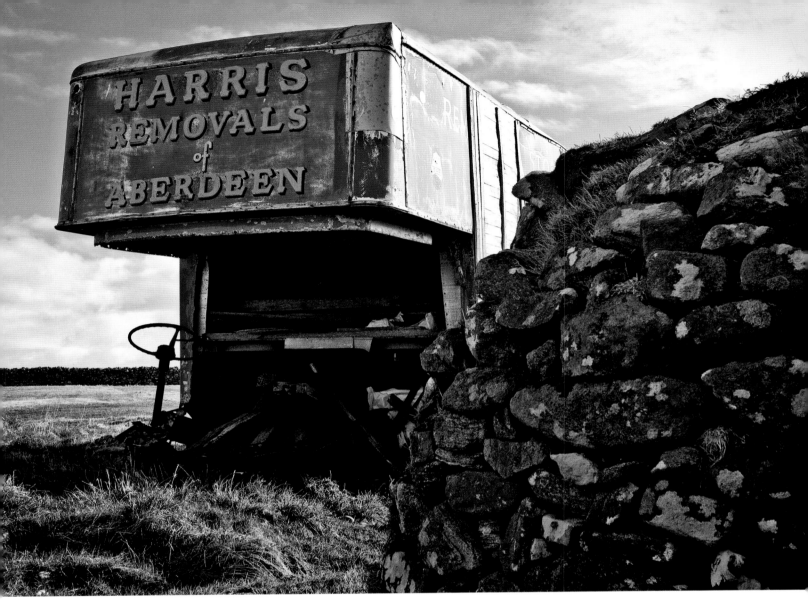

Removal van, Borve

These old wrecks form a crucial part of the visual experience of the Hebrides, becoming landmarks in their own right. This one, to be found at Borve on the west coast of Lewis, presumably marked someone's final move.

HARRIS
REMOVALS
of
ABERDEEN

Old road, Achmore

This is the old road that cuts diagonally across the moor from Stornoway to Achmore, in the centre of the island. The mountains of Uig, in the south-west, can be seen in the distance, and the moor is dotted with old, abandoned shielings. If planners have their way, this landscape will shortly be marred by forests of wind turbines.

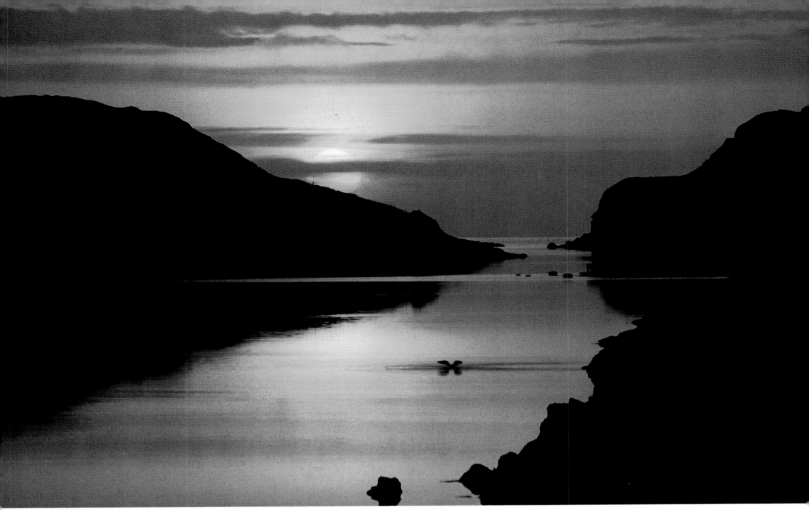

ABOVE **Dawn at Loch Grimshader**

The sun rising at 4 a.m. over Loch Grimshader, seen from the tiny settlement of Ranish. Could the islands offer anything more beautiful?

RIGHT **Golden Road, Drinishader**

This view from Drinishader, on the Golden Road, Isle of Harris, shows the mainland silhouetted faintly along the horizon of this still, blue sea, with the Isle of Skye in the middle distance on the right.

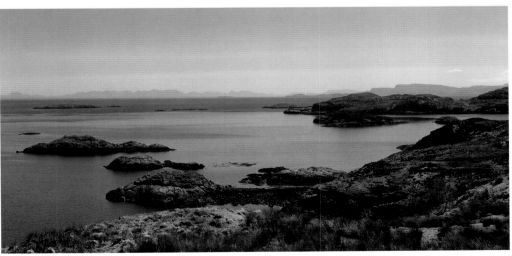

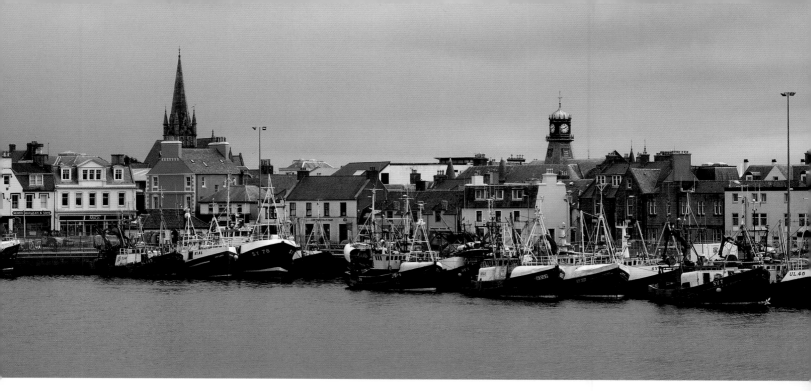

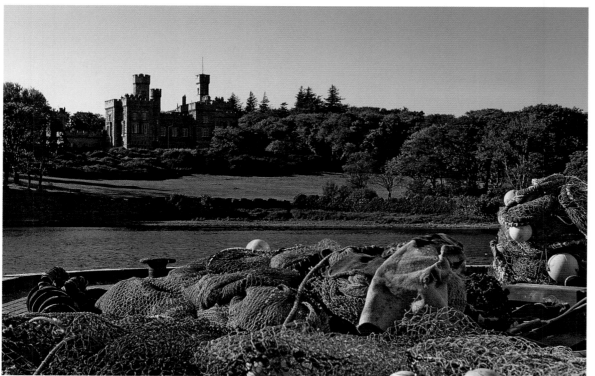

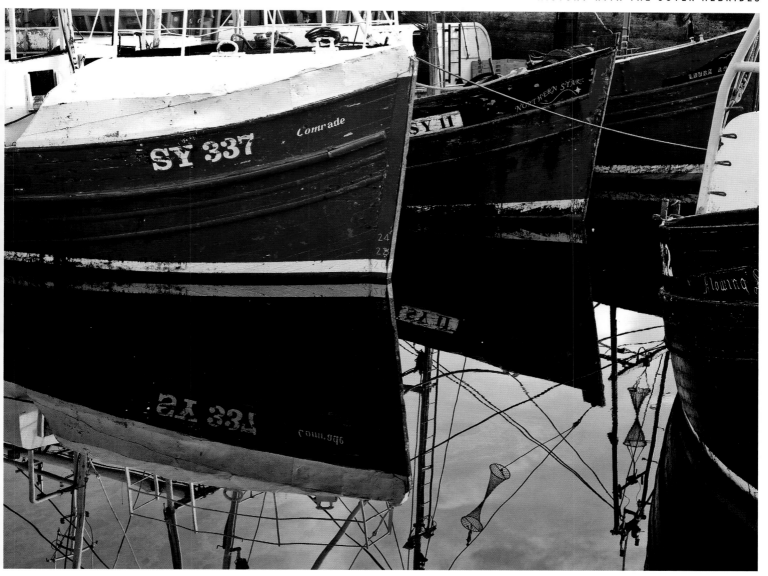

Boats, Stornoway

These boats ply their trade out of Stornoway harbour in all weathers and seasons – a brutally hard life for the fishermen. Prawns are a major catch out in the Minch, and once ashore are despatched down south, or overseas.

changed. Except that now there was a new ferry terminal, a new airport building, and there were Sunday flights and sailings. Pubs and restaurants were open on Sundays, and the Engebrets filling station and mini-market on the road out to the airport had been completely rebuilt. And it, too, had Sunday opening hours.

I walked through the grounds of Lews Castle, an oasis of trees clinging to the sheltered harbour of the only town on these treeless islands. How beautiful Stornoway was from here, with its gaily painted buildings, and its inner harbour filled with colourful fishing vessels. But after my brief dalliance with nostalgia it was back to work. This was, after all, a

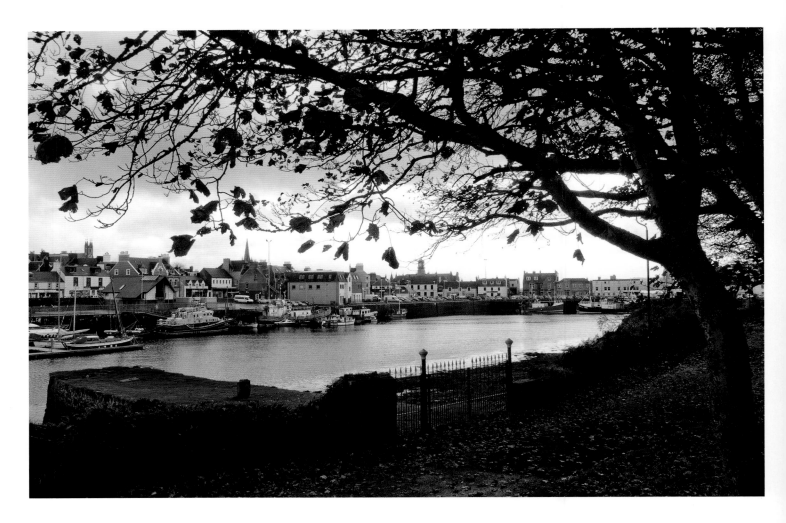

research trip. I visited the police station in Stornoway, its cells and incident room. I went to the morgue at the Islands Hospital, and the autopsy room there.

I went out to the township of Arnol, on the west coast, to remind myself what a real blackhouse was like. At Arnol there are the remains of dozens of blackhouses, but one has been preserved intact, inside and out, almost exactly as it would have been when still inhabited. The blackhouse is a long, low, rounded building with thick interior and exterior stone walls, the cavity between them filled with earth or rubble. The thatched roof comes down to the outer edge of

Stornoway from Lews Castle grounds

The town of Stornoway has changed little in decades. But there are fewer boats in the harbour these days as the fishing industry shrinks. It is seen here from the Woodlands Centre in the grounds of Lews Castle.

Police station, Stornoway

The police station in Stornoway is tucked away on the hill above the harbour, nestling among brightly coloured houses with steeply pitched roofs and dormer windows. When I visited the cells, I asked about the arrow painted on the floor pointing to the letter E. I was told it indicated the direction of east, for worshippers of the Islamic faith. It struck me as ironic that at the time of my visit, on a devoutly presbyterian island, there was a Koran behind the charge bar but the Bible had been misplaced.

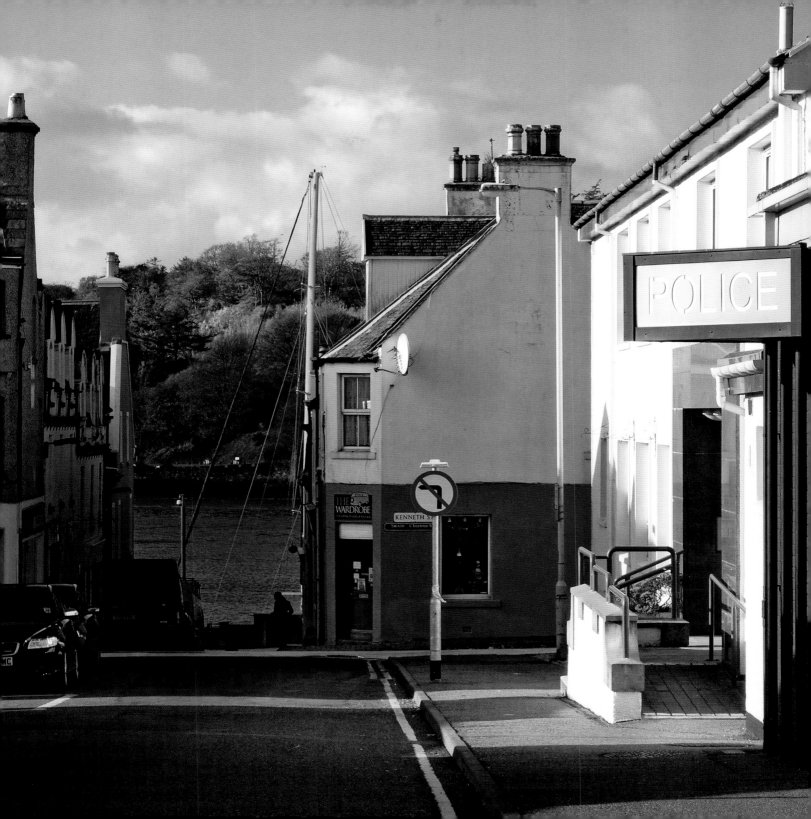

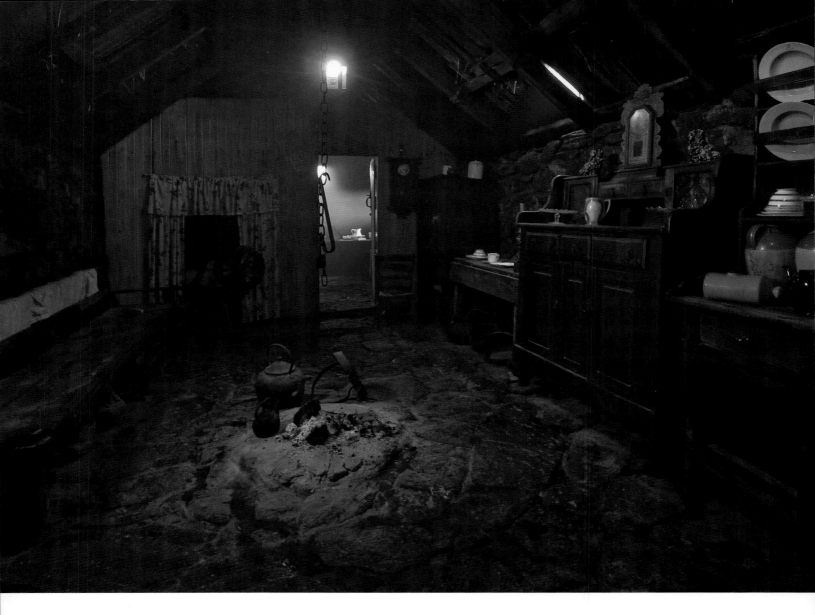

the inner wall, held down by fishermen's netting weighted with stones. It was usually turfed along the top of the two walls, and it would not be uncommon to see sheep grazing along this strip of grass at head-height. Inside, people lived at one end, their livestock at the other. A cosy arrangement, if a bit whiffy.

I interviewed the skipper of the trawler *Heather Isle,* which took the guga hunters of Ness on their annual

Blackhouse interior
The interior of the Arnol blackhouse shows how dark and gloomy life must have been inside, with little or no daylight. A peat fire was kept burning night and day in the centre of the living, or 'fire', room. The house would have been filled with smoke, and light provided by iron lamps burning fish oil.

Preserved blackhouse, Arnol

This blackhouse at Arnol is the most perfectly preserved dwelling on Lewis, and provides a very good idea of how the landscape would have presented itself to the eye in the days when everyone lived in these houses. Incredibly, although almost Stone Age in appearance, this particular house was lived in right up until the 1960s.

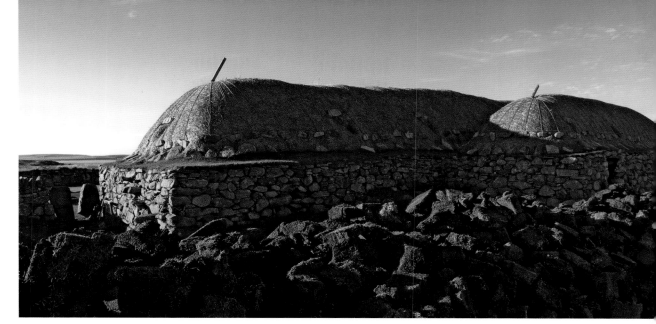

Blackhouse remains, Arnol

The remains of blackhouses are seen all over the islands. These at Arnol are particularly evocative.

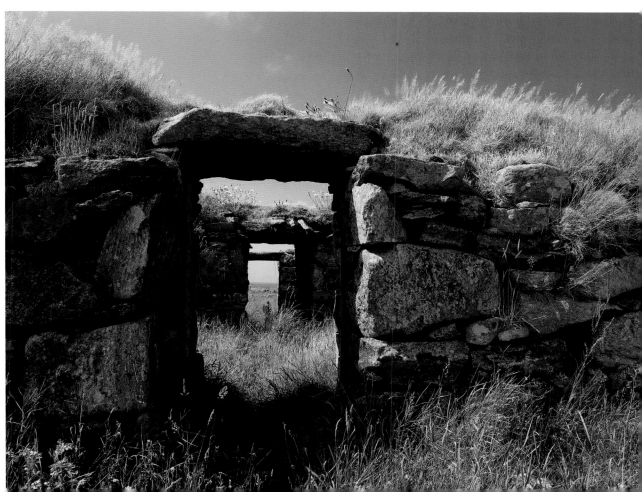

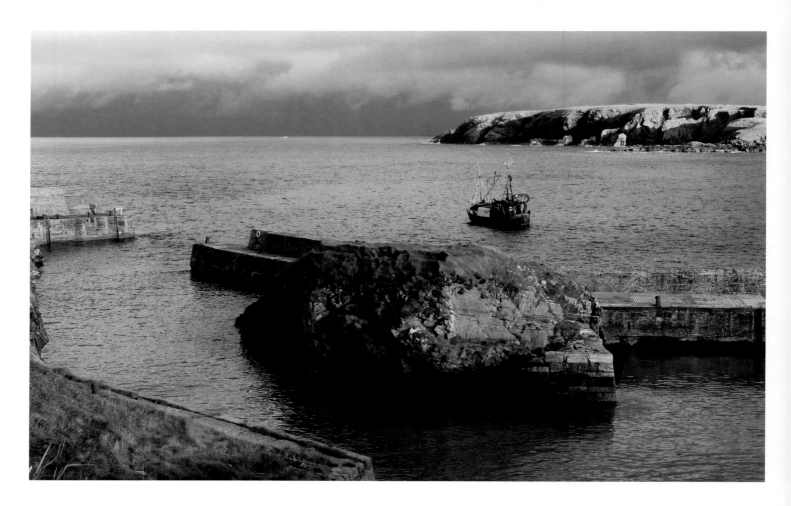

pilgrimage to Sula Sgeir, and two weeks later returned to pick them up along with their harvest of two thousand young gannets, plucked, gutted and pickled in salt. It was an old rust-bucket of a boat, and the wheelhouse was a shambles. But she's still making the journey today. Calum 'Pugwash' Murray was an extraordinary young man, on whom I would base the character Padraig MacBean in the book. Padraig took the story's hero, Fin Macleod, on his final journey out to the rock in the middle of a storm. Calum told me during our interview the story of how he lost his father's boat at sea, and it was a tale I would relate almost word for word in the book.

''Before my father died,' Padraig had to shout above the roar of the engines and the anger of the storm, 'he bought another boat to replace the *Purple Isle*.' He nodded and smiled to himself, keeping his eyes fixed on the screens in front of him and the blackness through the glass. 'Aye, she was a right beauty, too. The *Iron Lady* he called her. He spent a lot of time and money making her just the way he wanted her.' He flicked a glance at Fin. 'There are times you wish it was that easy with a woman.' He turned and grinned back into the darkness, and then his smile faded. 'He was going to sell this old dear when he got the chance. Only he never did. Cancer of the liver.

Heather Isle **leaving Port of Ness**
Here the Heather Isle *is seen leaving Port of Ness to make the perilous journey out to the remote and rocky island of Sula Sgeir in the North Atlantic where it will leave the guga hunters for two weeks to perform their ritual slaughter.*

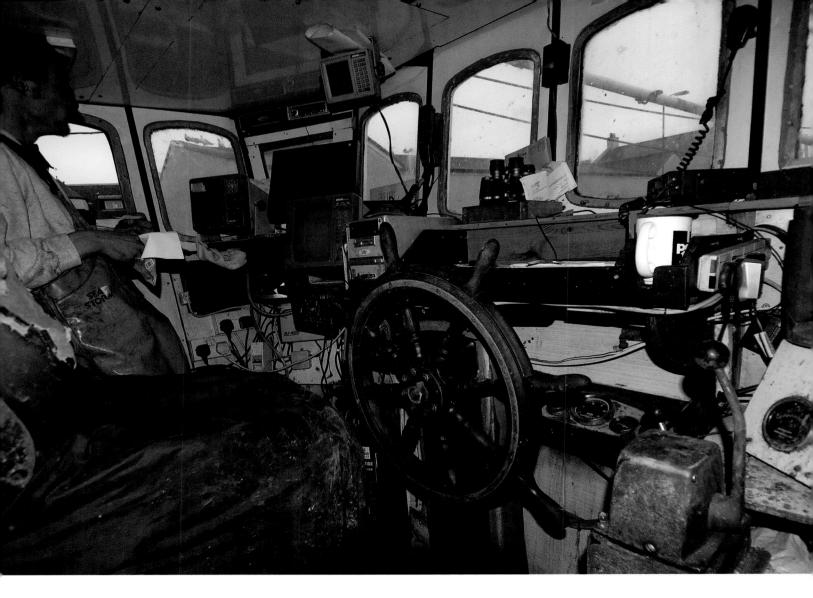

In the wheelhouse of the
Heather Isle
*The interior of the wheelhouse
of the* Heather Isle *is a mess of
wires and torn seat covers, broken
mugs and winking screens. How
any of it functioned was a mystery
to me.*

**Dods Macfarlane at
his day job**
*John 'Dods' Macfarlane has
led the guga hunters out to
Sula Sgeir for more than two
decades. He is pictured here at
his day job, selling foodstuffs
around Ness from the back
of his mobile shop.*

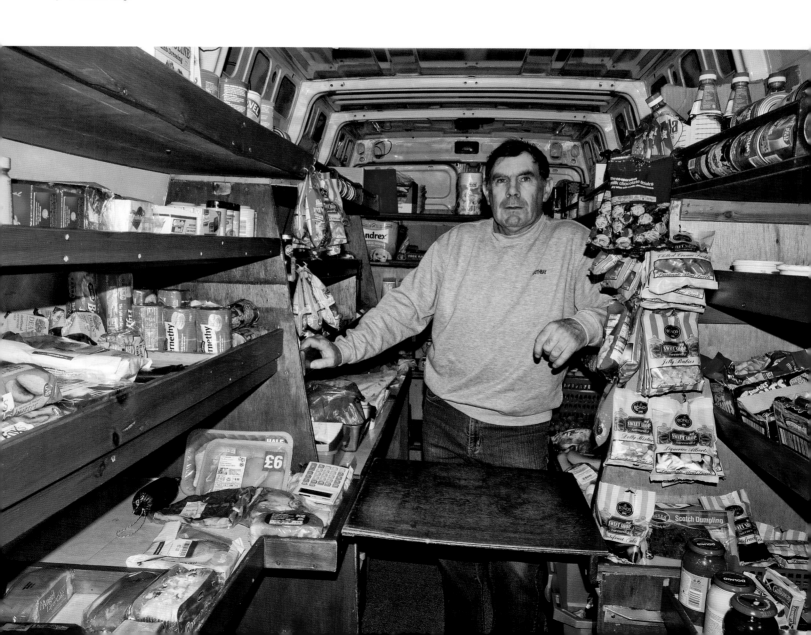

He was gone in a matter of weeks. And I had to step into his shoes.' He took a crumpled-looking cigarette one-handed from a Virginia tobacco tin and lit it. 'Lost the *Iron Lady* first time I took her out. A ruptured pipe in the engine room. By the time we got to it, there was more water coming in than we could pump out. I told the rest of them to get the dinghy out, and I tried everything I could to save her. I was up to my neck in the engine room before I finally baled out. Just made it, too.' Smoke swirled from his mouth in the turbulent air of the wheelhouse. 'We were lucky, though. The weather was good, and there was another trawler within sight. I watched her go down. Everything that my father had put into her. All his hopes, all his dreams. And all I could think was, how was I going to tell my uncles I'd lost my father's boat? But I needn't have worried. They were just glad that we were safe. One of them said, "A boat's just a bunch of wood and metal, son. The only heart it has is in those who sail her." He took a long pull at his cigarette. 'Still, I get goosebumps every time I go over the spot where she went down, and I know she's just lying there on the seabed, right beneath where we last saw her. All my father's dreams, gone for ever, just like him.'"

My next port of call was Ness, and the guga hunters themselves. Their story is one of huge courage and endurance. They are left on Sula Sgeir for two weeks to harvest the birds. There is nothing on the rock except for a small automated lighthouse at one end, and an old ruined dwelling in the centre of it, hundreds of feet up. There is no water, no firewood, nothing. The bird hunters have to take everything with them – food, water, fuel, essential equipment – and haul it up the cliffs to the top of the rock. There they construct a crude roof on the old habitation, and light a fire that will burn for the fortnight and fill the hovel with smoke, driving earwigs out from between the stones. They eat there, and read the Gaelic Bible in the evening as they gather by the fire and sleep on hard stone shelves around the walls. During the day they clamber over cliffs made slippery by guano, attacked by seabirds as they capture and slaughter the young gannets. The birds are snared by a claw on the end of a pole and killed immediately by a single blow to the head, before being beheaded and passed along the line. The white guano turns red with blood. Between harvesting trips the men pluck and gut and singe the birds over fires built on the clifftops. Then they split them and salt them and lay them down in a circle, or wheel, that grows daily until it is several feet high. Then they start another. Sundays are days of rest, and a chance to cook and taste the first of that year's catch.

'That night we had the finest meal of our stay. We ate the first of that year's gugas. By now our supplies were running low. The bread was stale and sometimes mouldy, and always crawling with earwigs. The meat

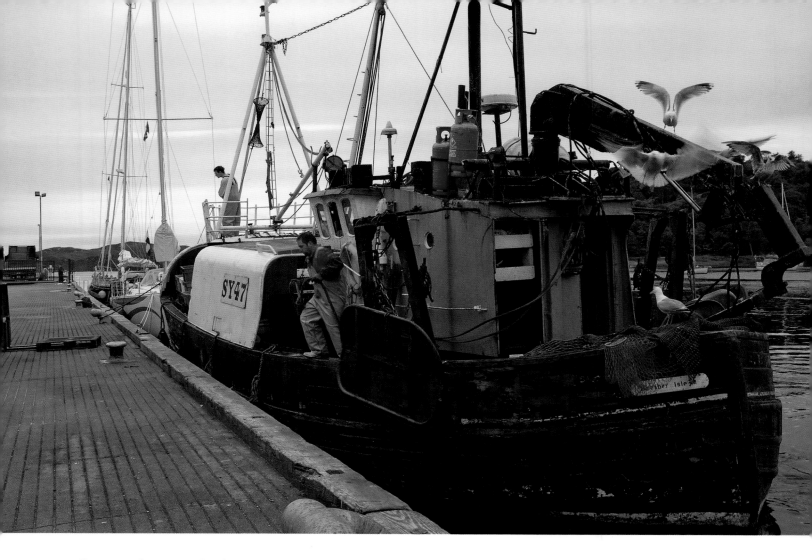

was all eaten, and we seemed to be living on porridge and eggs. The only constant at every meal was the diet of scripture and psalm served up from Gigs's bible. So the guga was manna from Heaven, a reward perhaps for all our piety.'

In the book, I created a fictitious version of events, renaming the rock An Sgeir, which means literally The Rock. But I based it very closely on the actual hunt. I met three of the real hunters at the Ness Social Club, John 'Dods' Macfarlane, Angus 'Bobby' Morrison and Angus 'Angie' Gunn. (It should be

explained that almost everyone on the islands has a nickname. So many of the Christian names and surnames are the same that nicknames are essential to distinguish one person from another. I was once awaiting the departure of a flight at Stornoway airport when an announcement came over the tannoy. 'Would passenger Macleod please come to the ticket desk.' Half the folk in the terminal got to their feet!)

Over several pints of beer and 'haufs' of whisky, I talked to the lads not only about how it was on

The *Heather Isle*, Stornoway

The Heather Isle *returns to Stornoway after collecting the guga hunters from their two-week sojourn on Sula Sgeir.*

Gugas on the boat at Stornoway

This is what the gugas look like when brought back to Lewis following the two-week hunt. Most people baulk at the idea of eating them, but they are much sought-after on the island. I was surprised when trying one myself to find that it was quite palatable. It has the texture of duck and the taste of fish.

the rock, but also what it was like to grow up on the islands. Beachcombing for the detritus washed ashore after a storm. Competition between villages to see who could build the biggest bonfire on Guy Fawkes night. Startling summer sunbathers on the beach at Port of Ness by throwing live crabs on to them from the cliffs. Stories of adventures at school in Stornoway, where the kids from Ness had to board during the week. All of it grist to the mill for this hungry writer. I soaked it all up, and put together with my own knowledge of the island and its

culture, and experiences and characters from my personal past, I quickly found I had the material I needed for the novel I wanted to write. And so *The Blackhouse* was born.

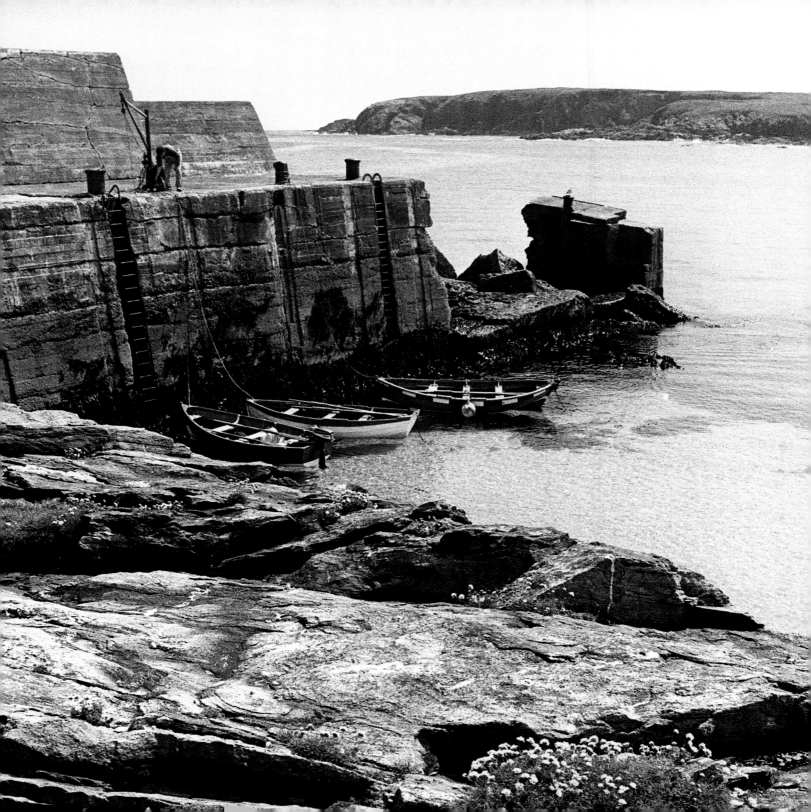

THE BLACKHOUSE

FACING PAGE **Smashed harbour, Port of Ness**
Here we see the damage done to the harbour wall by the sea at Port of Ness before repairs were effected. Sadly this once busy port is very little used now.

Ness is the most densely populated area of the Hebrides outside of Stornoway. It is the bleakest, most windswept and featureless part of Lewis, exposed on three sides to incoming weather from the west, north and east. It presents the most spectacular coastline of rugged cliffs, with an abundance of ragged rocks just offshore that shred the incoming ocean as it drives in on the winds that constantly batter this corner of the islands. But it also has unexpected beaches, often tucked away out of sight, and has bred a hardy but open and welcoming people known in Gaelic as '*niseachs*'. This is the place I chose as my setting for *The Blackhouse*. I didn't want to cause offence by picking on a particular village as the home of the book's main character Fin Macleod, so I created a fictitious village of my own and called it Crobost – after the fictional village we had invented in *Machair*.

RIGHT **Lighthouse at the Butt**
The lighthouse at the Butt of Lewis, at the northernmost tip of Ness, is a beacon of safety for all passing ships. It warns the world, 'Hebrides ahoy!'

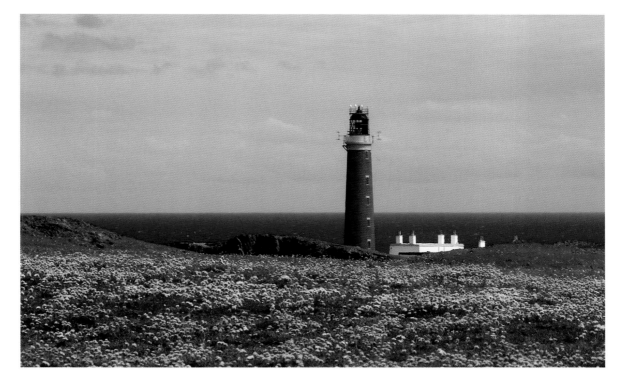

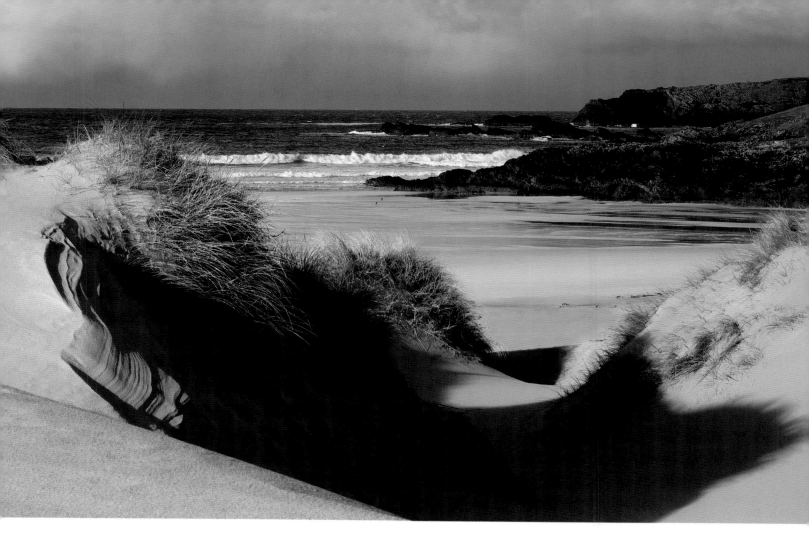

Eoropie, Ness

*Winter at Eoropie in Ness.
This coast faces the full fury
of the Atlantic onslaught.
Although you wouldn't guess
it from the sunshine spilling
across this beautiful sandy
beach, the temperature was
sub-zero at the time this
photograph was taken.*

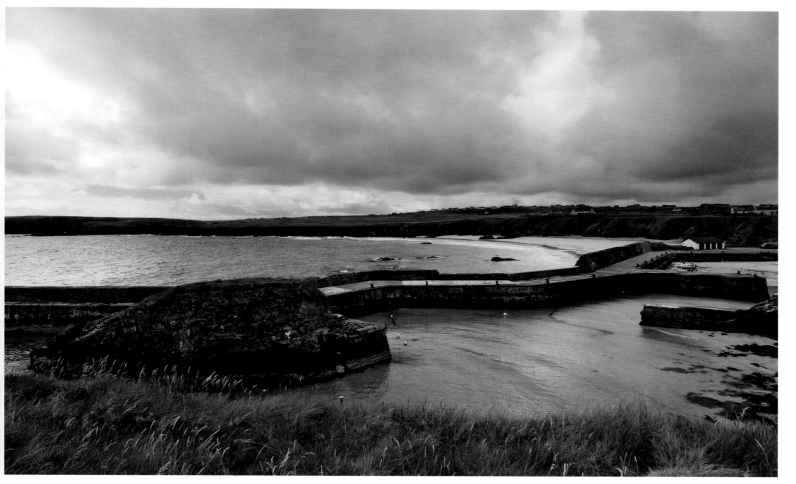

Port of Ness
Here we see the relationship between the harbour (left), the boathouse (right), the beach which curves off into the distance and the houses of the fictitious Crobost strung out along the far horizon.

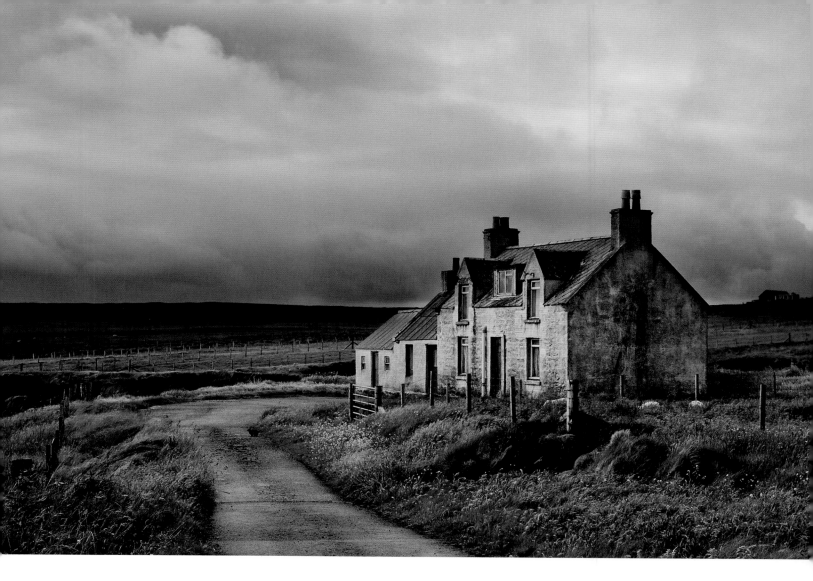

As the basis for the fiction, I picked the settlement of Adabroc, which runs along the crest of the hill above the beach at Port of Ness. I brought the village of Skigersta much closer to create a sort of amalgamation of the two, so that Crobost would be comprised of that string of houses at Adabroc, and the little hidden harbour at Skigersta. The derelict house that sits on the rise above that harbour became the model for Fin's aunt's house, where he goes to live following the death of his parents.

Fin's aunt's house
This is the derelict house overlooking the bay at Skigersta that I used as the model for Fin's aunt's house. I always imagined Fin's bedroom to be the one in the middle, between the two dormers.

I had been in my aunt's house before, and always thought it a cold, miserable place, for all the colourful pots of plastic flowers and fabrics she draped around. There was a chill damp in that house that got into your bones after a while. There had been no fire on all day, and so it seemed even more wretched than usual when she pushed open the door to let us in. The naked bulb in the hall was harsh and bright as we struggled up the stairs with the bag and the case.

'Here we are,' she said, opening the door to an attic room at the end of the hall, sloping ceilings, damp-stained wallpaper, condensation on rusted windows. 'This is your room.' There was a single bed pushed against one wall, draped with a pink candlewick bedspread. A wartime utility wardrobe stood with its doors open, empty hangers and bare shelves awaiting the contents of my case. She hefted the suitcase on to the bed. 'There.' She threw open the lid. 'I'll leave you to put away your things in the wardrobe the way you like. It'll just be kippers for tea, I'm afraid.'

She was almost out the door when I said, 'When will I be going home again?'

She stopped and looked at me. And although there was pity in her eyes, I'm sure there was a degree of impatience there, too. 'This is your home now, Fin. I'll call you when tea's ready.'

She closed the door behind her, and I stood in the cold, cheerless room that was now mine. My sense of desolation was very nearly overwhelming. I found my panda in the bag of toys and sat on the edge of the bed, clutching him to my chest, feeling the damp of the mattress coming through my trousers. And I realized for the first time that day, that my life had changed inexorably and for ever.

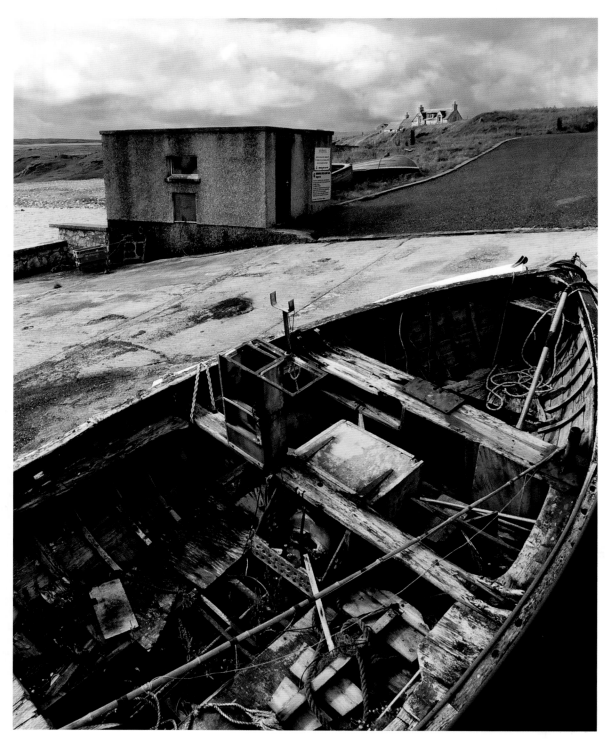

Skigersta harbour
The tiny harbour and slipway at Skigersta. The harled concrete block is the hut that houses the motor used to winch boats up the slipway from the water. Fin's aunt's house is seen in the distance.

Boat hull

Rope coils in the wooden hull of a fishing boat hauled up on to the slipway at Skigersta harbour.

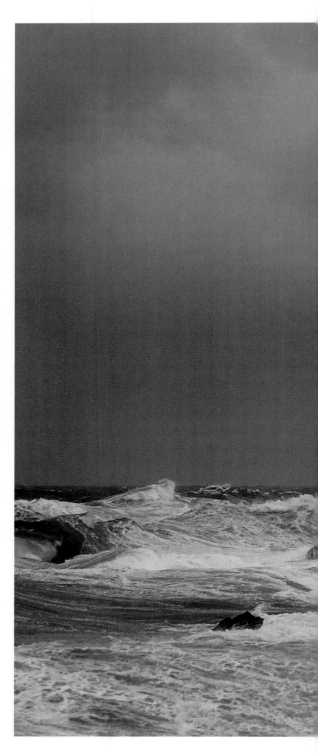

Skigersta cairns
Here is the view, taken on a stormy day, across the bay from the aunt's house at Skigersta. On top of the far cliffs are three cairns (piles of stones) said to have been put there by soldiers returning from the Second World War. No one knows why.

I knew this house well, because when we were filming *Machair* we frequently shot scenes at a house in Skigersta, and the 'chuck wagon' (location catering truck) would park on the tarmac apron in front of the derelict property. Crew and cast used to eat in an old bus that would drive about the islands with us, converted to have tables between rows of seats. The bus would park there, too. In spite of the makeshift nature of the eating arrangements, we actually ate like kings. The quality of the cuisine, produced in all weathers, would have made a Michelin-starred chef jealous. They say an army marches on its stomach. So does a film crew!

The house became a focus for Fin's dislocated childhood. A cold and miserable place, made colder by an aunt who treated him well enough, but never loved him.

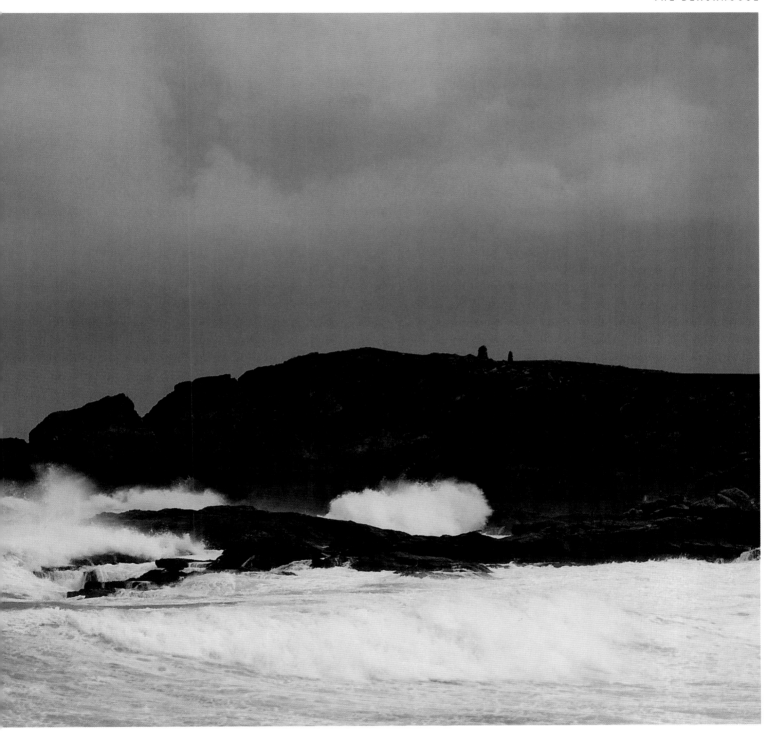

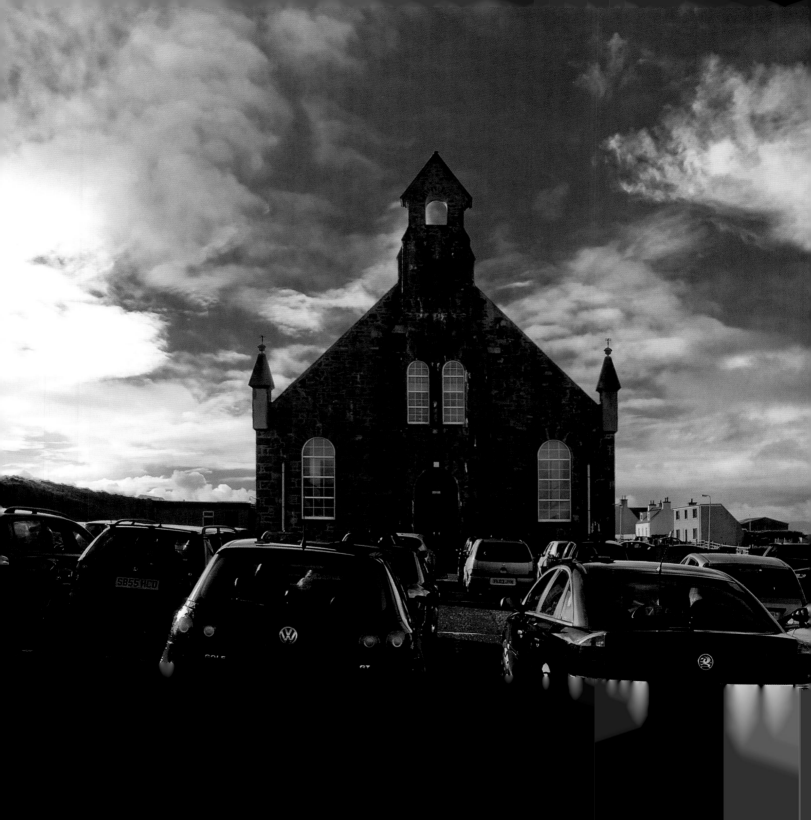

Cross Church
This formidable church building at Cross in Ness, was the model for the church I placed at the fictitious Crobost. The car park is always full on a Sunday, and on a still day the sound of the Gaelic psalm-singing carries a long way across the moor.

There are no churches at either Adabroc or Skigersta, and I felt that Crobost needed a church because one of Fin's enduring friends would be Donald Murray, the minister's son. Donald became one of my favourite characters, conflicted by his upbringing and his instincts to rebel against his father's strict Presbyterianism only to return to the fold in later life, as so often happens, and become a minister himself. So I borrowed the formidable building that houses the Free Presbyterian Church at Cross, and moved it a few miles up the road to the Crobost I was creating on the hill.

133

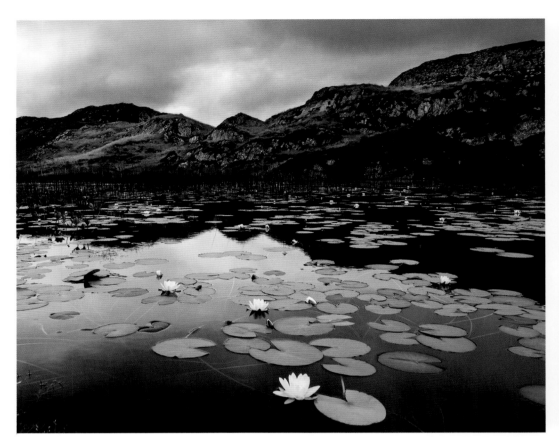

By now Crobost was almost complete. But it still needed a school and a village store. I borrowed both from the village of Lionel. The Lionel store at that time was a wonderful little shop, and passing through its doors was like stepping back in time. It was a positive treasure-trove not only of food but of all those little things you need in daily life. I repositioned it at the foot of the hill where the Crobost road takes a turn up towards the village. On the other side of the main street, a single-track road followed a straight line down to Crobost Primary School, which was in fact Lionel School, providing education for the seven years of primary and the first two years of secondary. It was here that Fin met the love of his life on his very first school day – Marsaili Macdonald.

In fact, Marsaili was based on a little girl called Jennifer whom I met on my first day at primary school. She, too, lived on a farm, and just like Fin, I ignored my parents' instructions, and walked the several miles to her farm every Saturday morning to play cowboys and Indians with her in the barn – until being found out!

When *The Blackhouse* was about to be published, I went to considerable lengths to track down 'wee Jennifer' to tell her that our childhood exploits were going to appear in a book. I was puzzled when, at first, I couldn't find any trace of her. I did, however, finally find her – in the register of deaths. The wee lassie I had fallen for on that first school day had died even before the book was written.

ABOVE LEFT **Water lilies at Calbost**
I have always associated lilies with death and funerals. But here on the islands these water lilies are to be found growing on the surface of literally hundreds of tiny lochs. They are very evocative. These particular flowers were shot at Calbost in the lochs region of south-east Lewis.

ABOVE RIGHT **Water lily close up**
Seen close up, these water lilies really are the most beautiful flowers.

It was cold and starting to rain, and I pulled up my hood, stealing a glance at the girl with the pigtails. They were blowing out behind her in the wind, and she seemed to be enjoying the sting of it in her face. Her cheeks had turned bright red. 'Marjorie.' I raised my voice above the wind. 'That's a nice name.'

'I hate it.' She glowered at me. 'It's my English name. But nobody calls me that. My real name's Marsaili.' Like *Marjorie*, she put the emphasis on the first syllable, with the *s* becoming a soft *sh*, as it always does in the Gaelic after an *r*, a Nordic inheritance from the two hundred years that the islands were ruled by the Vikings.

'Marsaili.' I tried it out to see if it fitted my mouth, and I liked the sound of it fine. 'That's even nicer.'

She flicked me a coy look, soft blue eyes meeting mine for a moment then dancing away again. 'So how do you like *your* English name?'

'Finlay?' She nodded. 'I don't.'

'I'll call you Fin, then. How's that?'

'Fin.' Again, I tried it out for size. It was short, and to the point. 'It's okay.'

'Good.' Marsaili smiled. 'Then that's what you'll be.'

And that's how it happened that Marsaili Macdonald gave me the name that stuck with me for the rest of my life.

Half a dozen small boats were pulled up along the edge of the slipway, angled against the foot of the cliff, one behind the other. Fin recognized the faded sky-blue of the *Mayflower*. Hard to believe it was still in use after all these years. Above the winchhouse, the skeleton of a boat long since fallen into desuetude lay tipped over, keelside up. The last flakes of purple paint lay curling along her spine. Fin stooped down to wipe away the green slime covering the remaining planks on her bow and saw there, in faded white letters, his mother's name, Eilidh, where his father had carefully painted it the day before he launched her. And all the regrets of his life rose up inside him like water in a spring, and he knelt beside the boat and wept.

Skigersta harbour, now Crobost harbour, became a location I visited again and again through all three books. One particularly poignant moment caught me completely off-guard as I was writing. Fin had stopped off to revisit old haunts – his aunt's (now derelict) house and the harbour. And there, by the concrete hut that houses the harbour's winch motor, Fin found the old boat his father had built when he was just a child, and named after Fin's mother, Eilidh. Rotting now, only a few flakes of the purple paint he had used on it still clinging to the planking. I had not storylined this, nor even anticipated it. It crept up on me unawares and left me sitting in front of my keyboard in tears.

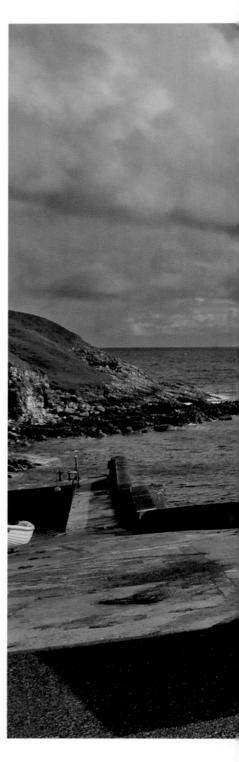

Purple boat at Skigersta
This is exactly the spot, behind the winchhouse at Skigersta harbour, where I imagined Fin stumbling across his father's old boat. Here we have cheated a little, employing the wonders of digital technology to colour the nearer boat purple, just as it is in the book.

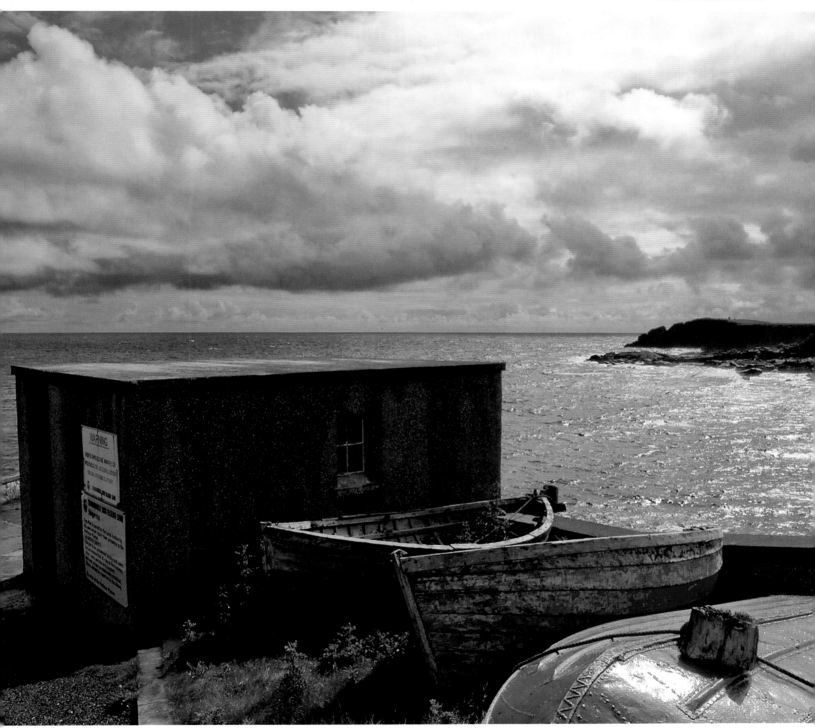

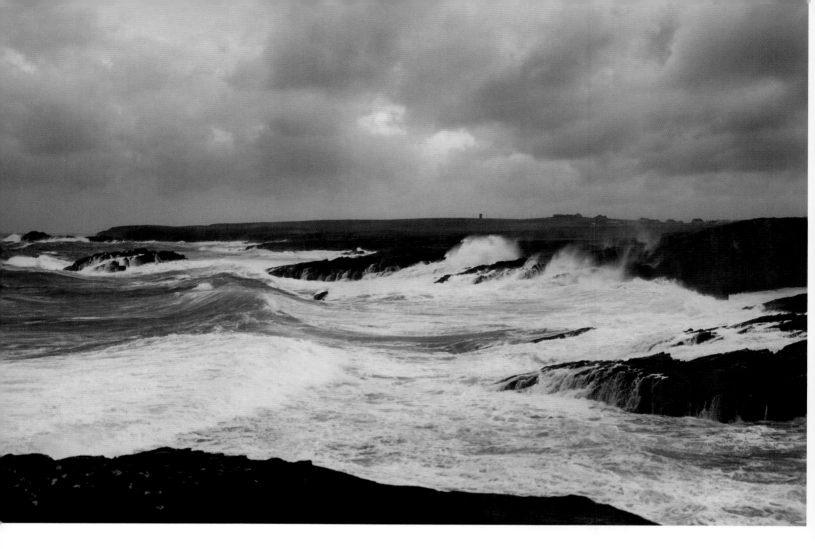

Port of Ness, which had been my very first stop on the islands all those years before, became the location for my murder scene. The boathouse at the port is set a little apart from the harbour, and overlooks the stretch of golden sand that arcs away towards the cliffs at the far end. At the time of writing, it was pretty much open to the elements at one end and the walls were covered in graffiti. The part of it where the boats were kept had doors on it, and it was in here that two hormonal teenage kids looking for privacy on a Saturday night found the murder victim strung up from the rafters.

Storm at Ness
Storm-force winds send wild seas crashing all along the coastline at Ness. The houses silhouetted on the horizon could even be those of Crobost. But in fact they are part of the township of Fivepenny.

The crime scene
Here is the exact space where the body was discovered, inside the boathouse at Port of Ness. This photograph was taken some years ago, showing the original graffiti. It has since been considerably smartened up.

The man is hanging by his neck from the rafters overhead, frayed orange plastic rope tilting his head at an impossible angle. He is a big man, buck naked, blue-white flesh hanging in folds from his breasts and his buttocks, like a loose-fitting suit two sizes too big. Loops of something smooth and shiny hang down between his legs from a gaping smile that splits his belly from side to side. The flame sends the dead man's shadow dancing around the scarred and graffitied walls like so many ghosts welcoming a new arrival. Beyond him Uilleam sees Ceit's face. Pale, dark-eyed, frozen in horror.

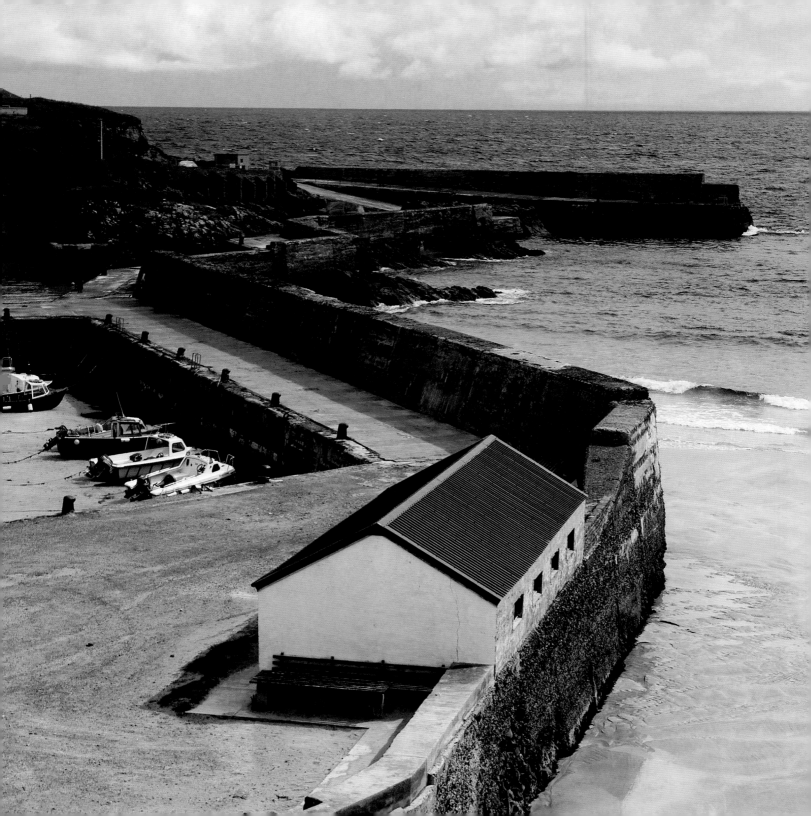

The boathouse
*The white building in the
foreground is the boathouse at
the harbour at Port of Ness where
the body was discovered at the
opening of* The Blackhouse.
*The harbour wall zig-zags away
in two parts beyond it.*

Ancient graffiti
*Past exponents of the art of
graffiti, showed considerably more
talent and imagination than
their successors, as evinced here in
this shot of carefully chiselled
names in the harbour wall at
Port of Ness. Donald Macleod
could quite possibly have pursued
a career as an engraver.*

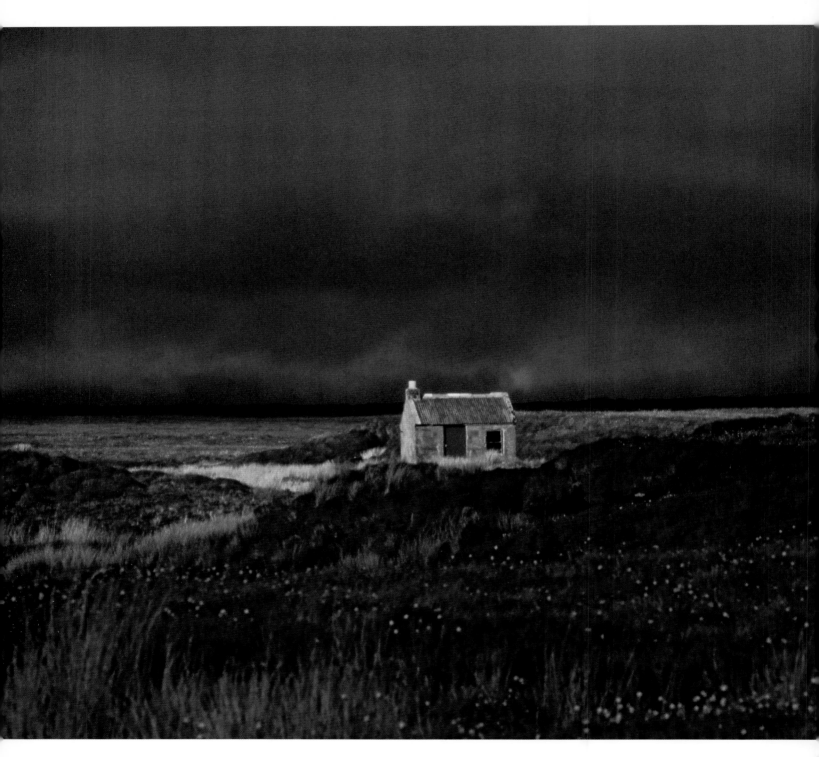

I was in shock. All that day the house seemed full of people. My aunt, some distant cousins, neighbours, friends of my parents. A succession of faces fretting and fussing over me. It is the only time I ever heard any explanation of what happened. My aunt never spoke to me about it once in all the years I lived with her. Someone said – I have no idea who, just a voice in a crowded room – that a sheep had jumped up from the ditch, and that my father had swerved to avoid it. 'By that shieling on the Barvas moor, you know, the one with the green roof.'

Shieling with the green roof

This shot of the green-roofed shieling was captured some years ago as unexpected sunlight suddenly threw it into sharp relief against the blackest of skies behind it. A print of this picture hangs proudly in the front room of my house.

One of the best-known landmarks on the Isle of Lewis is notable if only for its insignificance. It is an old shieling that sits some way back from the road that crosses the moor between Barvas on the west coast and Stornoway on the east. The shieling can be seen about halfway across the Barvas moor. But what makes it stand out is its brightly painted green corrugated iron roof. I passed it many, many times going to and from location during the *Machair* years, and when I came to write *The Blackhouse* it took on even greater significance as the spot where Fin's parents' car left the road as they were returning from a dance in Stornoway.

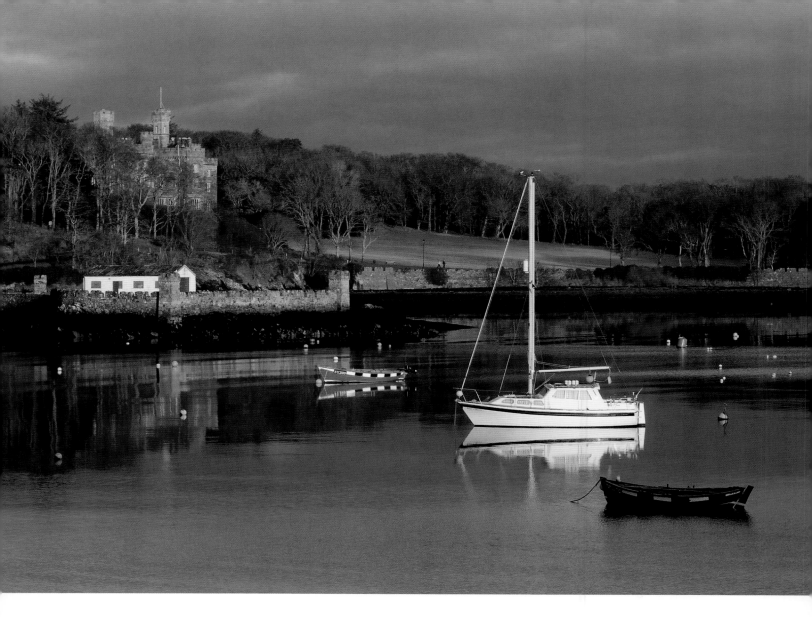

The town of Stornoway also features strongly in the book. It is from the harbour here that the guga hunters now leave and return, following the damage done to the harbour at Ness. The police, of course, are based here, and it was in Stornoway that Fin and his friends from Ness all went to school.

Fin being among the better qualified of his schoolfriends went to the Nicolson Institute, and stayed during the week at the nearby student accommodation. His best friend Artair, and some of the other characters, went to the more vocationally oriented Lews Castle College. And it was on the roof of the castle, during a foolish teenage prank, that an incident occurred that was to marr the remainder of Fin's teenage years, and left one of his friends crippled for life.

Lews Castle

This is one of my favourite photographs of the mock Tudor Lews Castle, taken on a still, frosty morning.

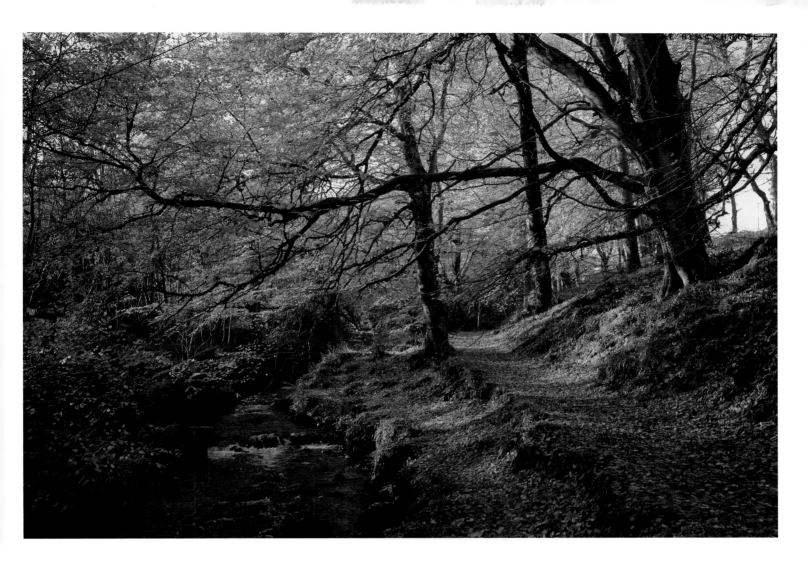

Lews Castle grounds

A most unusual sight on any of the islands: mature trees in full autumn colour shading a leafy path in Lews Castle grounds.

It is an extraordinary building of pink granite, with turrets and towers and crenellated battlements. It dominates the hill above the harbour, and is probably the most unlikely thing you will see on any of the islands that make up the Hebridean archipelago. Of course, in those days, I didn't know the full history. Lews Castle was just there, as if it had always been there. You accepted it, the same way you accepted the cliffs that ringed the Butt, or the fabulous beaches at Scarista and Luskentyre.

145

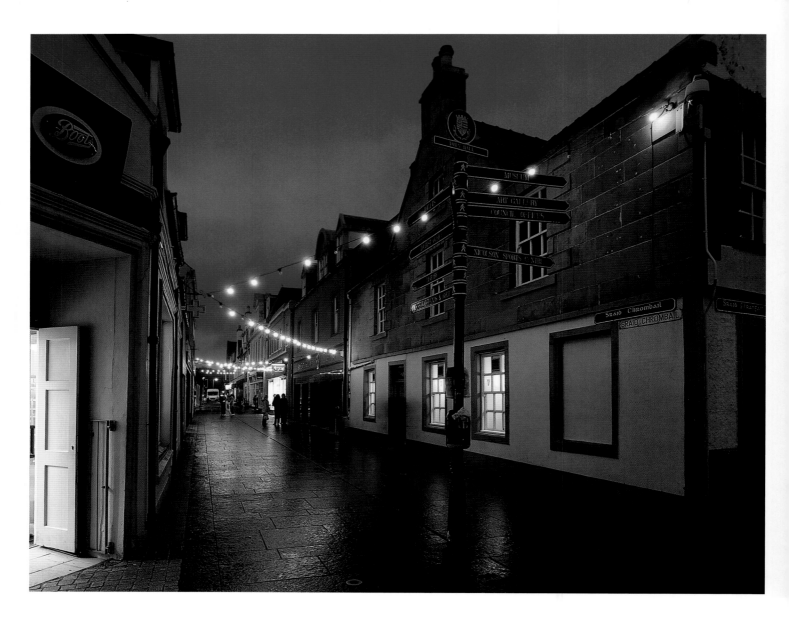

Still in town, Fin found himself in a showdown confrontation with the brother of the murder victim, a bully of a man who had made his childhood in Ness a misery. Their fight, which begins in McNeil's pub, spills out into what are known as The Narrows, where teenagers with nothing better to do hang out on Friday and Saturday nights.

McNeil's and The Narrows
McNeil's pub on the corner of Cromwell Street and Francis Street in Stornoway was the scene of a violent but short-lived fight between Fin and the bully who tormented him all through his schooldays.

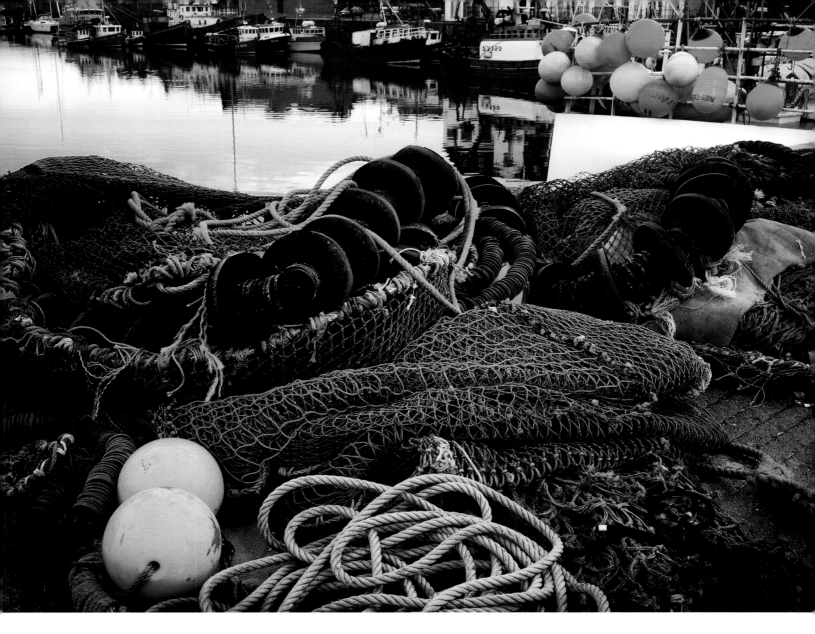

**Fishing nets,
Stornoway harbour**
*Just across the water from Lews
Castle a jumble of nets, ropes
and buoys litter Stornoway's
inner harbour.*

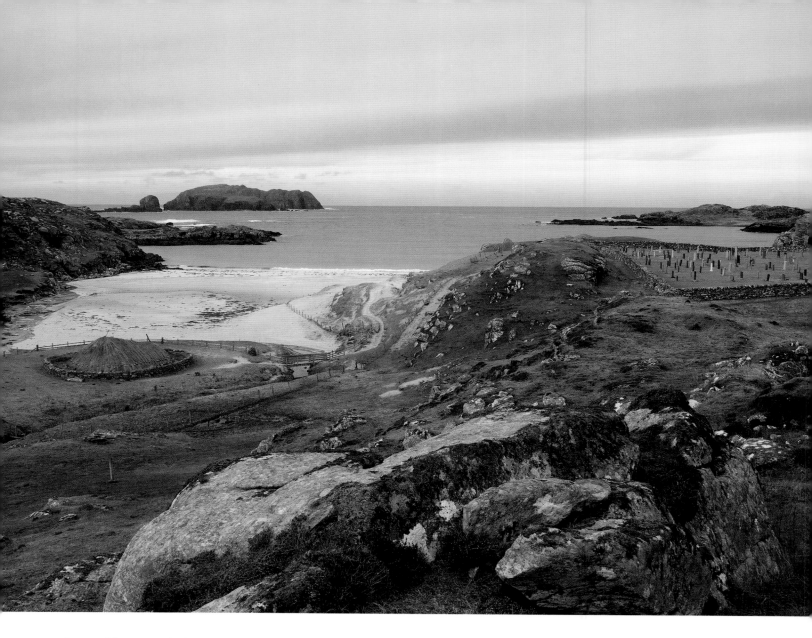

Most of the story of *The Blackhouse* revolves around Ness, Stornoway and my fictitious version of Sula Sgeir. But I made two other forays out into the island. One took a teenage Fin and his friends to a small island off the west coast, near Great Bernera, for the party of their lives. It is where Fin has his first puff of marijuana, and where he loses his virginity to Marsaili. He, Donald and others drive down the west coast in a red, open-topped car that Donald has acquired from the mainland (open-topped cars are rare beasts on the islands, for obvious reasons). Before they leave, Donald takes Fin's aunt out for a drive in it, allowing her for a moment to revisit the heady days of her youth just a few weeks before she dies.

Bosta, Bernera

Great Bernera also plays host to this Iron Age dwelling, pictured earlier, and one of those ubiquitous beachside cemeteries.

Croir crossing to Little Bernera

Donald would have parked his red soft-top at the bottom of the hill here, and he and Fin and the others would have been ferried from Croir at the eastern tip of Great Bernera, off the west coast of Lewis, across to the distant sandy beach of Little Bernera, where the party was held – bonfires on the beach and barbecues burning late into the night.

My aunt was an enigma, one of the great unexplored mysteries of my life. She loved the car. I suppose it must have appealed to that long-lost free spirit in her. She asked Donald if he would take her for a ride, and he told her to jump in. I sat in the back as he tore up the cliff road and over to Skigersta, sparks flying from the cigarette my aunt insisted on trying to smoke. Her hair blew back from her face to reveal its fragile, bony structure, crêpe-like skin stretched tight over all its slopes and angles, like a death-mask. And yet I don't think I had ever seen her so happy. When we got back to the house there was a radiance about her, and I think she almost wished she was going with us. When I looked back as the car slipped over the brow of the hill towards Crobost she was still standing, watching us go.

The second foray takes Fin and his sidekick, Detective Sergeant George Gunn, on a drive down to Uig to question a suspect – James Minto, an ex-soldier who was employed by the local estate to catch poachers.

Minto's house
This might or might not have been the house which inspired the location for Minto's cottage, sitting as it does almost on the sands at Uig beach.

Raindrops

Drops of rain on this tiny loch reflect an approaching storm. An island story told by a few concentric circles.

Minto's crofthouse was a former holiday let set amongst the dunes at the end of the shore road. It looked out over the whole expanse of Uig beach, from the distant ocean in the west to Uig Lodge in the east, an impressive hunting lodge that stood in splendid isolation on a bluff overlooking the sands, mountains rising behind it in layer upon undulating layer of pastel purple and blue, like paper cut-outs laid one behind the other. Immediately opposite, on the far side of the beach, was a collection of white-painted buildings at Baile na Cille, the birthplace of the Scottish prophet Kenneth Mackenzie.

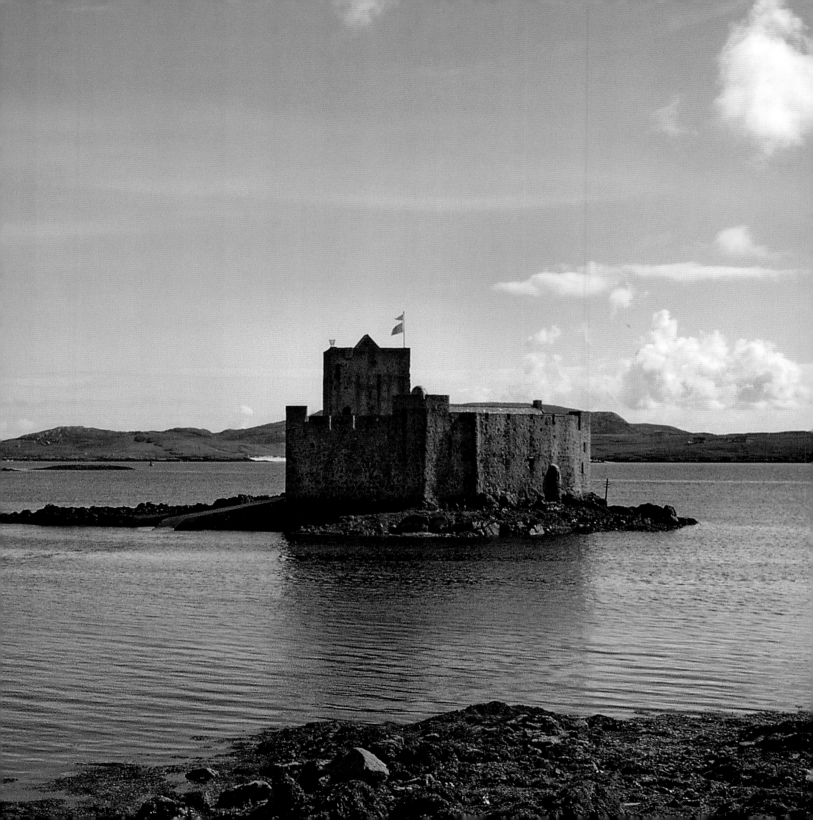

THE LEWIS MAN

This second book in the trilogy took both Fin and myself on a trip that extended almost the entire length of the Outer Hebrides, from Ness at the most northern point, to Eriskay at the most southern. The one major Hebridean island that did not feature in *The Lewis Man*, and indeed has not appeared in any of the books, is Barra. The omission was not deliberate, simply a case of where the story took me – and since some of the events that shaped the story are based on historical fact, the decision on which islands would be involved was effectively out of my hands.

I do, however, have a very personal relationship with the Isle of Barra. I first went there in the 1970s, when working as a reporter for *The Scotsman*. I was sent out to cover the opening of the new airport terminal on the island. What I didn't know before setting off was that the 'terminal' was little more than a hut, and that the small aircraft that operated the schedule – an 18-seater Trilander in those days – actually landed on the beach.

Imagine my surprise, then, when we came in to land and all I could see as we approached was water. I really thought we were going to ditch in the sea. And then suddenly the aircraft's wheels hit solid ground – or at least the hard, compacted shells left by the outgoing tide.

RIGHT **Barra 'airport'**
The schedules for landing on the beach at Barra are determined by the tides. Here, the 19-seater De Havilland Canada DHC-6 Twin Otter aircraft operated by FlyBe for Loganair has just landed at Barra.

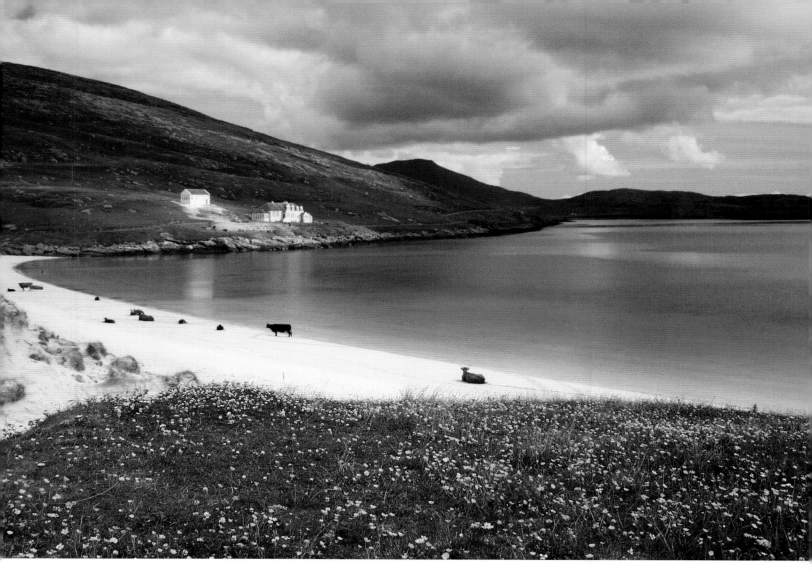

My other, more recent, sojourn on the island was in the company of my wife, in an attempt to track down the origins of her great-grandmother, a MacNeil, which is the clan name of Barra. With little more than family legend to go on, we had managed to track down her movements through the various census statistics published by the Records Office in Scotland. It led us to Barra where it seems she had been a young serving girl working in a 'big house' somewhere on the island. She had become pregnant and left for Greenock on the mainland, and given birth in a convent. A single surname mentioned on the birth certificate gave a possible clue as to who the father had been. In a café in Barra's main town, Castlebay, we sat and talked to a local expert on Barra history who pointed us in the direction of a big house on the island of Vatersay, attached to Barra by a causeway. The young girl, it appears, might have been made pregnant by her employer and immediately sent to the mainland to avoid a scandal. We are still working

Vatersay beach

Cows enjoy a spell of sunbathing on the beach at Vatersay, Barra, not far from the 'big house' where my wife's ancestor might have worked.

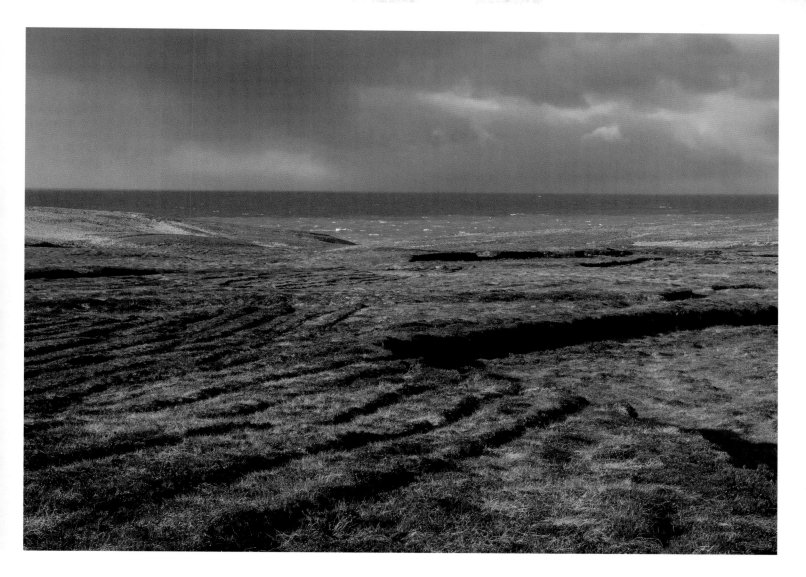

Peat bog

Here, peat cutters on the west coast of Lewis have carved their presence into the landscape, with the Atlantic simmering darkly in the background. In such a place the body was discovered in The Lewis Man.

to verify this story, but during our visit found the remains of what might have been that 'big house'.

The story of *The Lewis Man*, however, opens far away to the north, when the perfectly preserved body of a young man is recovered from a peat bog at Shader, near Ness. At first it is believed to be a 'bog body' dating back 2,000 years or more – until the pathologist conducting the autopsy discovers a tattoo of Elvis Presley on the right forearm. What had appeared to be an historical find turns into a murder investigation.

Fin conducts the investigation, but much of it unravels through the memories of a man suffering from dementia. This is, in fact, Marsaili's father Tormod. For background I drew very heavily on my experiences of looking after my own father during the last years of his life when he became completely lost in his dementia. The closeness with my father, and my growing understanding of the way his mind was working, helped me step into Tormod's shoes and tell his story in the first person. It was a story that took me on a research trip right down the spine of the archipelago.

The journey began in Eoropie, Ness, where Tormod and his wife had retired to a cottage after giving up the let on their farm. The lighthouse at the Butt was visible to him during the many hours he spent gazing from the window, lost in the labyrinth of his mind. It then led me back to the beach at Dalmore, a little further south on the west coast, where Fin takes Tormod walking in an attempt to waken old memories.

The next stop was the Isle of Harris and the extraordinary beaches at Luskentyre and Scarista. Then on to the Church of Scotland church at

BELOW LEFT **Lighthouse, Butt of Ness**
This is the lighthouse at the Butt of Ness, seen in an earlier chapter but from another viewpoint. Here, we see the buildings that provide a home for the keeper and his family, and the offices that administer it.

BELOW RIGHT **Stream, Dalmore beach**
A stream cuts its way through the sand to the sea at Dalmore beach, leaving a trail like a tyre track.

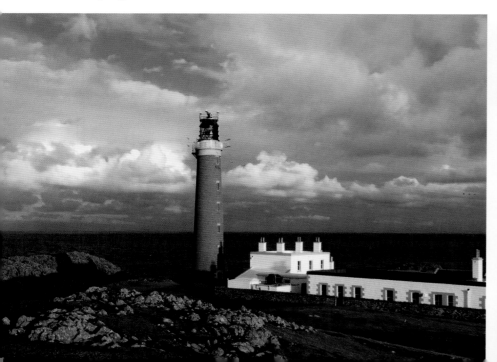

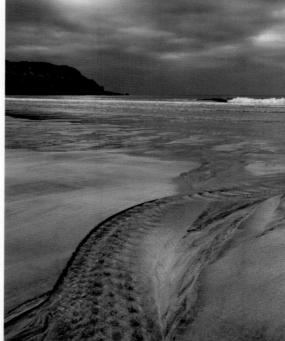

On the sand below the reinforcements at the cemetery wall, he spreads the travelling rug he took from the boot of the car, and we sit down. He has some bottles of beer. Cold, but not chilled. All right, though. He opens a couple and passes me one, and I enjoy that stuff foaming in my mouth, just like the very first time on the roof of The Dean.

The sea's a bit wild out there in the wind, breaking white all around those rock-stacks. I can even feel a hint of spray on my face. Light, like the touch of a feather. Wind's blown all the clouds away now. There were days out on the moor I'd have killed for a piece of blue sky like that.

Luskentyre beach
Luskentyre in glorious sunshine. Beautiful stripes of blue and gold, and two birds basking in the foreground.

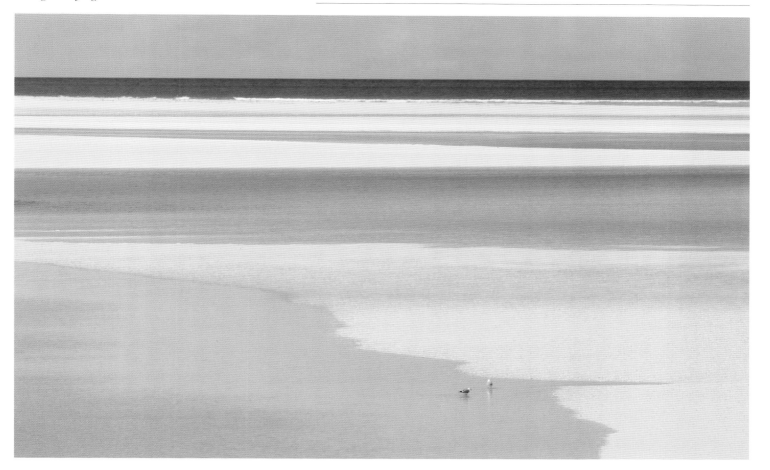

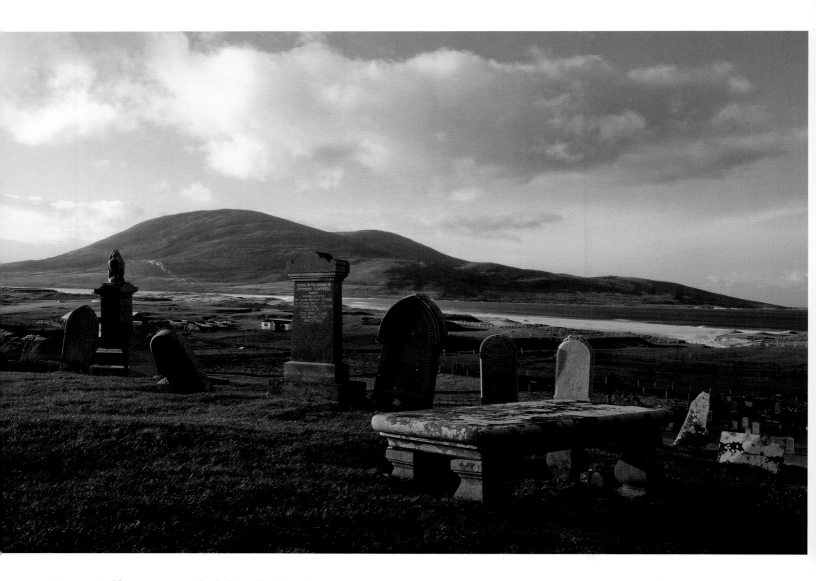

Scarista itself, sitting up on the hill overlooking the beach. Fin and Detective Sergeant George Gunn make an important and startling discovery in the graveyard there. It is a unique cemetery, built on the slope of the hill, with headstones and crosses leaning at odd angles, and a view from eternity that would be enough to make the living jealous.

My journey south was broken at Leverburgh, at the south-west end of Harris, where I had to wait for a ferry to take me across the Sound of Harris to the

Scarista graveyard

There is something very evocative about this cemetery at Scarista. Some people would die for a view like this!

Fin and Gunn drove through the gloom of gathering storm clouds, wind and rain sweeping down off the ragged mountain slopes, and crossed into Harris just before Ardvourlie, where a solitary house stands out on the broken shores of Loch Seaforth.

From there the road rose steeply, carved out of the mountainside, a spectacular view opening out below them of the black, scattered waters of the loch. Snowpoles lined the road, and the mountains folded around them, swooping and soaring on all sides, peaks lost in cloud that tumbled down the scree slopes like lava.

And then, suddenly, as they squeezed through a narrow mountain pass, a line of golden light somewhere far below dimpled the underside of the purple-black clouds that surrounded them. A tattered demarcation between one weather front and another. The grim gathering of cloud among the peaks fell away as the road descended south, and the southern uplands of Harris opened out ahead.

Luskentyre at low tide
This is another example of how different the islands can appear in changing light. Here we see the tide receding in the Luskentyre estuary.

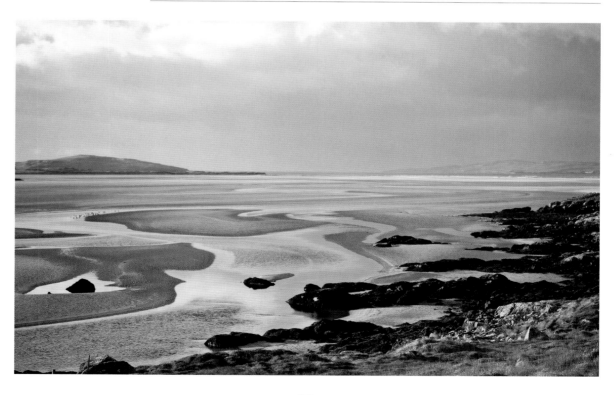

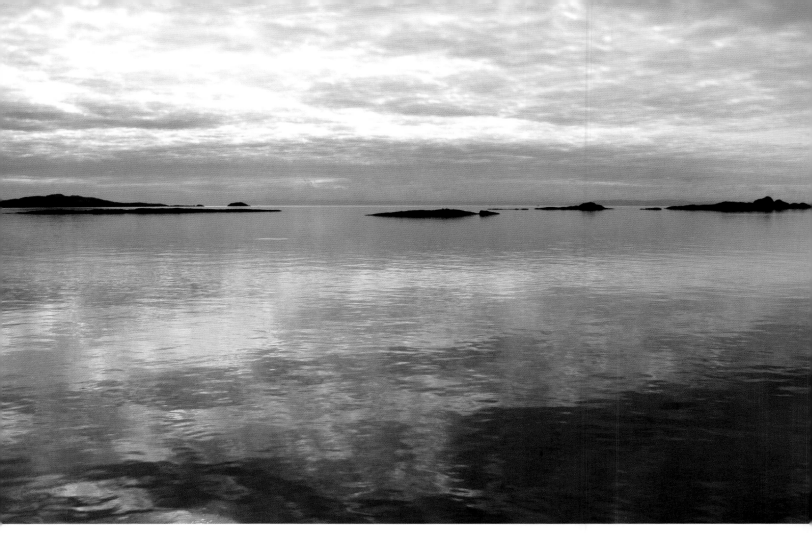

Isle of Berneray, which is linked to North Uist by a short causeway. I relived that sailing with Fin aboard the *Loch Portain*. Strangely, the experience described in the following extract has been repeated on almost every other sailing I have made across this beautiful but treacherous stretch of water.

Like Fin I was now into virgin territory. I had never been to the Uists before, and North Uist made a big impact.

This was a new experience for me. A different landscape. I couldn't resist writing about it in the book, describing it for readers, so that they could

Sound of Harris
I found this crossing between Harris and Berneray almost spooky. It is also very dangerous. The water is shallow and littered with rocks. The ferry has to follow a long loop to avoid them.

The one-hour crossing from Harris to Berneray drifted by like a dream. The ferry seemed almost to glide across the mirrored surface of the Sound, drifting past the spectral islets and rocks that emerged phantom-like from a silvered mist. Fin stood on the foredeck, grasping the rail, and watching clouds like brushstrokes leaving darker streaks against the palest of grey skies. He had rarely seen the islands in such splendid stillness, mysterious and ethereal, without the least sign that man had ever passed this way before.

Finally the dark outline of the island of Berneray loomed out of the gloom and Fin returned to the car deck to disembark at the start of his long drive south. This disparate collection of islands, which had once been miscalled the Long Island, was now largely connected by a network of causeways bridging fords where once vehicles could only pass at low tide. Only between Harris and Berneray, and Eriskay and Barra, was it still necessary to cross by boat.

Berneray
The little island of Berneray where the ferry from Harris docks. Debouching vehicles cross a short causeway to reach North Uist. The mountains of South Harris are seen here in the background.

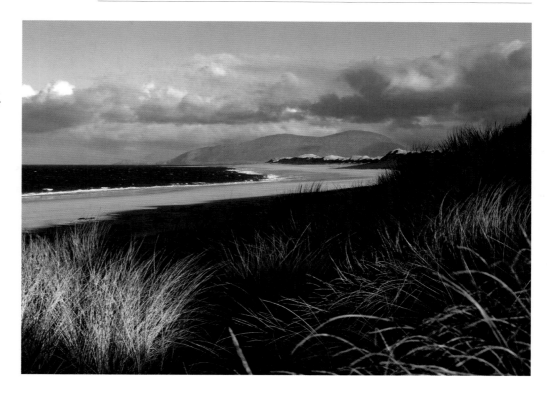

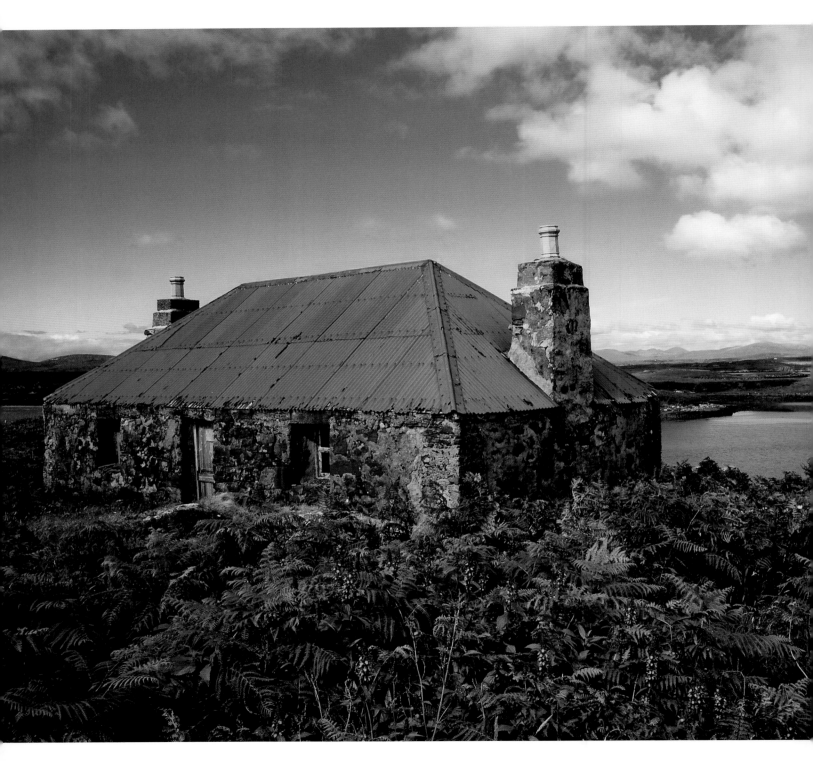

North Uist presented a dark, primal landscape. Soaring mountains shrouded in cloud that poured down their slopes to spread tendrils of mist across the moor. The skeletons of long-abandoned homes, gable ends standing stark and black against a brooding sky. Hostile and inhospitable bogland, shredded by scraps of loch and ragged inlets. The ruins of all the failed attempts by men and women to tame it were everywhere in evidence, and those who remained were huddled together in a handful of small, sheltered townships.

North Uist

North Uist on a sunny day presents quite a different aspect from the dark face of it I have seen on many journeys south.

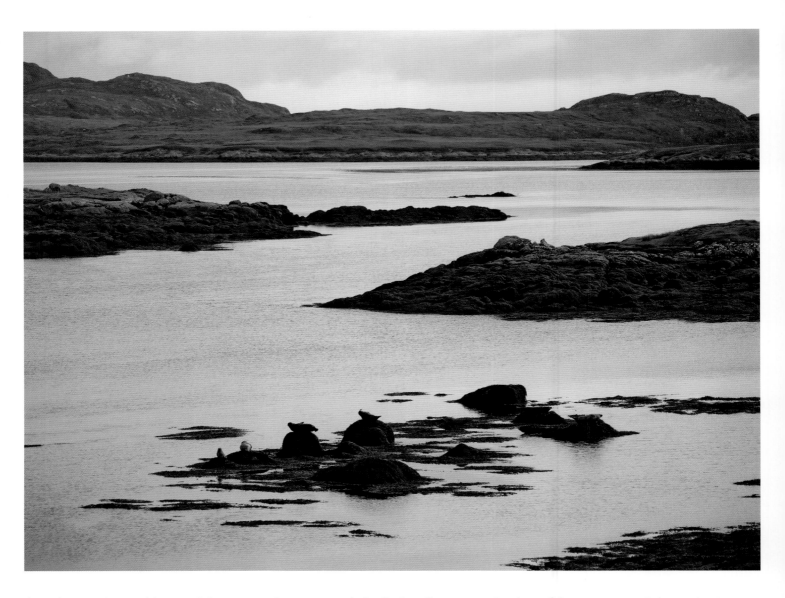

share the experience with me as I drove across the causeway to Benbecula, and in no time over another to South Uist. And there was a sense, when reaching that southern island, of light and space opening up around me, and the claustrophobia of the north giving way to easy breathing and a relaxation of the tension that had accompanied the gloom. I had been to Benbecula only once before, and that had been to watch the final performance at the close of the Gaelic Youth Theatre summer school at Lionacleit. A memorable trip, for it was there that I had found the group of young actors who would become the core cast of the Gaelic TV drama *Machair*.

I was making this journey to South Uist and on to Eriskay because of something I had heard twenty years before. Something which had stayed with me all

Seals at South Uist
Seals bask on the rocks of Loch Eynort on the east side of South Uist.

**Interior of a derelict
blackhouse, South Uist**
*This wreck of an old stove
was all that remained in the
interior of this derelict
blackhouse on South Uist.
The pans on the hotplates
were exactly as found.*

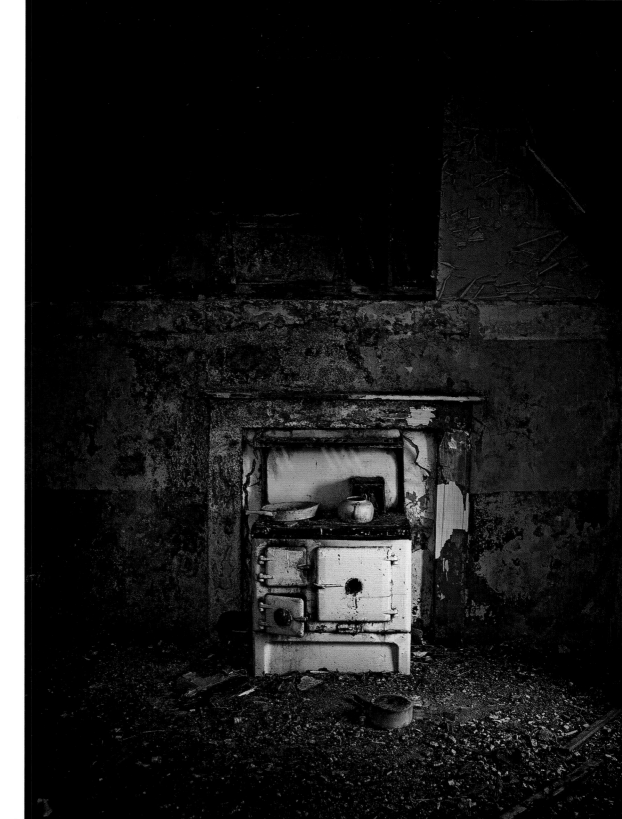

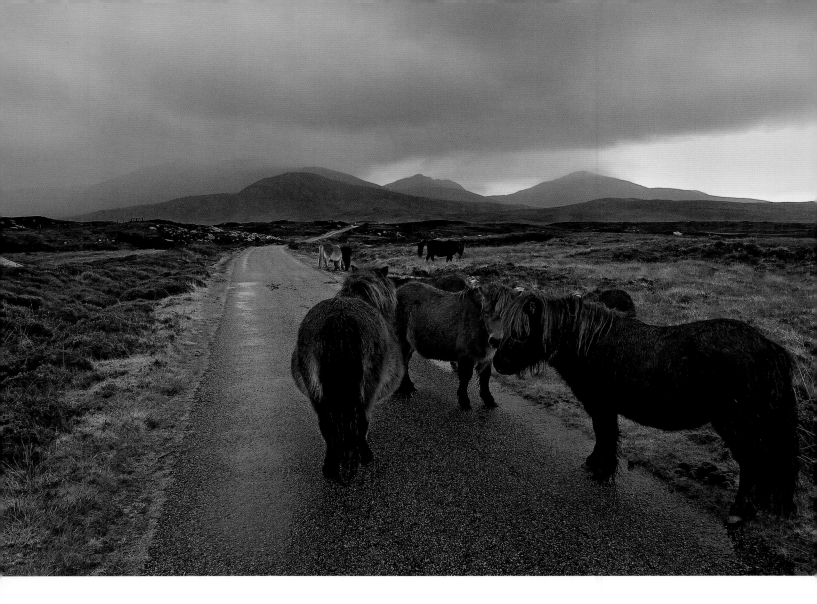

South Uist ponies on a wet day

Shetland ponies graze freely in South Uist. Beyond them, the mountain in the middle is Beinn Corradail, with Beinn Mhòr on the right and Maoil Daimh on the left.

Further south, over yet more causeways, the island of Benbecula, flat and featureless, passed in a blur. Then somehow the sky seemed to open up, the oppression lifted, and South Uist spread itself out before him, mountains to the east, the fertile plains of the machair to the west, stretching all the way to the sea.

The cloud was higher now, broken by a rising wind, and sunlight broke through to spill itself in rivers and pools across the land. Yellow and purple flowers bent and bowed in the breeze, and Fin felt his spirits lifting. He drove past the turn-off to the east coast ferry port of Lochboisdale, and away off to the west he could see the abandoned sheds of the old seaweed factory at Orasay, beyond a walled Protestant cemetery. Even in death, it seemed, there was segregation between Catholics and Protestants.

South Uist salt marsh
With this frozen salt marsh in the foreground, the view here is to the north, through a blink of sunlight, to the lowering cloud that hangs over Beinn Mhòr.

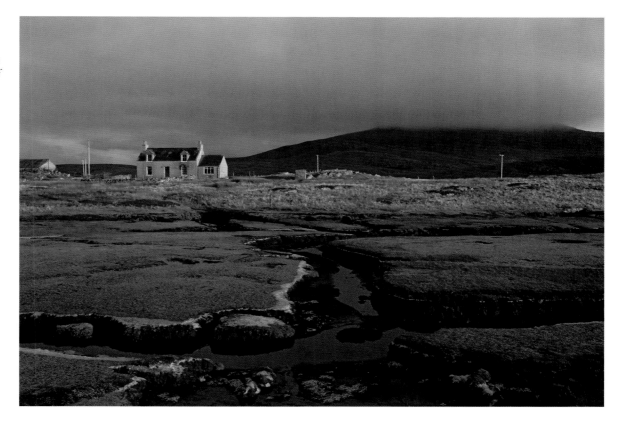

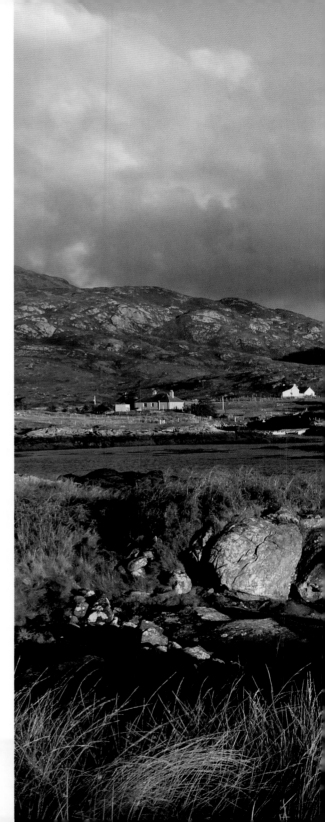

Ben Kenneth

Ben Kennethor or in Gaelic, Beinn Ruigh Choinnich, is the mountain that looms over the South Uist port of Loch Boisdale. It is where the orphaned 'homers' from the mainland were unceremoniously deposited on the pier to meet their future families. It is also where sailing ships dropped anchor in the nineteenth century to take on board the hundreds of tenant crofters who were being brutally cleared off their land by unscrupulous landlords.

that time, and which had come bubbling back to the surface when I began developing the story of *The Lewis Man*.

It was around 1991, and I was casting *Machair*. I had met for the first time an actress called Alyxis Daly whom I cast in the role of Morag, who was to become one of the series' favourite characters. Alyxis was born on Eriskay and grew up in South Uist. She said to me, 'Peter, have you ever thought of writing a drama about the homers?' I frowned. I had no idea what 'homers' were. And it was then that she explained to me that homers were orphan children taken from orphanages on the mainland and sent out to the southern islands of the Outer Hebrides, primarily by the Catholic Church. They were given into the care of families and individuals without any background checks, and many of those poor children were subsequently treated little better than slaves. They arrived by ferry at the port of Lochboisdale, and were left standing on the pier with the names of the families who were to become their keepers written on cards hung from their necks. I was shocked and asked Alyxis how she knew of all this, and that was when she revealed to me that her own father had been a homer.

In the book, two teenage brothers and a young girl are brought to South Uist, then boarded with families on Eriskay. On a very recent visit there I met an old

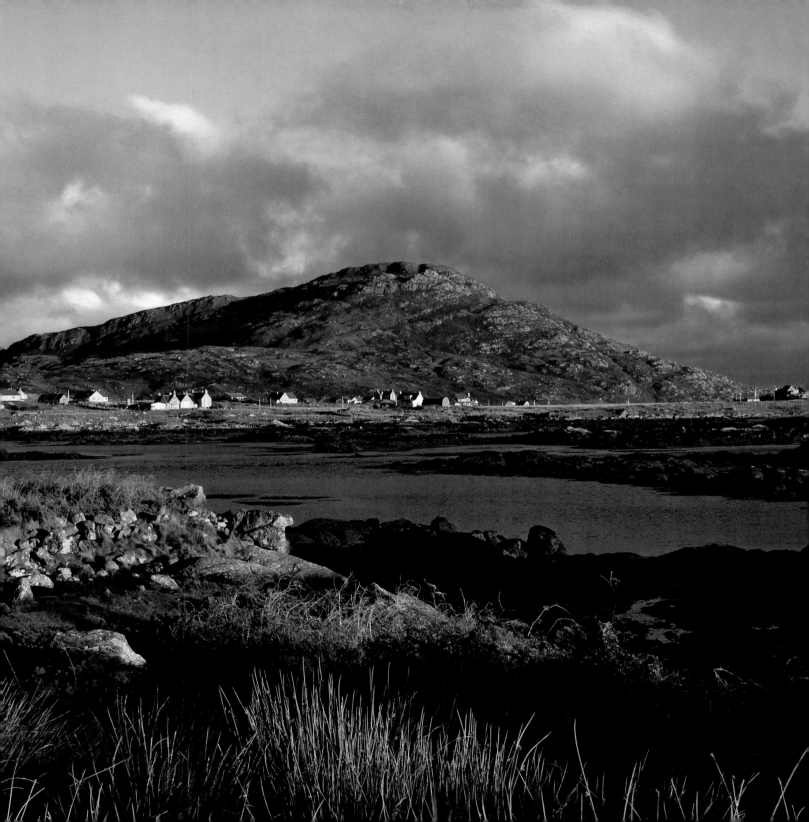

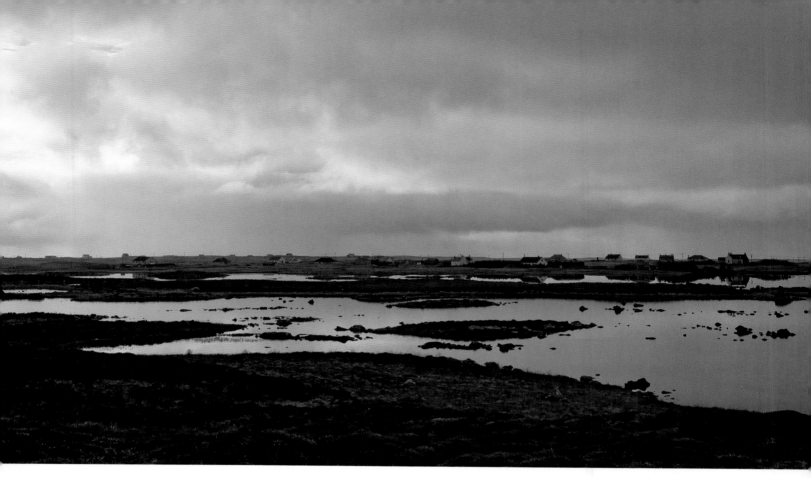

ABOVE **Threatening sky, South Uist**
A dark and brooding landscape on the west side of South Uist with a typical sky looming ominously overhead.

RIGHT **Abandoned boat**
A boat left to rot on the machair of South Uist.

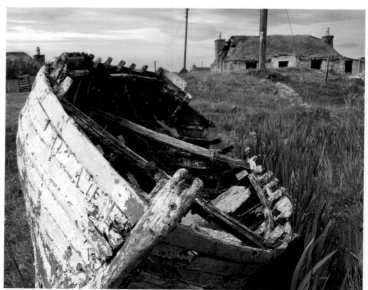

South Uist, Loch Eynort
*The more rocky, mountainous
east side of South Uist presents
quite a different scene. Here a
blue sky reflects on the still
water of Loch Eynort, with
Seabhal hill in the background.*

As the crowd thinned, heading for buses and cars, and darkness fell across the hills, we took out our little rectangles of cardboard and hung them around our necks, just as the nuns had instructed. And we waited. And waited. The lights started to go out on the ferry behind us, and the long shadows we had cast across the pier vanished. One or two people threw curious glances in our direction but hurried on. Now there was almost no one left on the pier, and all we could hear were the voices of the sailors on the ferry as they prepared her to spend the night at dock.

A feeling of such despondency fell over me as we stood there alone in the dark, the black waters inside the protective arms of the harbour slopping against the stanchions of the pier. The lights of a hotel beyond the harbour wall looked warm and welcoming, but not for us.

Then out of the darkness a figure emerged, hurrying along the pier towards us. She slowed as she reached us, a look of consternation on her face, and she bent to peer at the cards around our necks. Her frown vanished as she read the name O'Henley on Catherine's, and she gave her a good looking over. A hand came up to grip her jaw and turn her face one way, then the other. And then she examined both her hands. She gave us barely a glance. 'Aye, you'll do,' she said, and took Catherine's hand to lead her away.

man who had arrived on the island with his brother in the 1950s, just as the characters in *The Lewis Man* had done. He said to me, 'I read your book. It rang a bell. And as I read on all the hairs stood up on the back of my head.' I was very moved by that. For although the experience, as I wrote it, was imagined, I must have come pretty close to the truth.

Haun Pier, Eriskay
This is the pier at Haun on Eriskay where Tormod (better known as Johnny) and his brother, Peter, arrived on a dark night after being picked up from the quayside at Lochboisdale.

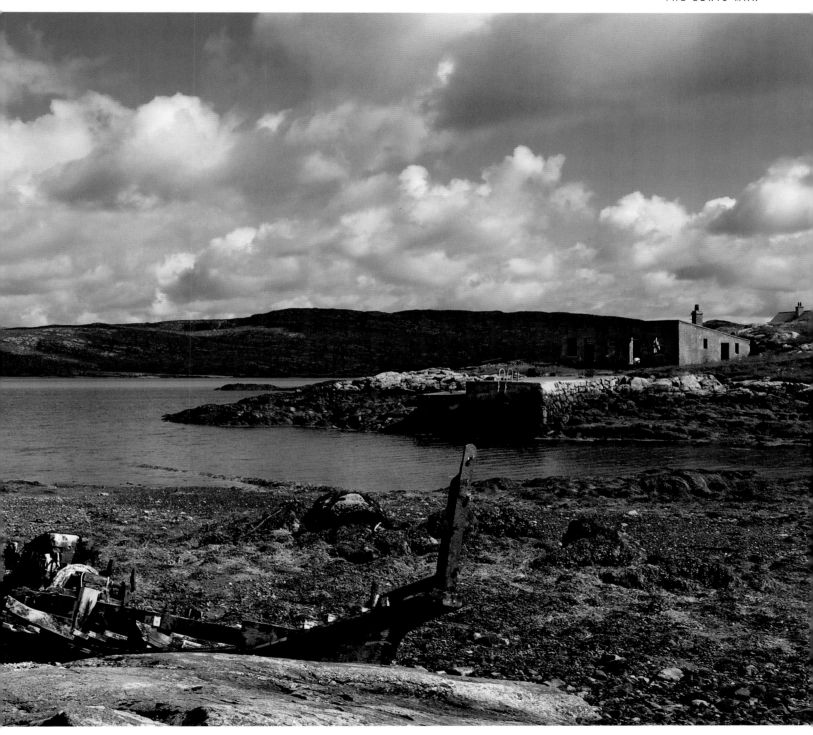

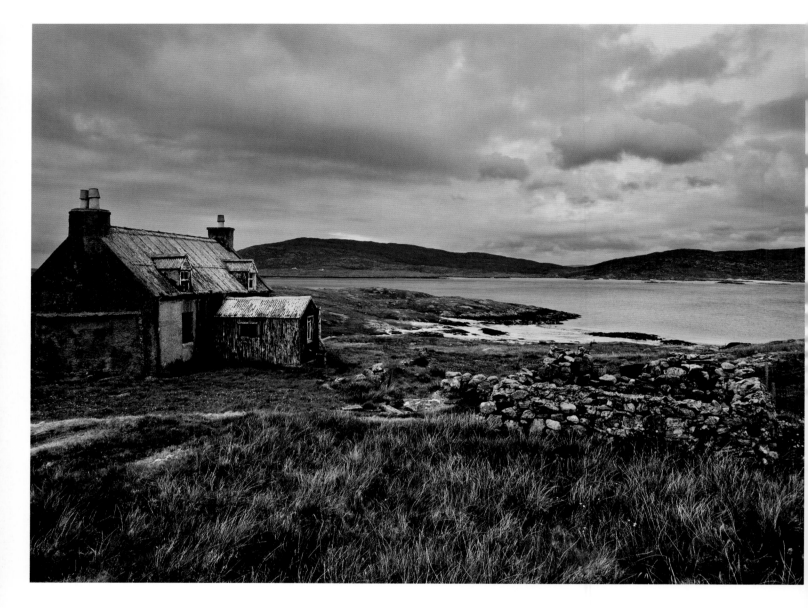

Johnny's home, Eriskay
*This derelict croft house at the
north end of Eriskay could well
have been the home where
Johnny and Peter grew up
through their teen years. It has a
beautiful view across the Sound
of Eriskay to South Uist.*

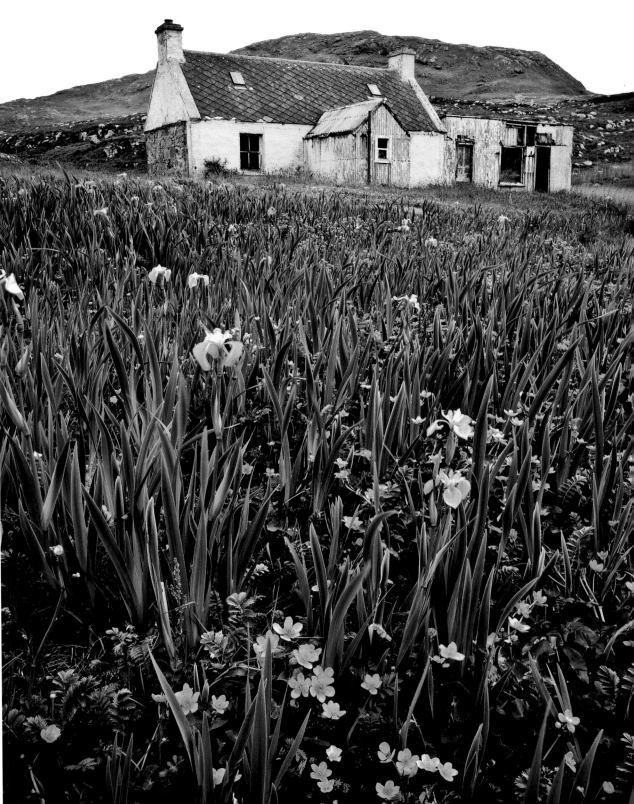

Ceit's home, Eriskay
This is the old post office that overlooks Haun harbour on Eriskay. It might have been the house where Catherine/Ceit spent her adolescence.

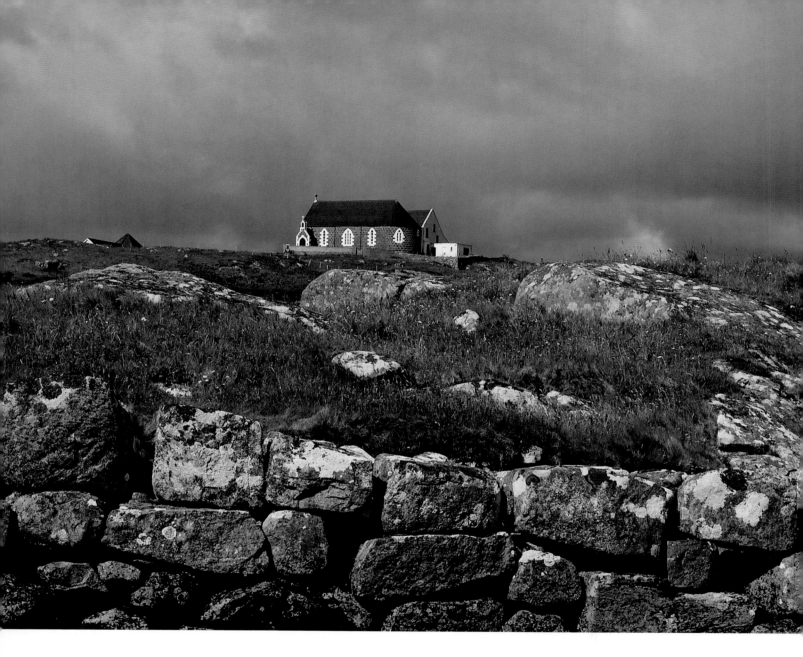

St Michael's Church, Eriskay

Fin finds his way here, to St Michael's Church on Eriskay, in an attempt to make sense of Tormod's demented ramblings.

Boat altar, St Michael's Church

The altar in St Michael's Church on Eriskay sits atop the front end of a boat, commemorating the fact that the church was built by the fishermen of the island.

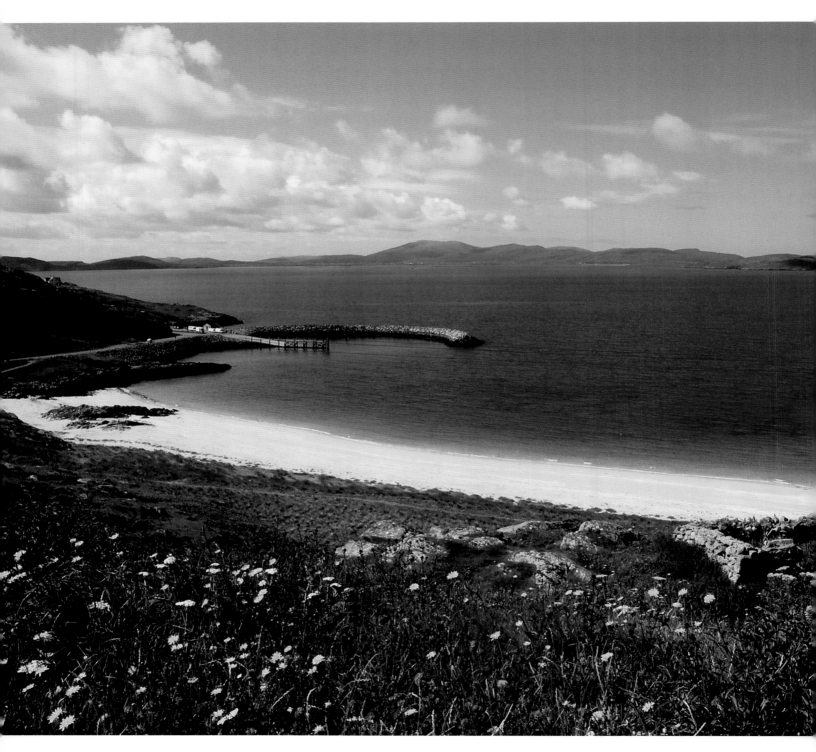

I scrambled to my feet and she took my hand, and we ran then up over the hill, past the primary school and along the road above the beach. We stopped, breathless, to take in the view. The sea simmered in a shimmering silence around the curve of the bay below us, rolling gently in to break in soft silver foam along the sand. The reflection of moon on water stretched away into a never-ending distance, the horizon broken only by a handful of dark islets and the brooding shadow of Barra.

I had never seen the island like this. Benign, seductive, almost as if it were colluding in Ceit's grand plan.

'Come on,' she said, and led me down a narrow path through the heather to where the remains of an old ruined cottage looked out across the sands, and we picked our way through the stones to its grassy interior. She promptly sat herself down in the grass and patted a place beside her. I sat down, immediately aware of the warmth of her body, the soft sighing of the sea, the vast firmament overhead, the sky black now and crusted with stars. I was full of breathless anticipation as she turned those dark eyes on me, and I felt her fingertips on my face like tiny electric shocks.

Charlie's beach, Eriskay
The beach on Eriskay where Bonnie Prince Charlie landed at the start of his abortive attempt to take back the British throne for the Stuarts in 1745. His Jacobite uprising came to a brutal end at Culloden the following year. But while the Highlanders who had supported him were hunted down and killed or imprisoned, Charlie escaped back to Rome where he eventually died from depression and alcoholism. The old ruined house on the foreground machair is the setting for two major events in The Lewis Man.

She crunched the car into first gear and kangarooed towards the gate, narrowly missing the gatepost as she swung the wheel to turn them on to the road up the hill. Dino had draped himself over her right arm, face pushed out of the open window into the wind, and she juggled her cigarette and the gear lever to propel them at speed up towards the primary school and the road leading off to the church. Fin found his hands moving down to either side of his seat and gripping it with white knuckles at the end of arms stiff with tension.

While visiting South Uist and Eriskay to research the book, I stayed with Alyxis, who by now had become a dear friend. A colourful character in her own right, she became my model and inspiration for the character of Morag in the book – a retired actress who drives around in a fuschia-pink soft-top car with a Yorkshire terrier draped over one arm, and a cigarette in her free hand. Just like Alyxis herself. How could I resist?

As always, on the return journey from the south, I stop off at Scarista and Luskentyre in Harris, just as Tormod does in *The Lewis Man*. I never tire of seeing these beaches. They look different every time. I think they offer some of the most marvellous views in the Hebrides.

South Uist, pink car
The pink car owned by the actress Alyxis Daly sits outside the house I used as the model for Morag's house in the book. I took the liberty of moving it across the sound from South Uist to Eriskay. Here you can see Eriskay and Barra across the water.

'Morag's' house

From inside 'Morag's' house we can see the pink car with its hood up and Barra in the background.

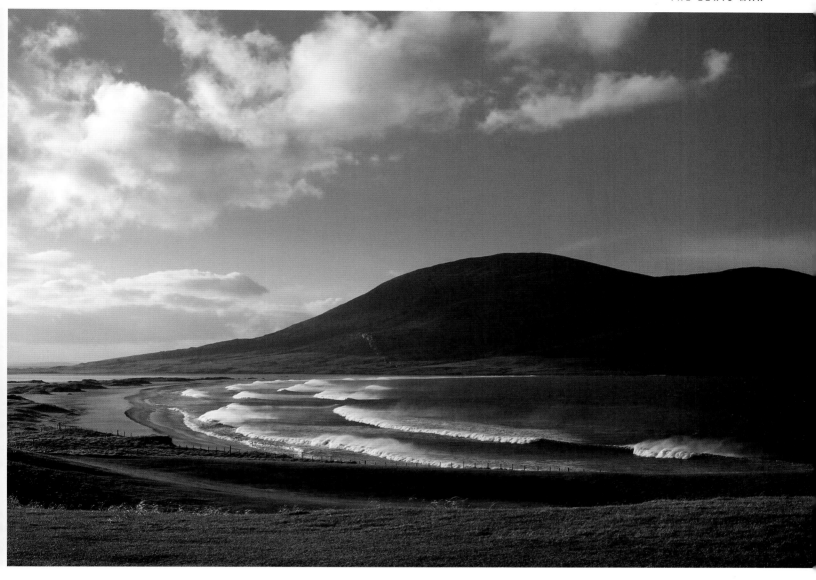

Scarista beach
*The surf pounds the golden sands
at Scarista on a winter's day.*

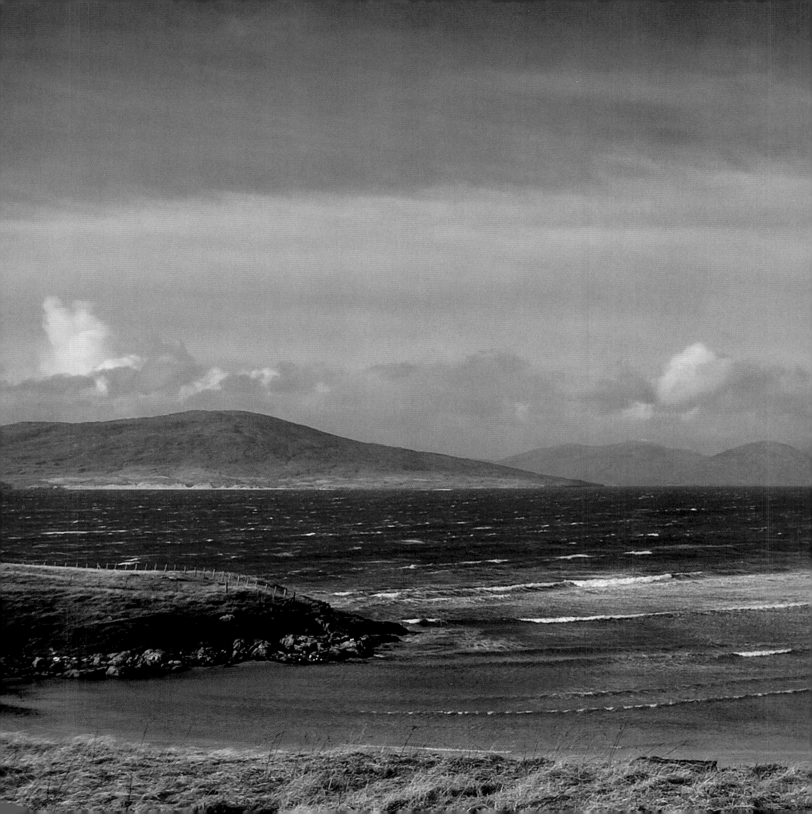

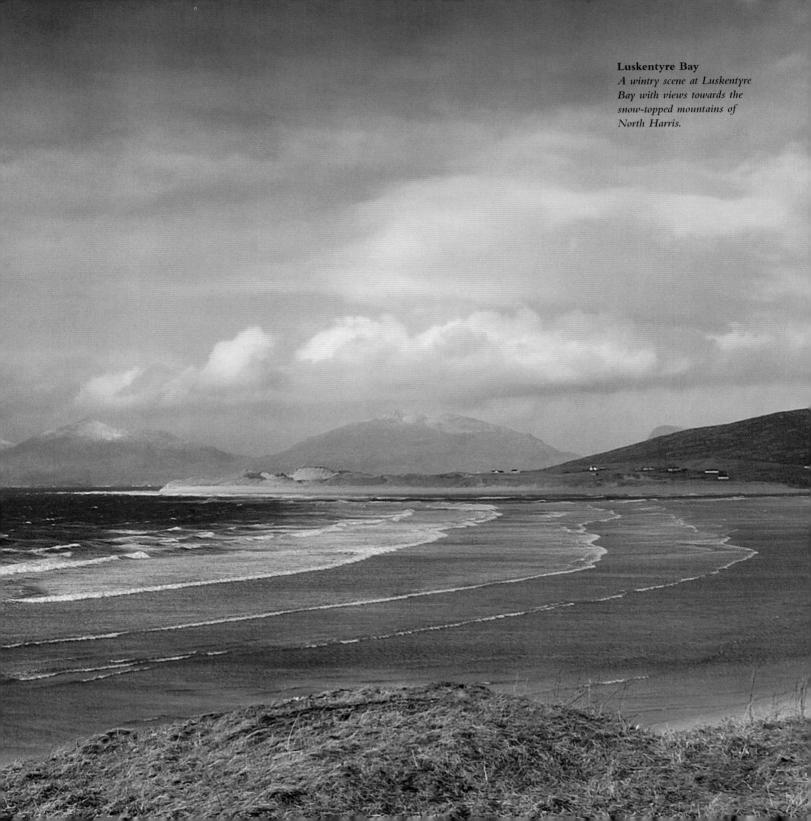

Luskentyre Bay
A wintry scene at Luskentyre Bay with views towards the snow-topped mountains of North Harris.

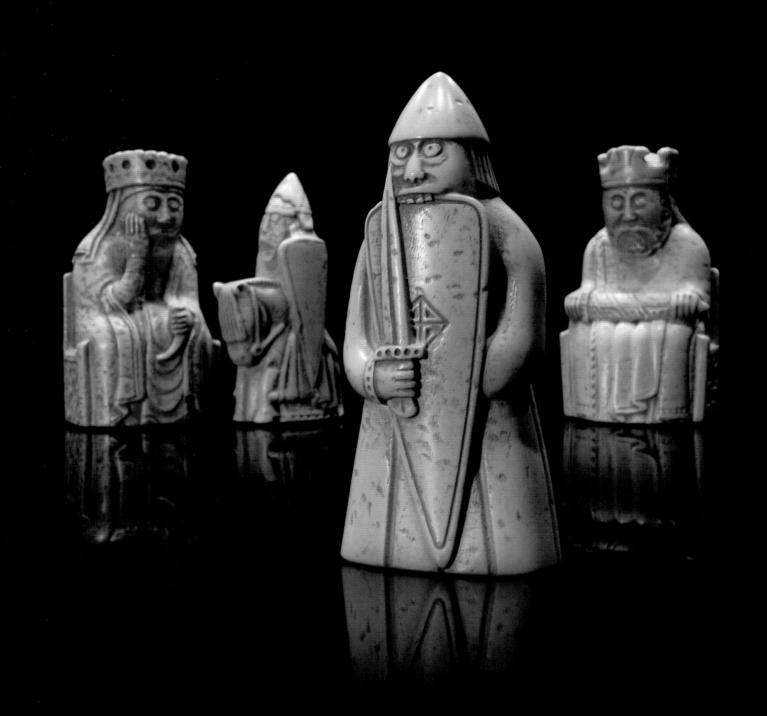

THE CHESSMEN

FACING PAGE **Berserker and other chess pieces**
Here we see four pieces from the collection. A king, a queen and a knight, with the berserker in the foreground. Some of the chessmen are thought to have been coloured red.

This final tome in what has become known as the Lewis trilogy, confined itself to the Isle of Lewis, home of the eponymous chessmen. It is important to understand first the relationship between these unique figures carved from walrus ivory and the island which lent them its name – the Lewis Chessmen. The chessmen were discovered in 1831 in a sandy cove in Uig Bay by a local man, Malcolm Macleod. The startled crofter thought at first that they were sprites or fairies. There were ninety-three pieces found in total. Seventy-eight of them were chessmen, the rest were plain round tablemen for the game of tables, and one ivory belt buckle. But it was the chessmen that caught the imagination. Extraordinarily detailed carvings thought to have been produced in Viking workshops in Trondheim, Norway, in the twelfth century. The Hebrides at that time were still under Norse occupation. They might be the only surviving pieces of that era, making them quite unique. The pawns range in height from 3.5 to 5.8 centimetres, with the major pieces standing anything up to 10.2 centimetres tall. The latter pieces are all carved in the shape of human figures, many of them soldiers in full battle dress. Among the most startling of these are the rooks, which are depicted as berserkers – Norse warriors whipped up into a trance-like fury for battle. These were carved biting down on the tops of their shields.

RIGHT **Giant king**
This giant facsimile of a king, has been erected close to the site at Uig where the chessmen were originally discovered, although no one knows the exact spot.

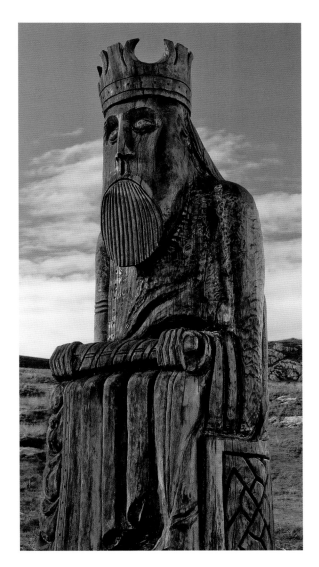

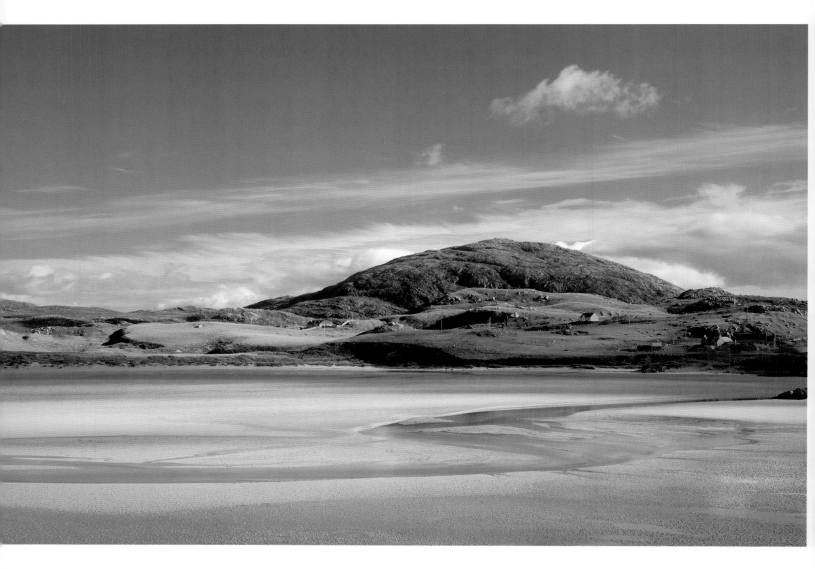

Eleven of the pieces are now on display in the Museum of Scotland in Edinburgh, while the remaining artefacts are on display at the British Museum in London. In 2003 experts at the British Museum placed them fifth in the list of top British archaeological finds.

Just exactly how the Lewis Chessmen relate to the story in the book is something I will leave the reader to discover.

In my book Fin Macleod has returned to the island of his birth and taken a job as head of security on an estate in south-west Lewis that is plagued by poachers. It brings him into contact again with his teenage friend, Whistler, who played in a Celtic rock band for which Fin was the roadie when they were still at school, and later at university. Whistler is genius verging on madness, and lives a bohemian life in an old blackhouse overlooking Uig beach at Ardroil.

Where Whistler lives
Whistler's old converted blackhouse with its tin roof I imagined to be somewhere here on the hill above the beach at Uig, with Suaineabhal rising behind it.

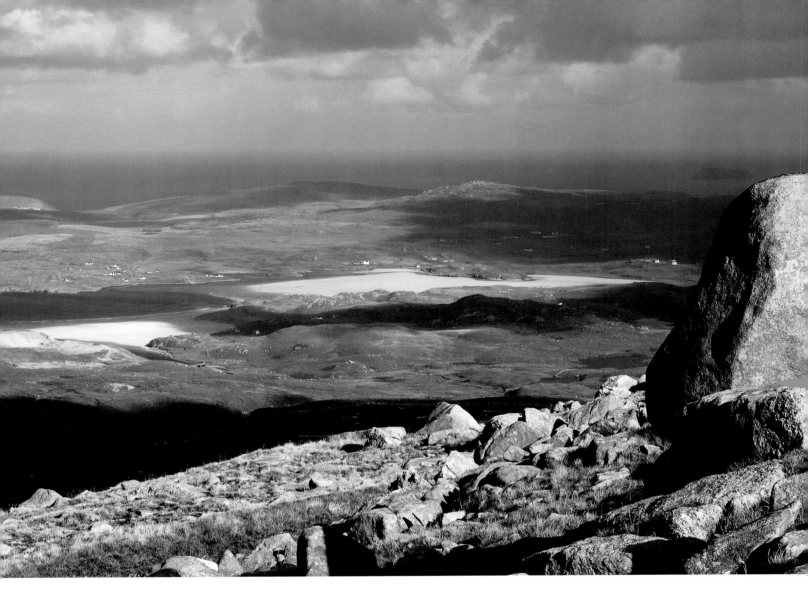

Uig Bay
This shot of Uig Bay was taken from the top of Mealaisbhal, the highest peak on the Isle of Lewis. Here we are looking north-west over Ardroil, with Gallan Head on the left in the distance.

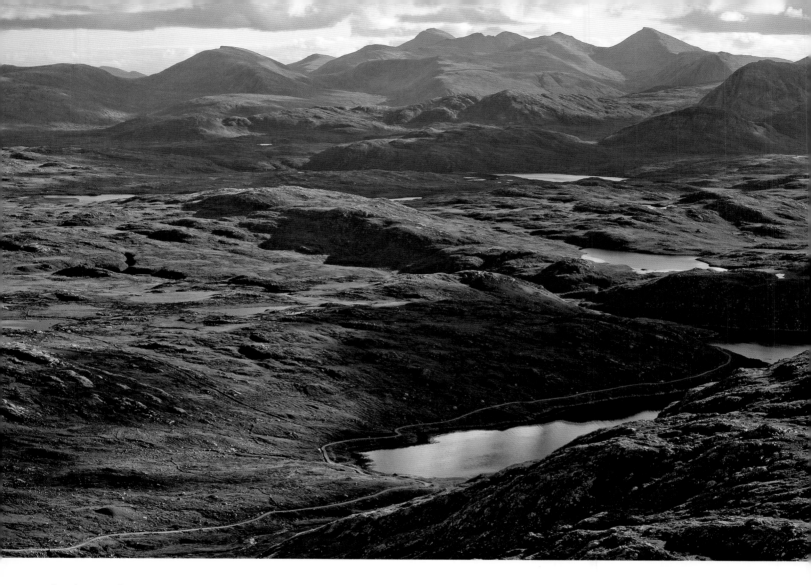

South towards Tamnavay

In this view from the top of Cracabhal, we see the track heading south to Tamnavay.

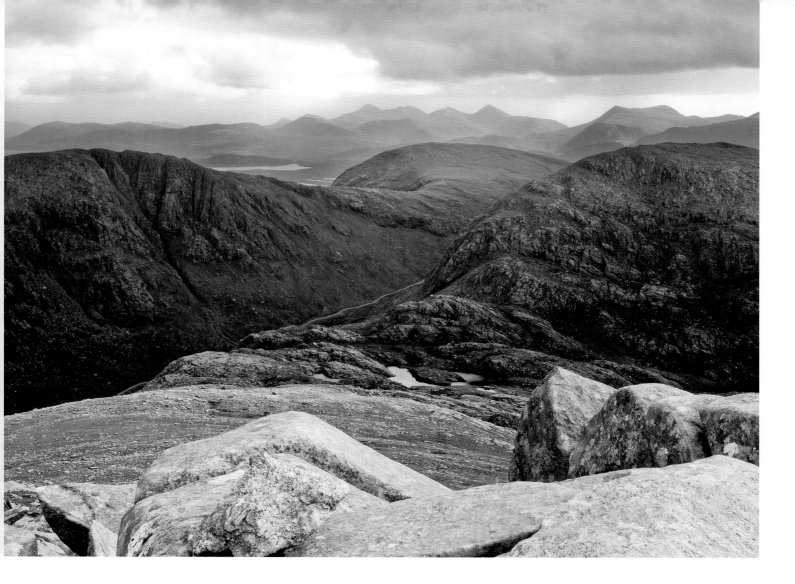

The mountain track

Taken again from the top of Mealaisbhal, we see the track that leads between the mountains, heading south to the lodge at Tamnavay. It was by this route that Fin and Whistler made their way up into the mountains on the night of the storm.

Although Whistler's poaching 'for the pot' is not a part of the 'industrial' poaching which is affecting the estate's income, the landlord bears a grudge against him, and a reluctant Fin soon finds himself in conflict with his old friend. But Whistler's intimate knowledge of the area, and the mountains that rise up almost from the beach, put him at a distinct advantage. He leads Fin a merry dance up into the mountains on the night of a great storm, and ends up having to rescue him from almost certain death.

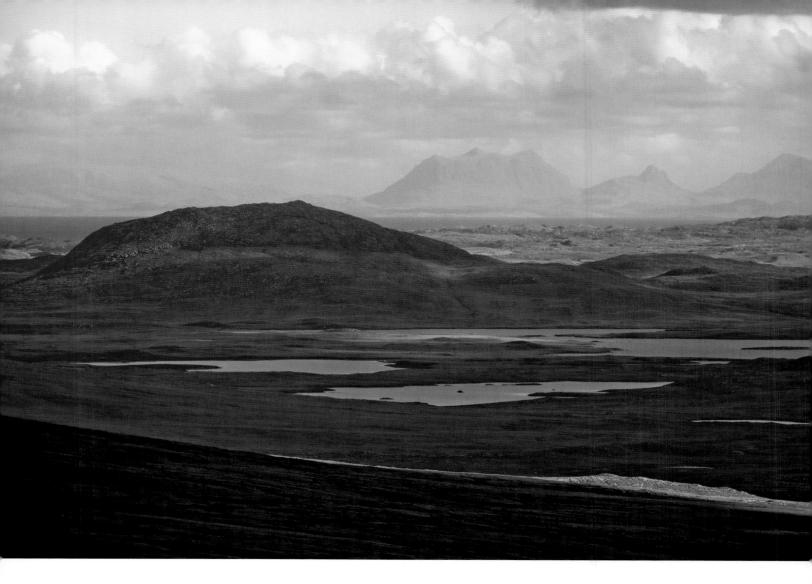

After sheltering the night in what is known as a beehive dwelling – a tiny crude shelter built of stone and turf – Fin and Whistler awake in the morning to find themselves confronted by a dramatic and almost unique geological phenomenon.

The phenomenon they witnessed is known as a 'bog burst'. After an extended dry period (rare in the Hebrides), heavy rain drains down through the cracked peat creating a sludge beneath it. The weight of the top layer, and pressure from the loch it contains, means that it just slides away and the loch drains itself empty. This very event occurred in the 1950s, when a loch between Morsgail and Kinlochresort, near Uig, vanished overnight. The Press arrived in force from the mainland, speculating in the papers and on TV that a meteorite had crashed into the loch and vaporized it. In fact there had been a bog burst, and the depression that once contained the body of water is still known today as the Disappearing Loch.

The mainland

Turning to look east from the summit of Mealaisbhal presents this stunning vista across Loch Langavat – the longest loch in the islands – to the mountains of the mainland in the far distance.

The sight that greeted him was almost supernatural. The mountains of south-west Lewis rose up steeply all around, disappearing into an obscurity of low clouds. The valley below seemed wider than it had by the lightning of the night before. The giant shards of rock that littered its floor grew like spectres out of a mist that rolled up from the east, where a not yet visible sun cast an unnaturally red glow. It felt like the dawn of time.

Whistler stood silhouetted against the light beyond the collection of broken shelters they called beehives, on a ridge that looked out over the valley, and Fin stumbled over sodden ground with shaking legs to join him.

Whistler neither turned nor acknowledged him. He just stood like a statue frozen in space and time. Fin was shocked by his face, drained as it was of all colour. His beard looked like black and silver paint scraped on to white canvas. His eyes dark and impenetrable, lost in shadow.

'What is it, Whistler?'

But Whistler said nothing, and Fin turned to see what he was staring at. At first, the sight that greeted him in the valley simply filled him with confusion. He understood all that he saw, and yet it made no sense. He turned and looked back beyond the beehives to the jumble of rock above them, and the scree slope that rose up to the shoulder of the mountain where he had stood the night before and seen lightning reflected on the loch below.

Then he turned back to the valley. But there was no loch. Just a big empty hole. Its outline was clearly visible where, over eons, it had eaten away at the peat and the rock. Judging by the depression it had left in the land, it had been perhaps a mile long, half a mile across, and fifty or sixty feet deep. Its bed was a thick slurry of peat and slime peppered by boulders large and small. At its east end, where the valley fell away into the dawn mist, a wide brown channel, forty or fifty feet across, was smeared through the peat, like the trail left by some giant slug.

Fin glanced at Whistler. 'What happened to the loch?' But Whistler just shrugged and shook his head. 'It's gone.'

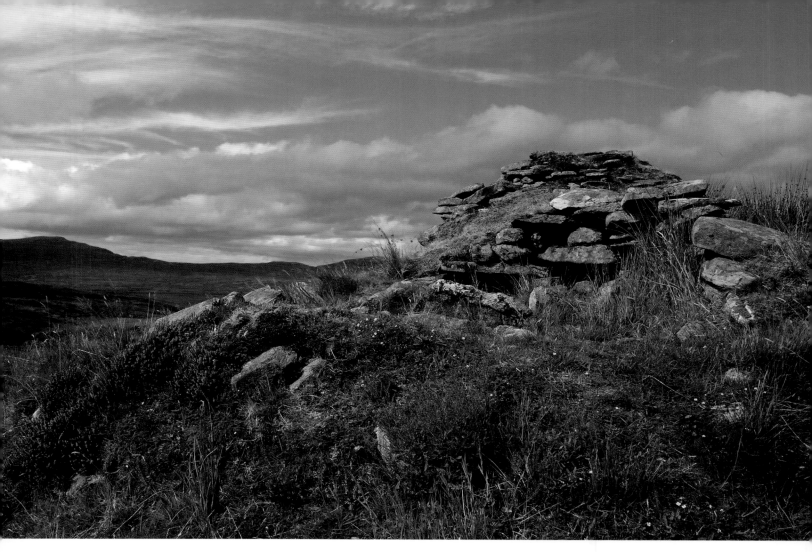

Beehive, Morsgail

This is the best preserved of the Morsgail beehives, sitting proud on a small hillock. It is almost possible to crawl inside.

Beehive and rainbow

This is a classic beehive dwelling, big enough to crawl into but not to stand up in. This one can be found on a headland a mile off the Road to Nowhere, and is still serviceable as a shelter. The rainbow simply confirms that we are, indeed, on the Isle of Lewis.

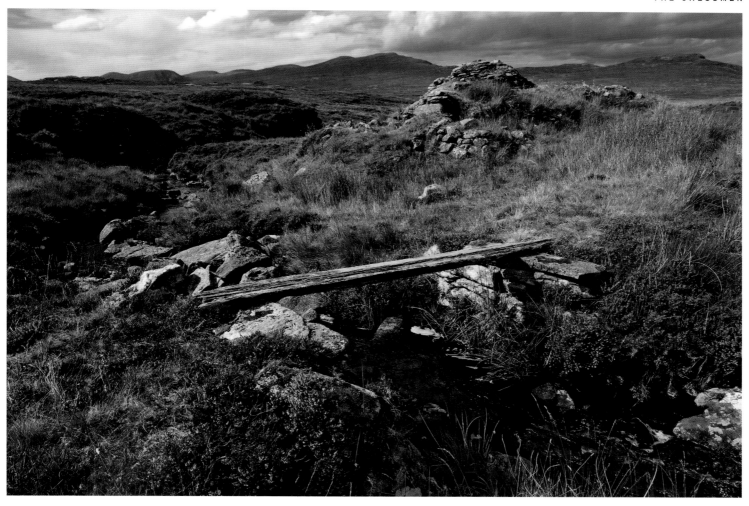

Beehives, Morsgail

These were the beehives near Morsgail that I stumbled upon while searching for the Disappearing Loch. Most of them are derelict and unserviceable.

As part of my research for the book, and equipped for all weathers, I trekked out over the moor from Morsgail Lodge in search of the vanished loch. It took me well over an hour crossing unforgivingly rough bogland to find the unremarkable depression, now almost completely grown over. But on the way, I was fortunate enough to stumble upon an extraordinary collection of broken-down beehive dwellings beside a small stream.

When Fin and Whistler are confronted by the loch which has burst its banks and drained overnight, they see a small plane lying at an angle at the bottom of the depression. It is the plane in which fellow band member Roddy Mackenzie went missing seventeen years before, although from his registered flight plan it was believed to have gone down in the Atlantic somewhere off Mull. When they investigate, they find the body of their old friend still in the cockpit, only to discover that he has been murdered. And so begins the unravelling of a 17-year-old mystery.

My research for the story also took me up into the mountains from North Harris, where my guide was

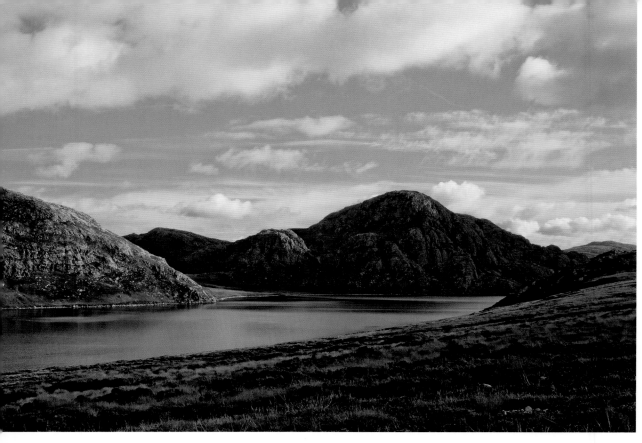

Loch Suaineabhal
Loch Suaineabhal was one of those I looked down upon from the heights of North Harris.

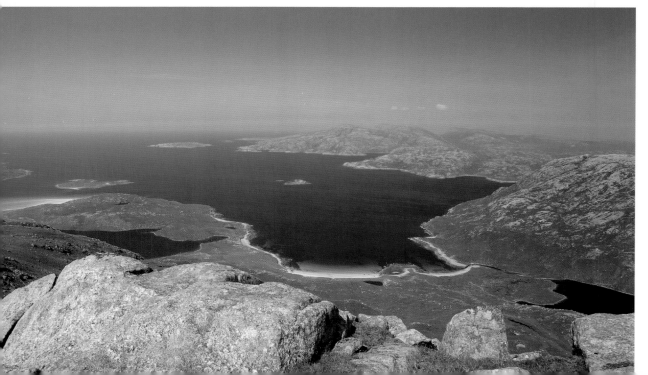

From Harris
This shot looks north from the summit of Oireabhal in North Harris towards the distant peaks of Mealaisbhal and Cracabhal. The track that runs between them from Uig can just be seen winding its way down to the loch.

From Lewis
This photograph almost reverses the view of that from Harris on the facing page. The track wends its way south past Cracabhal on the right. In the far distance are the hills of North Harris and the Clisham, the highest peak in the Hebrides.

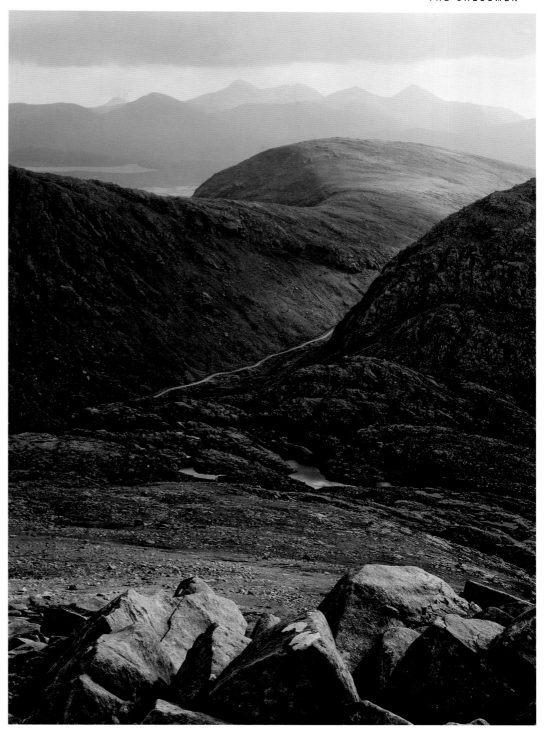

Kenny's Range Rover bounced and rattled over the potholed track, following the course of the river, the ground rising up ever more steeply around them. Bare, rugged hills peppered with rock and slashed by gullies rose up into mountainous peaks lost in cloud. Boulders clung to the hillsides, great chunks of gneiss four billion years old. Kenny glanced at Fin and followed his eyes. 'Oldest rock in the world,' he said. 'Those slabs of it have been lying around these hills since the last ice age.' He pointed up into the shadow of the mountain on their left. 'You see those watercourses running through the rock? Originally cracks in the face of it, they were. And when the water in them froze the ice expanded till the rock exploded, and threw these massive big lumps of it all over the valley. Must have been quite a show. But I'm glad I wasn't around for it.'

the ranger from the North Harris estate. He led me through mountain passes, past lonely 'lunch huts' or 'bothies', where fishermen shelter from the elements to grab a bite to eat during fishing trips. Then up into the mountains themselves where, from windswept peaks, I was afforded the most amazing views on all sides. Fin follows a similar route with his new employer.

I also followed in the teenage footsteps of Fin and Whistler along the track that leads from Uig into the mountains, to the loch where Whistler once saved the young Fin's life. It is an extraordinary thing how in telling a story it can become so vivid in your mind and memory that you end up almost believing it actually happened. This is very much the feeling I get when I visit that loch. So evocative, somehow, that I can almost hear their voices calling out to each other, a distant echo of long-lost ghosts.

Lunch hut
A typical lunch hut, or bothy. These are found on estates all over the islands. This one is at Soval, near Laxay, on the east coast of Lewis.

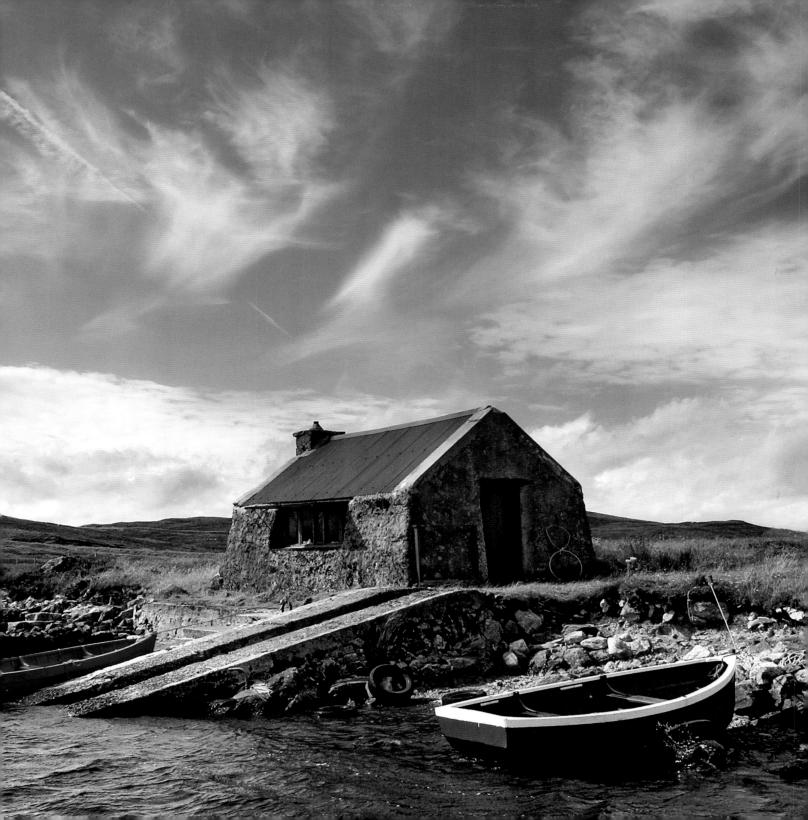

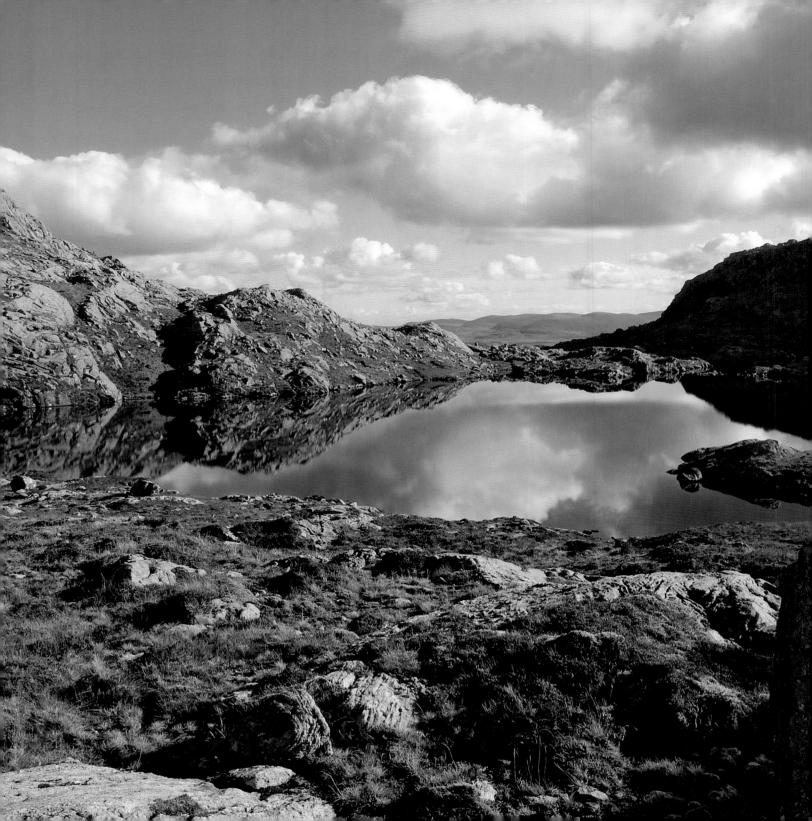

Here he turned east, tyres kicking up peat and stone in his wake as he left the track and followed the faintest outline of an ancient pathway. It rose steeply, taking him up to the still waters of Loch Tathabhal, tucked away in the shadows of sharply rising slopes of scree. Tongues of water in the river that ran out of it flickered and licked over an almost dry stone bed, tumbling in a succession of tiny falls to Loch Raonasgail below.

Whistler's loch
This little loch stands in the shadow of Cracabhal. It is the setting for two scenes in the book. I called it Loch Tathabhal, but I just made that up, borrowing the name from a nearby mountain.

Mangersta rock
Seabirds sit upon this majestic rock in the seas at Mangersta. The colour of the water here has an extraordinary luminosity.

A wedding in the story took me for the first time during my researches out to the settlement of Mangersta, at the extreme western tip of Uig. Here the Atlantic beats relentlessly upon a jagged coastline of soaring cliffs. It presents a majestic vista, and standing on the clifftops you can just see St Kilda on the far horizon.

The many trips I have made up and down to Uig over the years are now coloured by the stories I have written, and many of the stops and views on the way are populated in my mind by the characters I created, as if they really existed.

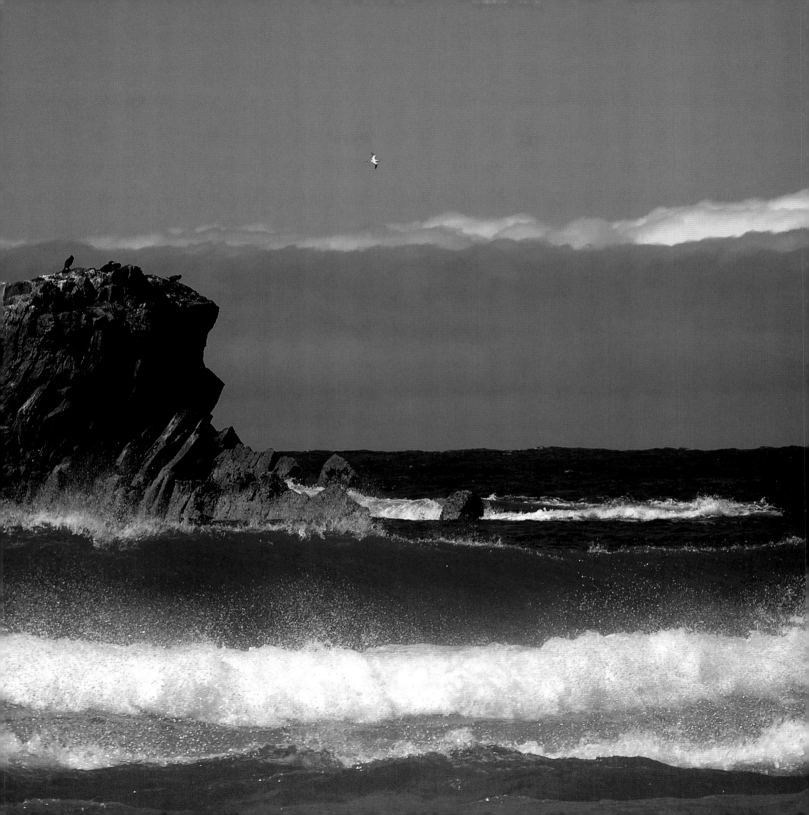

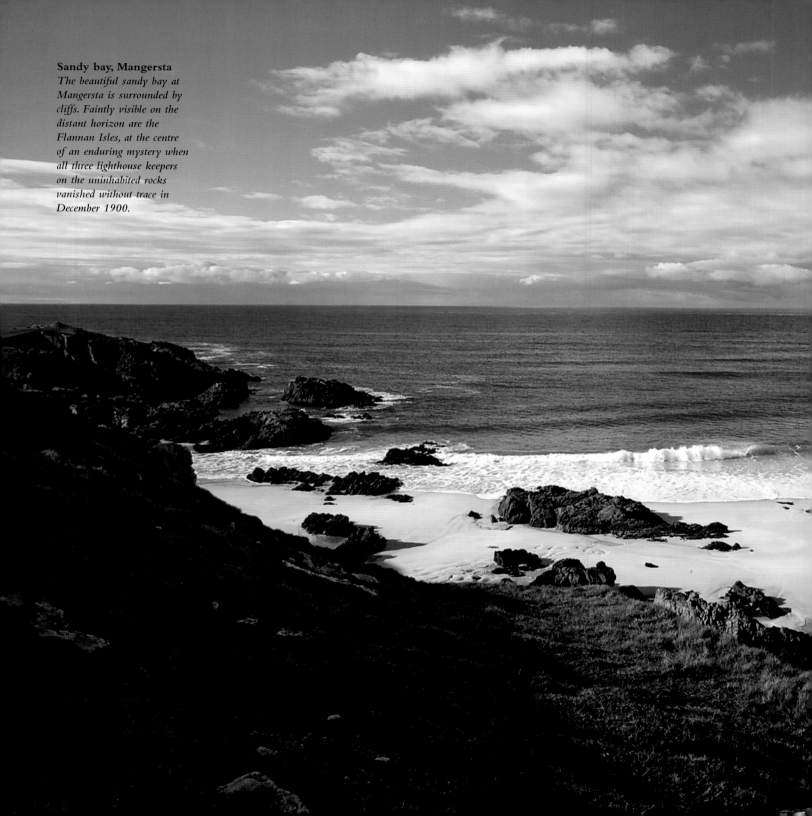

Sandy bay, Mangersta
The beautiful sandy bay at Mangersta is surrounded by cliffs. Faintly visible on the distant horizon are the Flannan Isles, at the centre of an enduring mystery when all three lighthouse keepers on the uninhabited rocks vanished without trace in December 1900.

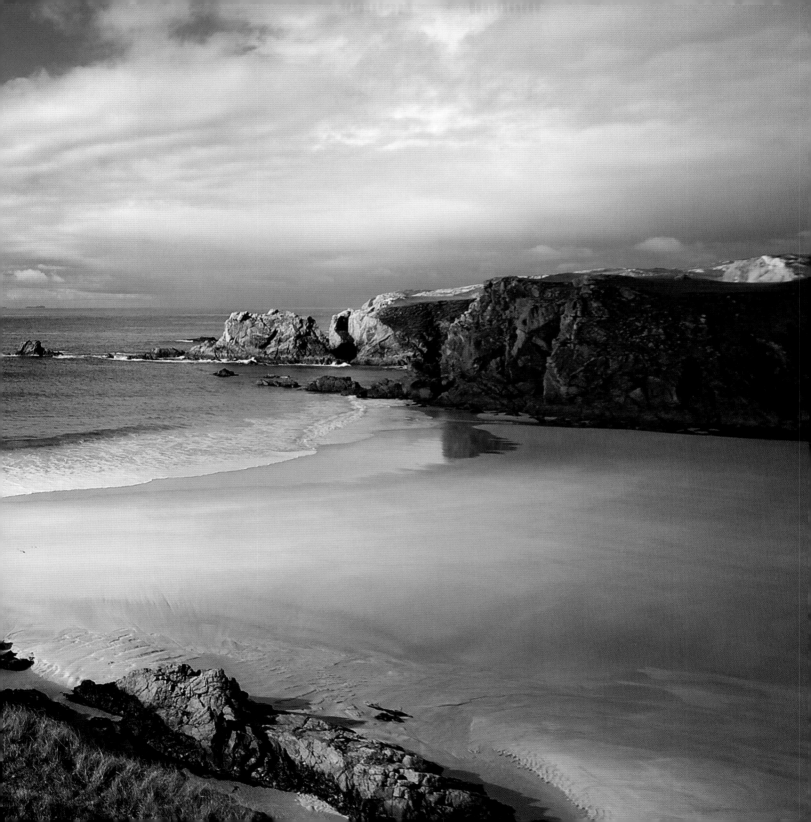

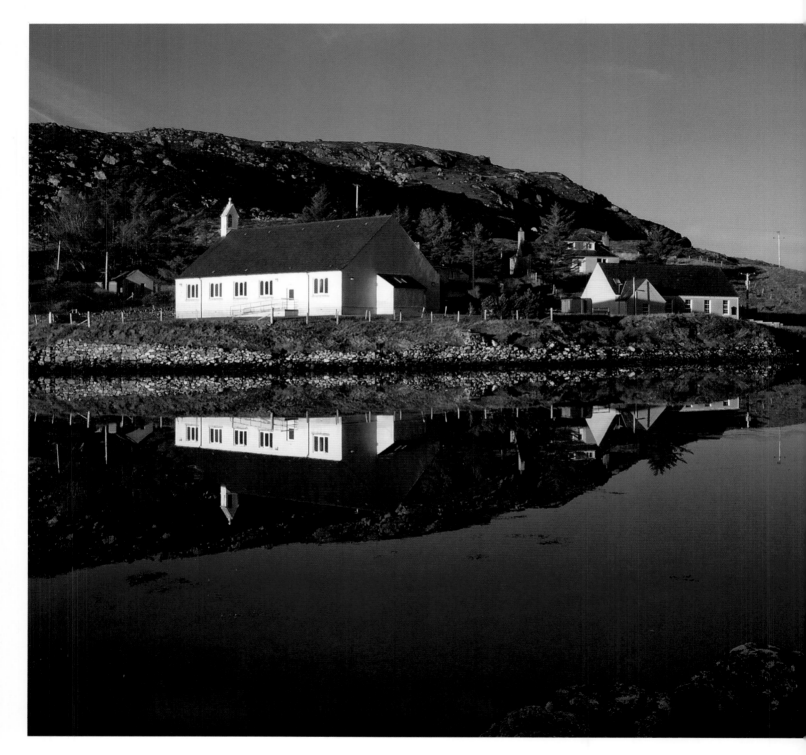

Mairead's voice rang around the rafters of the church, clear and pure and unaccompanied. The doors were open so that those outside could hear her, and in the still of this sad grey morning, her voice drifted out across Loch Ròg, a plaintive lament for a lost friend and lover.

Two churches at Miavaig
There are two churches at Miavaig on Loch Ròg, one the Church of Scotland and the other Free Church of Scotland. One of them played host to the second funeral of Roddy Mackenzie.

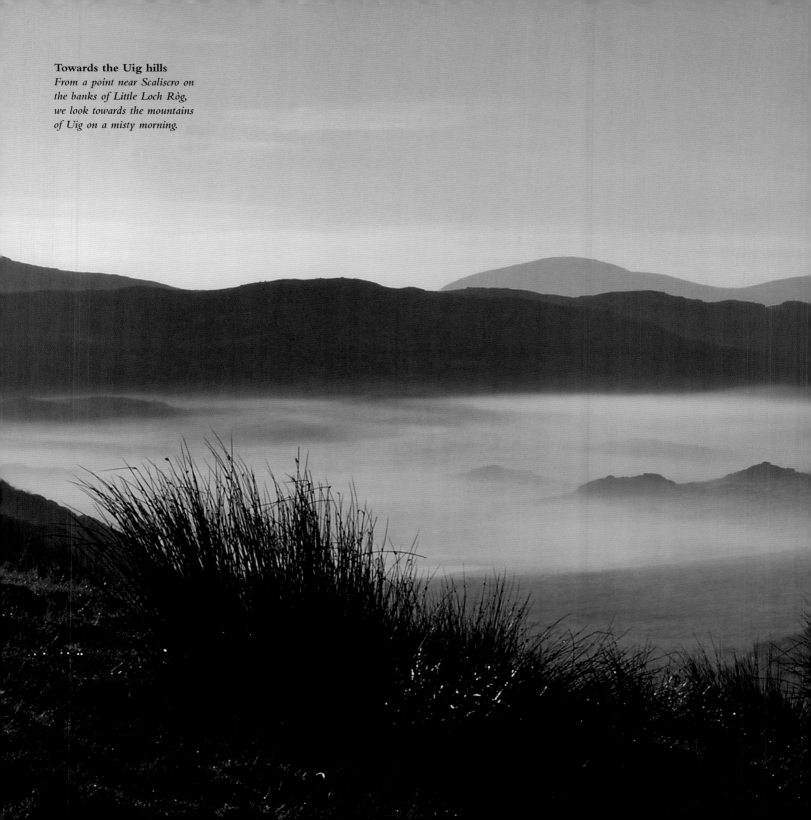

Towards the Uig hills
From a point near Scaliscro on the banks of Little Loch Ròg, we look towards the mountains of Uig on a misty morning.

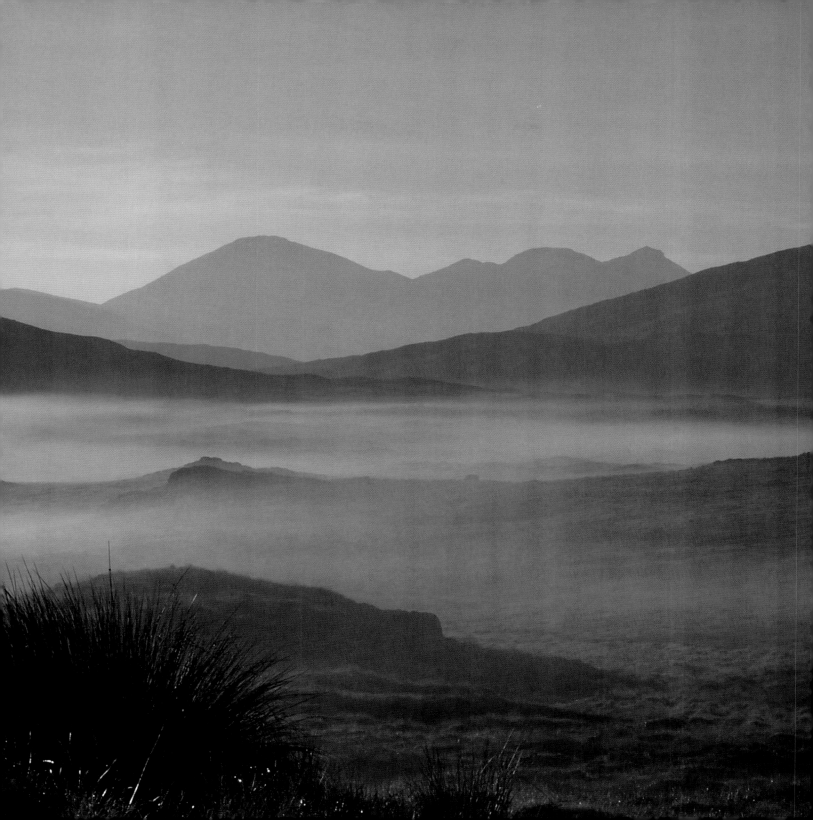

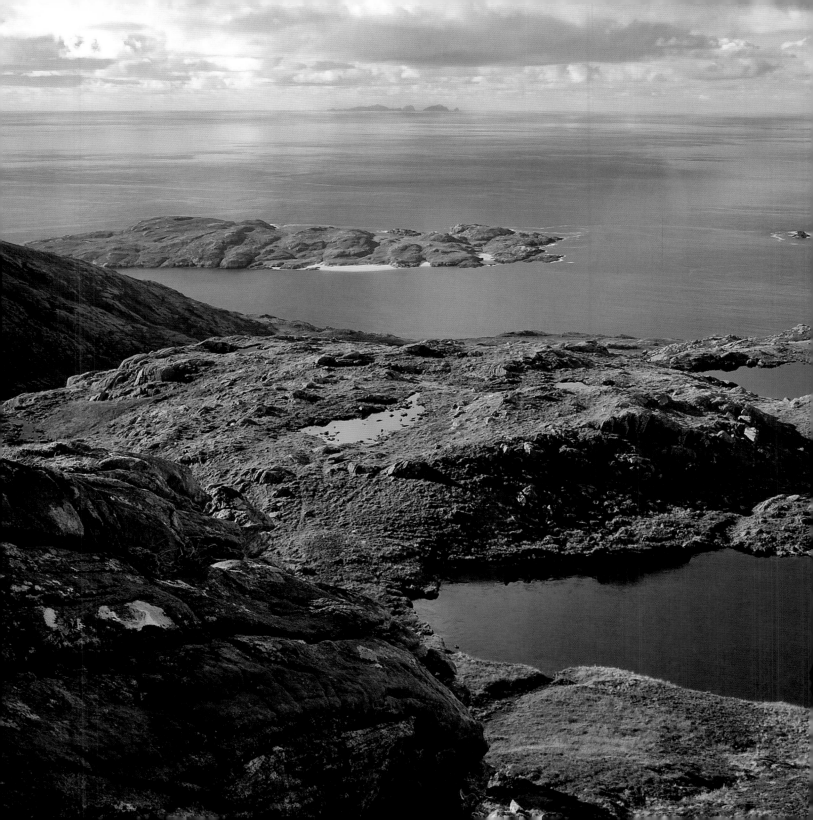

The mountains where Roddy's plane had come down all those years before loured over them, dominating the skyline to the south. The cemetery itself sloped down to the west, and the rain began as the procession made its way among the headstones to the small walled extension which had been built on to it at the bottom end. Its original planners, apparently, had not taken account of the relentless nature of death.

It was a fine rain, a smirr, little more than a mist. But it almost obliterated the view beyond the wall towards the beach, and made the last few yards treacherous underfoot. The lowering of the coffin on wet ropes by hands and arms which had all but seized up was made perilous by the rain, and it bumped and scraped the side of the grave on its way down. The grave itself had been excavated the day before, and the remains of the coffin they had placed there seventeen years earlier exhumed. Beneath the grass the soil was pure sand, without rocks or pebbles, and was already crumbling as the coffin settled at the bottom of the hole. The original headstone lay to one side, to be replaced once the grave had been refilled.

**From Cracabhal towards
St Kilda**
*St Kilda, about forty miles
away, can be seen here faintly
in the distance.*

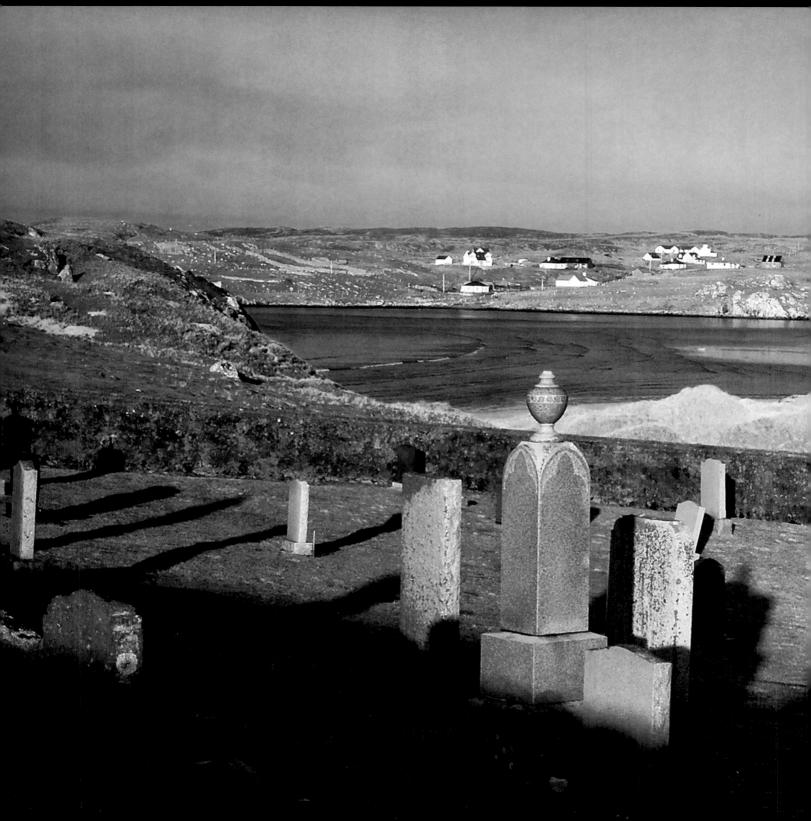

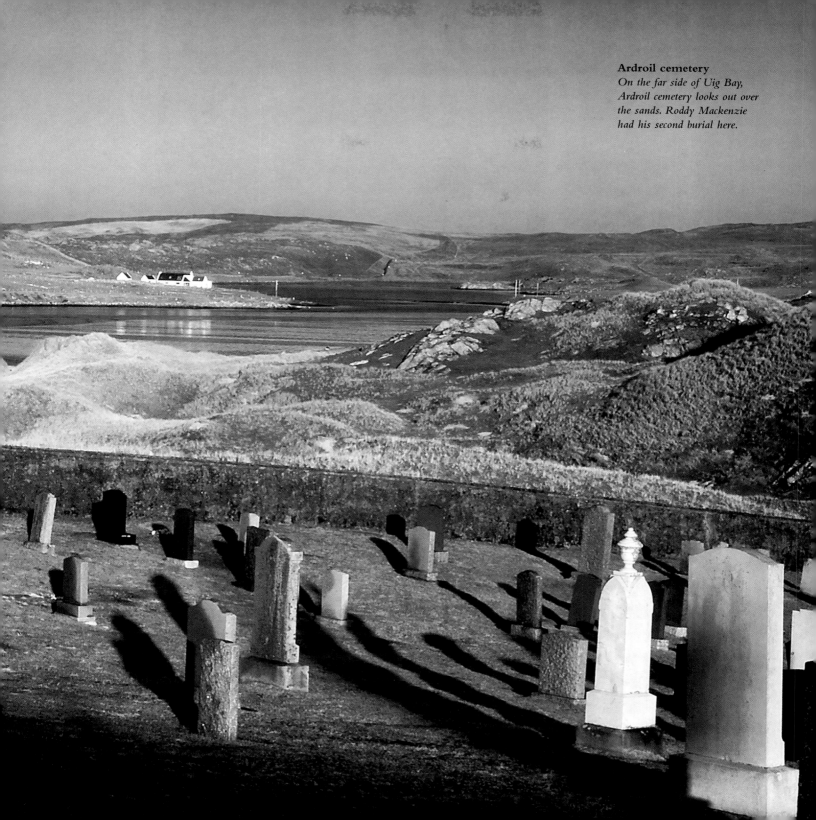

Ardroil cemetery
On the far side of Uig Bay, Ardroil cemetery looks out over the sands. Roddy Mackenzie had his second burial here.

Valtos loop

If you take the loop around Valtos from Miavaig to get to Uig, you will be treated to this stunning view across the reeds toward Reef beach and the islands of Pabay Mor and Vacasay beyond.

Bus shelter, Glen Valtos

If you take the road through Glen Valtos instead, then you will meet this bus shelter at the head of the glen. Designed to provide protection, no matter the direction of the weather, we dubbed these curious structures 'giants' picnic tables'.

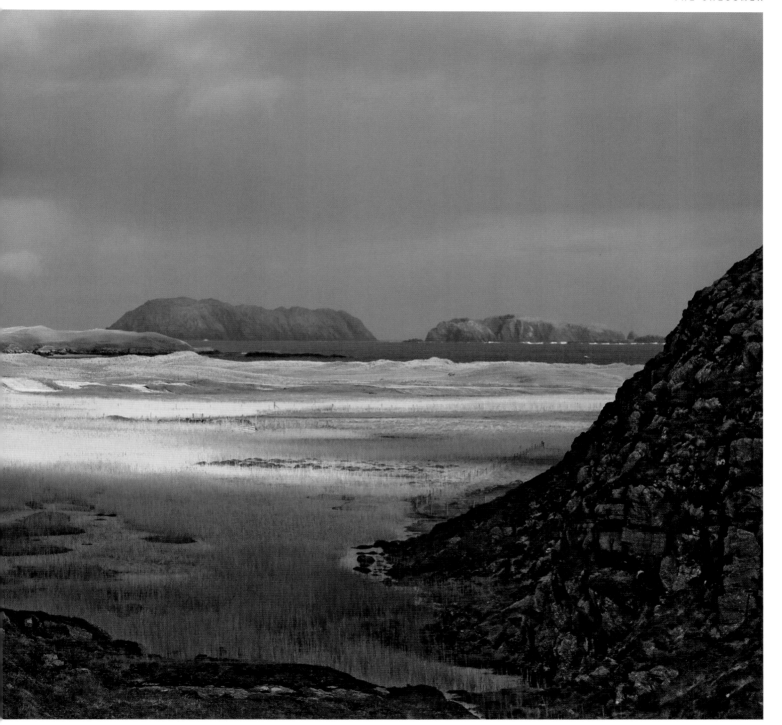

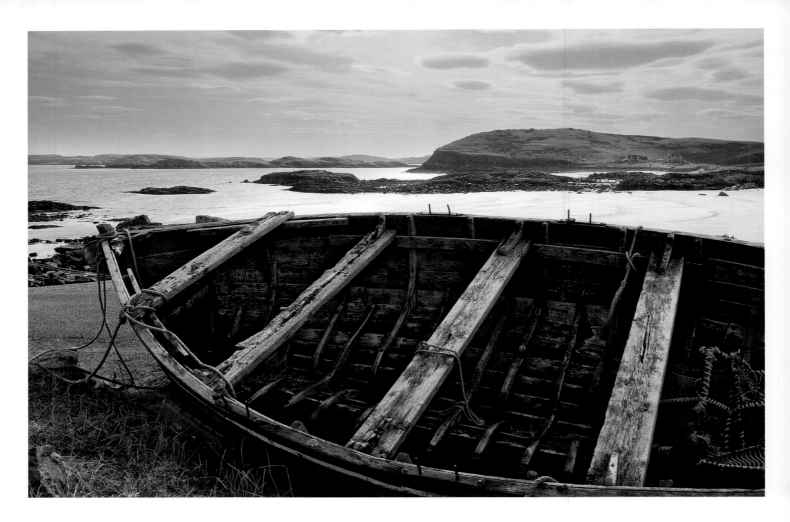

Boat at Cnip

*Further around the loop at
Valtos at Cnip, this old fishing
boat lies rotting.*

Sollas beach

The tide is receding across the sands at Sollas as we look north towards the hills of Harris.

There were three other important areas of research that I still had to cover. The first required a return trip to North Uist and the vast expanse of beach exposed at low tide at Sollas — one of the few beaches in the Hebrides on which it is possible to land a small aircraft. Coincidentally, I later discovered during research for a subsequent book that the township of Sollas had been the setting for one of the most brutal evacuations effected during the Hebridean clearances.

The next area of research involved the setting for a motorbike race — a challenge between two members of the Celtic rock band over a disagreement on the new name for the group. The race was to be held along a stretch of what is known as the Road to

Nowhere, its starting point not unnaturally being the Bridge to Nowhere. Both lie a short way beyond the village of Tolsta on the east coast of Lewis, north of Stornoway. Both the bridge and the road were built during a period between 1918 and 1923 when Lewis and Harris were owned by Lord Leverhulme. Unfortunately, like many of Leverhulme's ambitious plans, they were never seen through to completion. The bridge was completed, but the road, which was supposed to open up the east coast to Skigersta to traffic, was begun but never finished. Lord Leverhulme himself died in 1925. What remains of the road is now little more than an overgrown, rocky track.

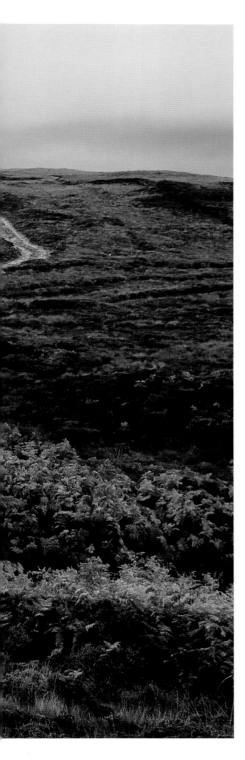

It was one of those rare, delicious, early summer days when the wind was soft out of the south-west and the sky was broken by high white clouds that only occasionally masked the sun. Spring flowers shimmered yellow and purple and white across the moor, and the midges were kept at bay by the breeze. Of course, there was always something to spoil a perfect day, and in this case it was the cleggs. The little biting bastards were out in force among the long grasses. Horseflies the English call them, and they give you a real dirty bite, even through clothes if they're tight-fitting.

We were all gathered on the bridge. About a dozen of us, drinking beer, scraping our names in the concrete, or just lying along the parapet sunning ourselves, fearless of the drop into the gorge below. The sun washed across the golden sands of Garry beach and out over the Minch, and I remember thinking there was something almost idyllic about it. The exams were by us, and a new, exciting future lay ahead. Escape from the island, the first chance any of us had had to spread our wings and fly. At that moment, anything seemed possible.

Bridge to Nowhere
The graffiti-scarred concrete Bridge to Nowhere still stands testament to Lord Leverhulme's failed dreams. Peat banks can be seen cutting through the autumn bracken on the hill beyond it.

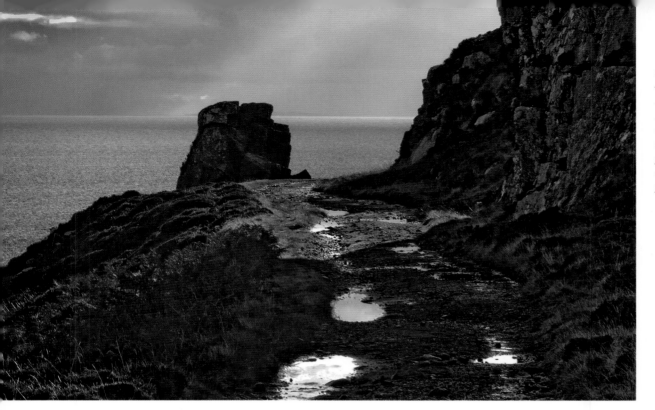

**LEFT Road to Nowhere
– looking back**

Looking back on the Road to Nowhere, through pillars of rock left by the dynamiting road-builders, we see sunlight playing on the Minch. On clear days the mainland is perfectly visible.

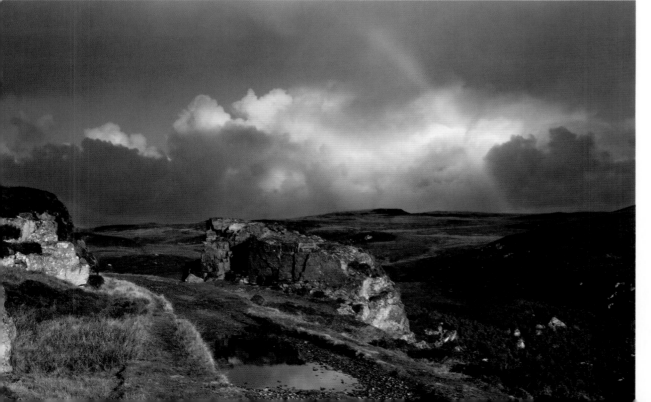

LEFT Ubiquitous rainbow

A rainbow arches over the Road to Nowhere, like a gateway to the future that never was.

RIGHT Going nowhere

The sad remains of the Road to Nowhere wind their way to oblivion. The east coast of Lewis stretches away into the distance.

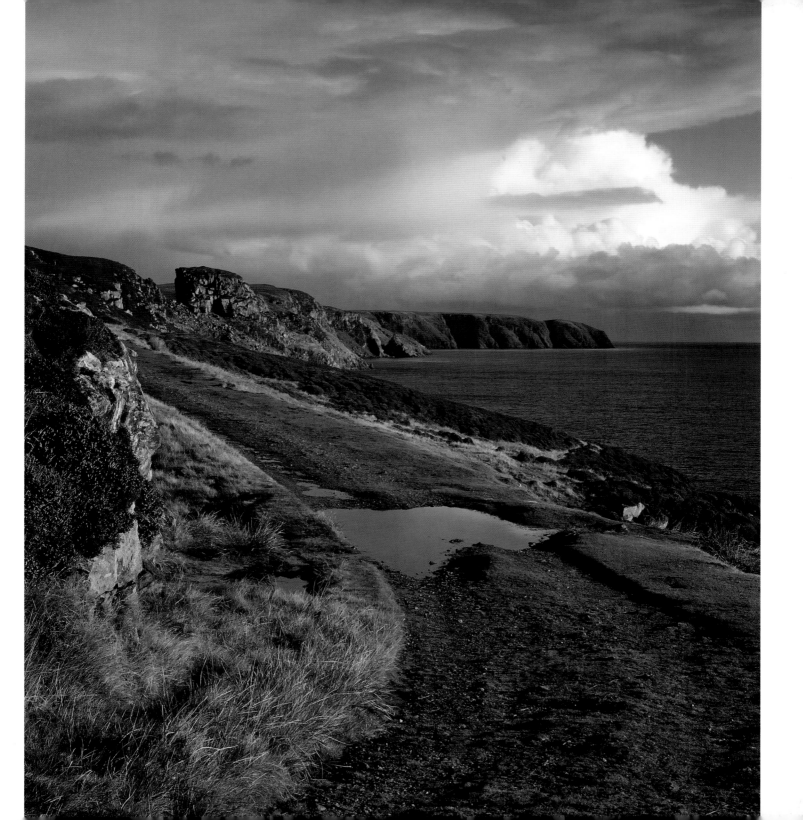

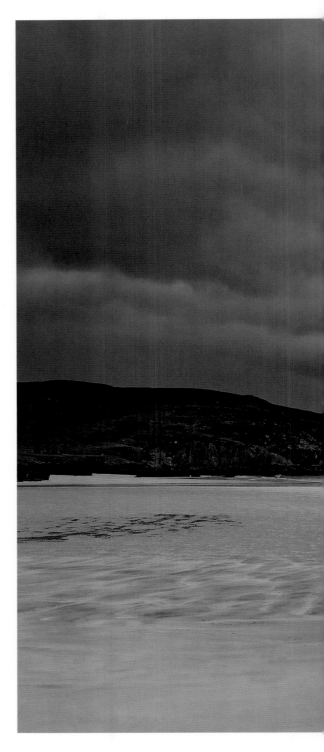

Garry beach
Beautiful golden sands on Garry beach make this a magical place when the sun shines.

This was an area I was familiar with from my *Machair* days. Garry beach, which sits just below the Bridge to Nowhere (which is sometimes called Garry Bridge), was a favourite Sunday haunt for members of the *Machair* cast and crew. Hidden from the rest of the island, we spent many a happy Sunday lighting barbecues and partying till the midges drove us away.

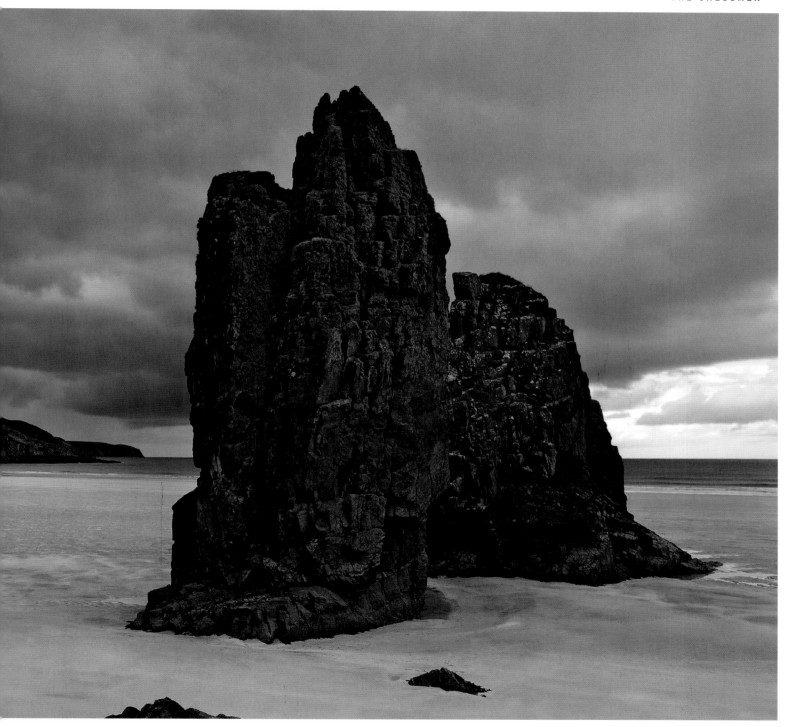

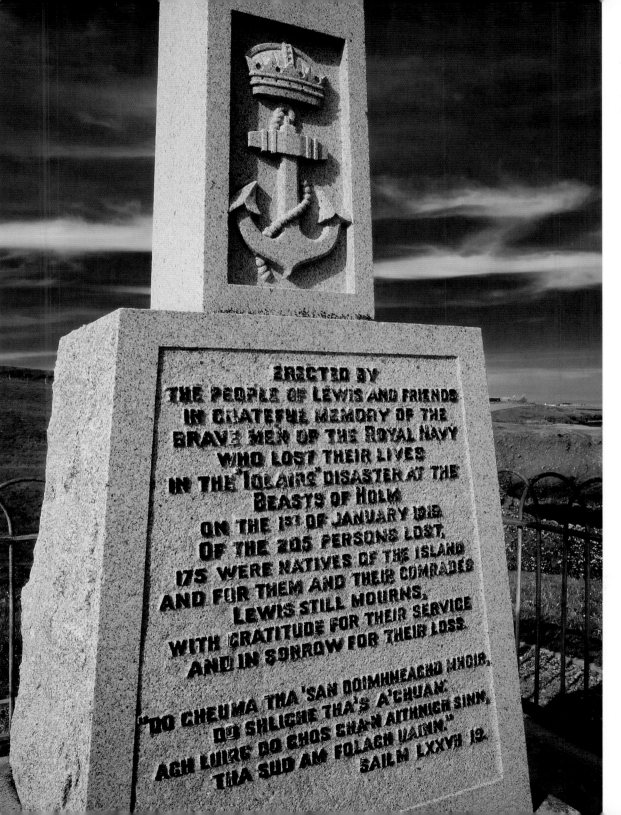

ERECTED BY
THE PEOPLE OF LEWIS AND FRIENDS
IN GRATEFUL MEMORY OF THE
BRAVE MEN OF THE ROYAL NAVY
WHO LOST THEIR LIVES
IN THE "IOLAIRE" DISASTER AT THE
BEASTS OF HOLM
ON THE 1ST OF JANUARY 1919
OF THE 205 PERSONS LOST,
175 WERE NATIVES OF THE ISLAND
AND FOR THEM AND THEIR COMRADES
LEWIS STILL MOURNS,
WITH GRATITUDE FOR THEIR SERVICE
AND IN SORROW FOR THEIR LOSS.

"DO CHEUMA THA 'SAN DOIMHNEACHD MHOIR,
DO SHLIGHE THA'S A'CHUAN;
AGH LUIRG DO CHOS CHA-N AITHNICH SINN,
THA SUD AM FOLACH UAINN."
SAILM LXXVII. 19.

The *Iolaire* monument
*The monument erected at Holm
Point in memory of those who
died in the* Iolaire *disaster.*

'They were only a few yards from shore. That was the irony, after surviving all those years at war. The sea was wild, and many of them were simply dashed against the rocks. Others couldn't swim. Didn't know how.' She glanced at Fin. 'You know how it is with islanders.' She returned her gaze to the window, raising her glass to her lips. 'Some were middle-aged, others just teenagers. More than two hundred men died, nearly a hundred and eighty of them from the island. Some villages lost all their menfolk that night, Finlay. All of them.'

She turned back into the room. I couldn't see her face properly against the last of the light from the window, just flickering features highlighted by her candles. It seemed hollow, like a skull, her hair a thin, wispy halo around her head.

'I once heard the old men of the village talk about it. When I was a girl. The only time I can ever recall anyone speak of it. The bodies arriving back in Ness en masse. On horse-drawn carts that pulled four or six coffins apiece all the way up that long west coast road.' She laid down her glass and lit a cigarette, and the smoke billowed around her head like breath on a frosty morning.

The final area of research involved something that few people on the islands had spoken about in nearly a hundred years. The *Iolaire* disaster. The *Iolaire* was a ship bringing island soldiers back from the First World War on New Year's Day 1919, when it struck a reef in the dark within sight of Stornoway harbour and went down with the loss of more than 200 lives.

It was the second worst peacetime disaster in British maritime history – second only to the sinking of the *Titanic*. And almost no one on the mainland has even heard of it. It was a different story on Lewis and Harris, where there was hardly a village which didn't suffer a loss that night. Men who had survived the war returned home in coffins.

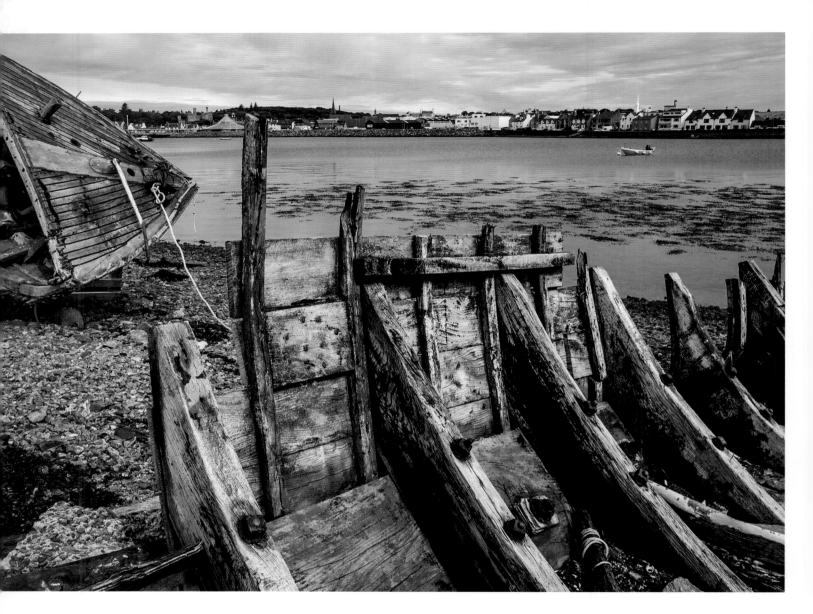

I visited the rocks on which the *Iolaire* had foundered. They are to be found just off Holm Point on the road out of Stornoway that leads towards the Eye Peninsula.

The rocks that sank the ship seem innocuous enough in daylight on a still day, and so close to shore, it is hard to believe so many men perished.

But one can only imagine the horror of that night, in the dark, with the sea breaking all around.

Today, Goat Island in the bay of Stornoway harbour is a place where old boats are broken up. The carcasses of once proud seagoing vessels are a distant echo and grim reminder of that long-ago day when the *Iolaire* went down.

Goat Island
The skeletons of broken-up boats on Goat Island, with the town of Stornoway in the background.

226

More boat wrecks
Wrecks of innumerable boats litter Goat Island.

On fine spring afternoons, after school, we used to motor out on our bikes, past Engie's and Kenneth Mackenzie's mill, over Oliver's Brae towards the airport and the turn-off to Holm Point. This was a finger of land that extended out into the bay just before the narrow neck of beach and causeway that led to the Eye Peninsula. The fields around us were fallow and shimmered yellow, full of dandelions. There was a cluster of buildings at Holm Farm, but we stayed away from there, and congregated just beyond the road end looking out over the rocks that were known as the Beasts of Holm.

The Beasts of Holm
In 1919 the rocks known as the Beasts of Holm took more than 200 lives – hard to believe on a calm day like this. The mountains of the mainland can be seen in the distance.

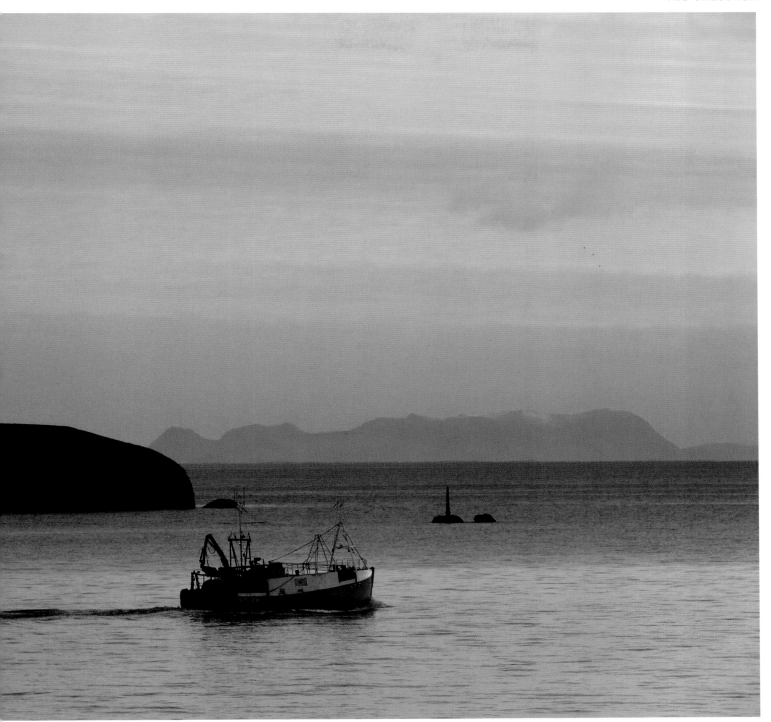

Free Church, Stornoway
The Free Church of Scotland church in Kenneth Street, Stornoway, attracts a large number of Sunday worshippers. Here endeth the lesson – and the trilogy.

One final location was required for a story that needed resolution at the end of the trilogy. The Free Presbyterian church in Kenneth Street in Stornoway provided the setting. But since it ties up the final book of the three, I will say no more about that here.

And so my Hebridean adventure, which had lasted more than twenty years, came to an end. I had made a commitment to writing only three books, and the writing of them was done.

But somehow it seemed impossible for me simply to walk away, like the parting of lovers at the end of a relationship. It was hard to imagine my life without the Hebrides as a part of it. And so I came up with another idea, for a new book with a Hebridean setting – a tale forged from my long association with the islands, a tale that took me halfway across the world and left me frequently in tears.

But that's another story, for another day.

A VIEW FROM BEHIND THE LENS

When I first came to work on the Isle of Lewis, in 1994, I rented a little cottage only a few metres from the head of Loch Grimshader, in Ranish on the east coast of the island and stayed there for the next eight years. In fact, a sunrise view from my front gate there can be seen on p. 109.

Each evening as I drove home from work in Stornoway or from film locations around the island, I would be drawn like a magnet into taking photographs of sunsets, wild skies and tweedy-coloured moors until the sun eventually dropped behind the Atlantic horizon.

Some of those thousands of images have only just survived the subsequent years in attics and basements. All taken on Fuji Provia transparency film using either my Canon EOS 1n 35mm SLR or a Rolleiflex 6008 square medium format camera, the best of them appear occasionally throughout this book. Examples include the green-roofed shieling on the Barvas moor (p. 142) and the Rocks at Luskentyre (p. 72) which are both still among my all-time favourites.

However, time and technology moved on and the Olympus E1, a highly regarded camera at the time, was my first venture into the world of digital photography. It delivered excellent images and was a joy to use. But with a mere 5MP sensor it had a fairly short life in my camera bag – the only shots in this book taken with it are those on Barra, such as the wonderful Vatersay Cow.

At this time I was also lecturing at a college on both digital and traditional darkroom photography and felt I couldn't fall behind the pixel counts of my students' cameras. So an upgrade was necessary!

I have always loved Olympus cameras for both their design philosophy and superb lens quality (my first being the classic OM1 when it was first introduced in 1973, followed by the OM2n and the OM3) so I moved on to their E3. This was the camera, with its 12-60mm lens, that was used to take the remaining 95 per cent of images in this book.

Of course, the Hebrides had me completely seduced and it was a foregone conclusion that I would soon move here. I now live in a characterful house on the west side of Lewis, with an uninterrupted view over the Atlantic coastline, and this continually offers up sunsets and seascapes of unbelievably vivid hues and textures, as can be seen on the following pages.

Modern professional digital cameras and photo-manipulation computer programs now offer almost limitless opportunities to alter any image, a facility often abused. But I can assure the reader here that colours such as these remarkable sunsets are quite genuine, occurring regularly during Hebridean autumns and winters. It doesn't take long practising landscape photography here to realize that a technique very different from that espoused in books and magazines on the subject is required – at least for the type of images I prefer.

My overriding motivation for pressing that shutter release is not so much to take classic landscapes, but more to capture the fleeting light patterns, startling skies and ever-changing weather conditions that are so redolent of this exciting place. My desire is to convey the atmosphere and power of the elements which have such effect on life here.

However, because of the speed with which the weather can change here as fronts sweep in across the Atlantic, I find I simply do not have the time (or inclination) to go down the traditional route of the landscape photographer – carefully setting up a tripod, mounting a large format camera, using tiny apertures (and, hence, slow shutter speeds) for greater depth of field. The aforementioned shots of the cow strolling on Vatersay beach and the green-roofed shieling, where the single shaft of light in which it is captured was racing across the moor, would have been quite impossible to shoot in this way.

So although my photography may not be of classically shot landscapes, I do hope that I have conveyed to you those things about the islands that have so enchanted me – the wildness, colours and beauty, the ever-changing light and sense of peace – leaving me no choice in the end but to come and live here and be proud to call the Hebrides my home.

David Wilson

OVERLEAF LEFT **First sunset**
This sunset was taken from my back garden as the sun dropped behind gathering clouds in the west.

OVERLEAF RIGHT **Second sunset**
And here the sun finally sinks below the horizon to cast its fiery glow into the heavens in the moments before it vanishes.

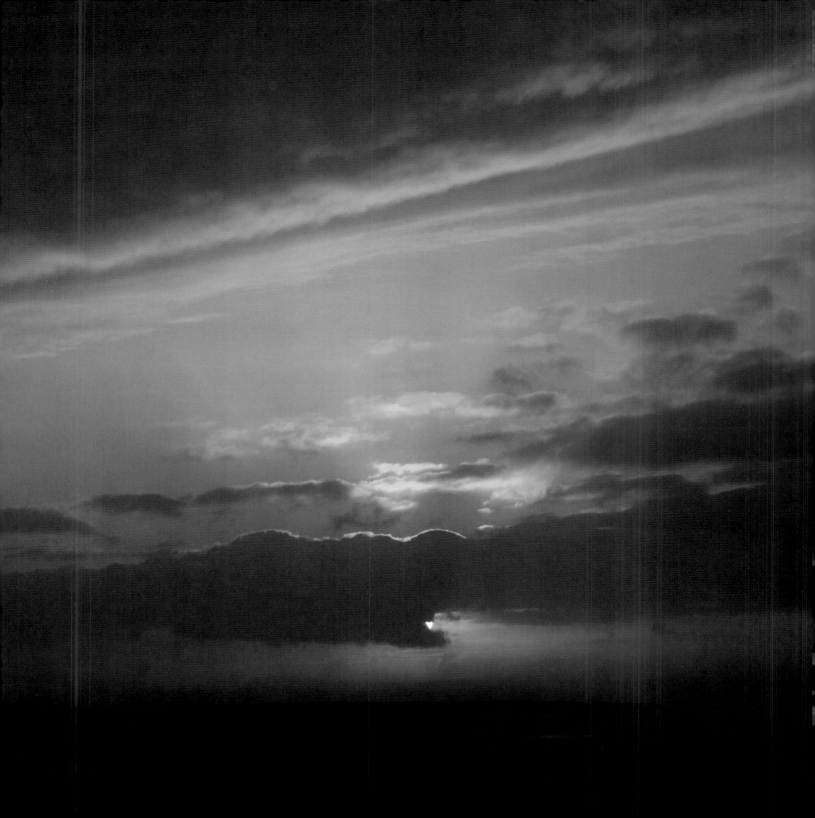

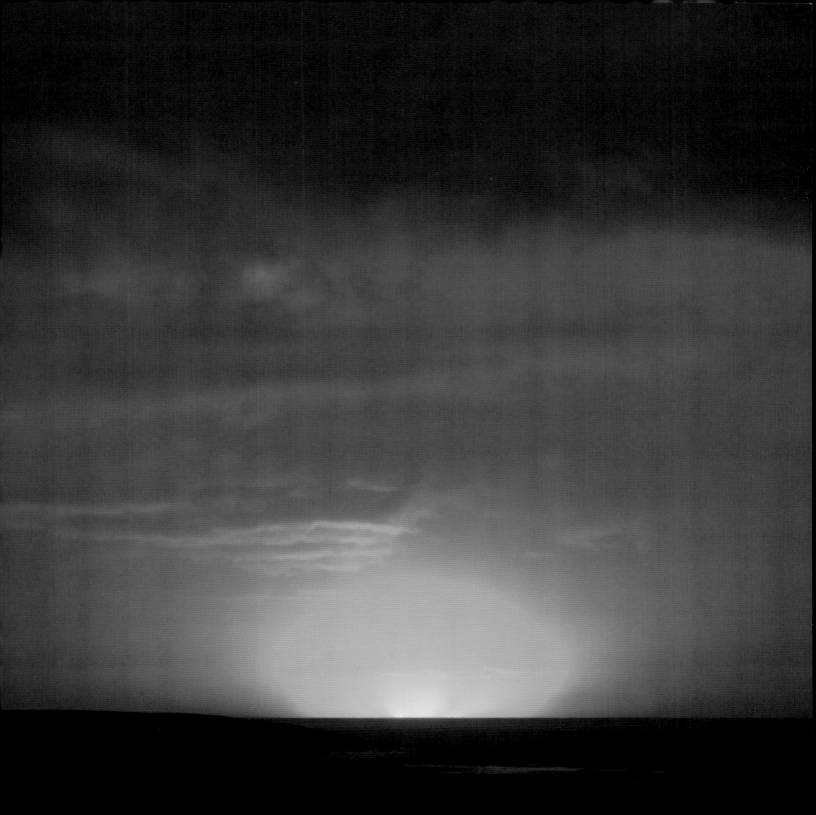

INDEX

First published in Great Britain in 2013 by

Quercus Editions Ltd
55 Baker Street
7th Floor, South Block
London
W1U 8EW

A CIP catalogue record for this book is available from
the British Library

HB ISBN 978 1 78206 238 7
EBOOK ISBN 978 1 78206 239 4

Printed and bound in China

Designed by Grade